Y0-BXR-578

Studies in the History of Greece and Rome

Robin Osborne, P. J. Rhodes, and
Richard J. A. Talbert, EDITORS

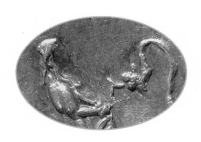

WOMEN'S RELIGIOUS
ACTIVITY IN THE
ROMAN REPUBLIC

CELIA E. SCHULTZ

The University of North Carolina Press

Chapel Hill

© 2006 The University of North Carolina Press

Designed by Kristina Kachele
Set in 10/14 Minion with Sophia display
by Tseng Information Systems, Inc.

Manufactured in the United States of America

Sections of Chapter 2 are reprinted courtesy of *Zeitschrift für Papyrologie und Epigraphik*.

The publication of this book has been made possible by the generous assistance
of the Frederick W. Hilles Publication Fund of Yale University.

The paper in this book meets the guidelines for permanence and durability
of the Committee on Production Guidelines for Book Longevity of the
Council on Library Resources.

Library of Congress Cataloging-in-Publication Data
Schultz, Celia E.
Women's religious activity in the Roman Republic / Celia E. Schultz.
p. cm. — (Studies in the history of Greece and Rome)
Includes bibliographical references and index.
ISBN-13: 978-0-8078-3018-5 (cloth : alk. paper)
ISBN-10: 0-8078-3018-6 (cloth : alk. paper)
1. Women — Religious life — Rome. 2. Women and religion — Rome. I. Title. II. Series.
BL625.7.S38 2006
292.07082 — dc22 2005034945

10 09 08 07 06 5 4 3 2 1

For
Sylvia, Gertrude, and Dora

CONTENTS

ILLUSTRATIONS AND TABLE

PREFACE

At an early stage in my introduction to the Roman world, I heard the famous tales about Roman women — Claudia Quinta bringing the Magna Mater from the mouth of the Tiber to Rome, the priestesses of Vesta buried alive if they forsook their vows of chastity, and the scandal that followed Clodius's infiltration of the exclusively female December rite of the Bona Dea — but as I read more widely in graduate seminars, I found hints that there was quite a bit more we could know about their activities. This first became clear in a seminar on Livy and was reinforced through an introduction to the methods of Latin epigraphy. In order to pursue the question of how much there was to know about the ways Roman women participated in the religious life of their families and communities, it was clear that I was going to have to go beyond the literary sources that form the bulk of an education in classics. I had to become familiar with, though by no means expert in, aspects of

epigraphy and archaeology. Thus I began to work on a dissertation on "Women Worshipers in Roman Republican Religion," written at Bryn Mawr College under the direction of Russell T. (Darby) Scott, which has developed into the present work. I credit Professor Scott and the interdisciplinary approach encouraged at Bryn Mawr with setting me on the path that has led me to this point.

For a project with as long a gestation as this one has had, the number of people to whom thanks are owed is legion. I owe an enormous debt to my teachers, especially Darby Scott and Paul B. Harvey Jr., for making Roman history come alive for me and for teaching me not to believe everything I read. Earlier versions of this study benefited from criticism from both teachers, as well as from Elaine Fantham, Susan Treggiari, Fay Glinister, Tara Welch, Harriet Flower, and Gil Renberg. Help with specific parts of the project came from Davida Manon, Bjoern Ewald, John N. Dillon, and Carlotta Dus. Fay Glinister, Rebecca Flemming, Lora Holland, Jean Turfa, and Paul Harvey kindly shared their research in progress. Valentina Livi helped with photographs. Sue Feingold tirelessly read numerous drafts and improved the prose considerably. Charles Grench and the staff at the University of North Carolina Press and the expert readers, John North and Richard Talbert, to whom they sent my typescript offered further suggestions for refinement. Ayelet Haimson Lushkov has kept me from many errors. Whatever mistakes remain are entirely my responsibility and are usually the result of ignoring good advice given to me. In an effort to make my work accessible to as many people as possible, I have provided my own translations or paraphrases of all ancient texts included here.

Support came in various forms from different quarters over the years. My colleagues and students at Johns Hopkins University and Yale University were unstinting in their willingness to discuss, and on some occasions to argue about, issues of Roman religion with me. The efforts of Susanna Braund, John Matthews, Christina Kraus, Victor Bers, and Kay Claiborn merit special note. Support of a different sort came from my parents, Michael and Susann Schultz, and my husband and son, David and Liam Driscoll, whose patient tolerance of the long evenings

and weekends I spent in the library was the most important incentive to finish my work and get out of the library. Several institutions offered financial support as the project progressed: the Mrs. Giles Whiting Foundation, the Fondazione Lemmermann, the Whitney Humanities Center and the Department of Classics, both of Yale University, and the National Endowment for the Humanities. The project came to a conclusion during a year of leave spent as a Fellow at the American Academy in Rome, made possible in large part by a Morse Fellowship from Yale University.

Finally, this book is dedicated to my great aunt and my grandmothers. Each of these women, in her own way, has been a role model to the generations that followed her. Each has demonstrated that a woman's participation in her own religious heritage—no matter how formal or informal, no matter how prominent or inconspicuous—is something of which she can be proud.

INTRODUCTION

Religion permeated the daily lives of the Romans: public festivals, periodic expiations of prodigies, regular sacrifices (public and private), trips to sanctuaries to seek help for a host of concerns, daily household rites, and religious celebrations of life's many transitions.[1] By performing rituals and offering sacrifice and appropriate gifts, the Romans hoped to ensure divine goodwill, that is, to maintain the *pax deorum* (peace of the gods). This relationship was somewhat contractual in nature: the Romans hoped, if not expected, that the gods would hold up their end of the arrangement if Romans did what was demanded of them. Rites and sacrifices, performed with scrupulous attention to detail, were offered in exchange for the continued prosperity of family and state. Correct performance of the prescribed steps was essential: failure to please the gods was often attributed to errors and omissions. Any rite or sacrifice improperly enacted had to be repeated until the *pax deorum* was once again restored.

This distinctly Roman approach to interacting with the divine meant that the Romans spent a great deal of time and effort ascertaining the state of their relationship with the gods: before political assemblies, military campaigns, weddings, and almost any other undertaking of uncertain outcome. Most commonly the will of the gods was made clear by certain signs (*auspicia*), such as a flash of lightning or the flight of birds. The entrails (*exta*) of a slaughtered animal also could reveal the gods' favor or anger. In more extreme circumstances, divine displeasure was made clear by prodigies (*prodigia*), perversions of the regular natural order such as a talking mule, a statue sweating blood, or a rainfall of stones. These occurrences often required grand measures to expiate them: the donation of a statue, the establishment of new public games, or even the importation of a new deity. The steps necessary to keep the gods in a good humor were governed by the *ius divinum*, the divine law that was the special concern of various groups, or colleges, of public priests, especially the *pontifices*, the augurs, and the priests in charge of conducting sacrifices (*sacris faciundis*).

With a calendar full of festivals and other religious observances, there were many opportunities for Romans to worship their gods. Not all opportunities, however, were available to all Romans: social status, marital status, and gender often determined who could, and who could not, take part in a particular observance. This book explores the range of opportunities for religious participation available to women in Rome and neighboring regions during the period of the Republic, both as a general group and as smaller groups marked out by social and marital status. As the discussion progresses, several questions will be approached from various angles: To what extent were women involved in the religious life of their communities and of their families? What forms did that involvement take? How did social and marital status factor into the mix? What kinds of concerns did women address to the gods, and to what gods did they address them?

The religious activities of Roman women have been a popular topic for study because women appear in almost the full range of Roman literature, particularly within a religious context. Yet discussion has often

been limited in one way or another, a circumstance due to the fact that most treatments of the topic form only sections of works of broader scope. In general studies of Roman religion, the role of women is not treated per se, though the subject is addressed as it pertains to certain priesthoods or involvement in, or exclusion from, individual cults.[2] These treatments are supplemented by numerous more narrowly focused accounts of particular cults that offer thorough investigations of portions of the religious world in which Roman women existed. These tend to focus on cults thought to address the traditionally feminine concerns of fertility and childbirth.[3] In recent years, the field has been expanded by two larger studies, Boëls-Janssen's *La vie religieuse des matrones dans la Rome archaïque* (1993) and Staples's *From Good Goddess to Vestal Virgins* (1998), which examine aspects of Roman women's religious experience across several cults and rites. Yet here, too, the focus remains on cults and rites that appealed to an exclusively female audience.

The present work is intended to enhance the picture of female religious activity in the Roman world that is already emerging, piecemeal, from these earlier studies. In particular, the discussion here moves beyond the confines of fertility and chastity cults and beyond exclusively female rituals. These topics have already received much excellent treatment and so will not be the focus here, though they form part of the discussion. This book emphasizes the importance of other kinds of female religious activity. Although traditionally feminine cults and rites were of central importance to Roman women, those observances were not the only avenues for participation available to them. The religious activities of Roman women also concerned cults of deities who watched over broader civic concerns, which have traditionally been categorized as falling into the masculine realm. Furthermore, female religious participation was not confined to the private sphere, the traditional domain of women, but often included public events. In addition to great public festivals, women worshipers were also essential participants in some events that fell outside the regular religious calendar, such as the expiation of prodigies. On a personal level, wealthy women advertised

their devotion to a particular cult through the large-scale restoration of religious sites.

The focus here is on the period of the Republic, from the late sixth century through the last decades of the first century B.C.E., rather than on the whole temporal expanse of the Roman world. In the aftermath of the civil wars that dominated the last century of the Republic, political control was consolidated into the hands of one man, and thus Rome was turned from a Republic into a Principate. In the early Empire, the emperor Augustus established an official, consistent religious policy— a program of government sanction for certain elements of religious life and indifference toward, or suppression of, others. Such a policy had not existed at Rome since the earliest stages of the Republic, if it had existed in Rome at all. Throughout the republican period, Romans generally worshiped as they pleased, and it was only in extraordinary circumstances that the Senate intervened to promote certain religious activities (such as the introduction of the Magna Mater in 204 B.C.E.) or to restrict others (e.g., the Dionysiac scandal of 186 B.C.E.).[4] Augustus, on the other hand, directed government involvement in religious affairs to encourage political stability, to promote the Empire, and to solidify his own position: rebuilding temples, filling vacated priesthoods, and reviving cults and rituals that had fallen into desuetude.[5] Individual elements of Augustus's program and many of its themes had republican antecedents, but as a strategy Augustus's religious restoration does not appear to have had a republican or even Caesarean precedent.[6] The unexampled scope and unified purpose of the Augustan restoration significantly reshaped the religious activities of the Romans. Such a monumental change and reorganization requires a separate study of religious participation by women during the imperial period. Therefore, the present study is generally limited to a consideration of evidence from the Republic; all dates given are B.C.E. unless otherwise noted.

From a survey of literary, epigraphic, and archaeological evidence, the religious activities of Roman women appear to have been more extensive than they are often portrayed as having been: Roman religion

offered women more, and more important, opportunities for participation than is commonly considered. This is not to assert that in the religious sphere Roman women were treated as if they were equal to men: Roman women never had access to the full range of opportunities for religious expression that men had, a situation seen most acutely in the observance of public rites. That said, it will become clear in the chapters that follow that Roman women were more fully engaged in the religious life of their communities and of their families than appears from a standard reading of the literature, both ancient and modern. The evidence for this expanded view is scattered widely throughout the sources, but when those tidbits of information are pulled together, they amount to a significant mass of material.

A further aim of this book is to pursue the ramifications of the conclusions drawn here for the more general study of Roman religion. This is an important goal since some of the findings of the following chapters necessitate the critical reevaluation of several ideas and methodologies frequently used, either explicitly or implicitly, in modern scholarship on Roman religion. Among those practices that must be reviewed is the blurring of the distinction between an individual rite and a cult: modern scholars do not often make explicit whether their arguments pertain to a specific ritual celebration or to a whole range of such celebrations observed in honor of a particular deity. Another practice in need of reevaluation, corollary to the obfuscation of the difference between rite and cult, is the assumption that restrictions pertaining to a specific rite automatically extend to the cult in general. For example, because men were excluded from the December ritual of the Bona Dea, we often treat this goddess's cult as if it only attracted women worshipers — despite a significant amount of epigraphic evidence to the contrary.

Perhaps the most significant contribution being made here is pointing out that Roman religion was far more gender-inclusive than is usually presented. This conclusion contradicts the widespread belief that a rigid division was (almost) always maintained between the religious activities of Roman women and Roman men.[7] One immediate result is

that, while this book is concerned with the religious activity of women, I avoid the terms "women's religion" and "women's deities."[8] These two phrases, ubiquitous in modern scholarship, most often refer to cults and gods that addressed concerns about marriage, fertility, chastity, and childbirth, thus reinforcing rather narrow parameters for the consideration of female religious activity.

The Sources

LITERATURE

Most historical accounts of classical Greece and Rome, including studies of women and of ancient religion, are drawn primarily from the evidence of ancient literature. There is no question that this body of material is an invaluable source of information. Literature often provides the only record of rituals, festivals, and practices observed by the ancients, as well as offering interpretation of events by those who observed and participated in them.

Unfortunately, the kind of information preserved for us is subject to the interests and biases of ancient authors.[9] These writers usually focus on large public festivals attended by women and offer little information about other types of female religious activity; modern scholars tend to follow the ancient emphasis and interpretation. Yet, by focusing on a few famous episodes and rites, we have overlooked a significant amount of evidence found in those same ancient sources that supports an expanded view of female religious activity: traditionally feminine concerns were not all that Roman women addressed to the gods.

The idiosyncratic and highly selective nature of literary sources is well illustrated by the analogy with which John Scheid begins his article "The Religious Roles of Roman Women." Scheid writes, "In his memoir of childhood Elias Canetti recalls that prayer in the synagogue meant little to his mother because, being a woman, she was excluded from the religious ritual. Such an attitude, frequently described by Jewish writers, might well have been expressed by a Roman matron. As a woman, she was, if not excluded from Roman religious practice, at least relegated to a marginal role."[10] This comparison between the female

role in modern orthodox Sephardic Judaism and ancient Roman religion calls on a circumstance from contemporary experience to help fill in what we may have trouble imagining of antiquity. The analogy is very useful, though not necessarily in the way Scheid intended.

Canetti's memoirs present some of the same methodological problems as do our ancient sources when used as evidence of female religious attitudes and activities. The report of Mrs. Canetti's feelings about her own religious tradition is not relayed to us in her own voice; in reality, she may or may not have held the opinion her son attributes to her.[11] Likewise, accounts in the relevant ancient literary sources should not be accepted uncritically, if for no other reason than that almost all surviving ancient texts were written by men who, by virtue of their gender, would have been prevented from participating in, and in some instances even from observing, some of the rituals they record.

Perhaps more important for our purposes, Canetti's text serves to illustrate the selectivity and subjectivity of a literary account. Although Mrs. Canetti may have felt alienated from Judaism within the synagogue, it is also clear from this same memoir that she took part in other religious activities. Furthermore, there are occasions when Elias Canetti himself recounts religious observances at which his whole family was in attendance, such as a Passover Seder, but he so focuses on the ritual role of the men of the household that he ignores the role of female participants, though he has made clear they were present.[12] Canetti's attention to a few aspects of his mother's Judaism and his own lack of interest in the rest are akin to the popularity among ancient authors of certain elements of the religious life of Roman women, such as the rites of the Bona Dea and the responsibilities of the Vestal Virgins. This contrasts with the relative lack of interest among the ancient sources in other exclusively female rites and priesthoods, including rites in honor of Juno Regina and the priesthoods of Ceres and Liber. The same small selection of topics treated extensively by ancient authors is also given relatively full consideration by modern scholars, resulting in a myopic modern view of female participation in Roman religion that matches the ancient presentation.

The disproportionate interest our sources show in certain aspects of

female religious activity is a product of several factors. Among these is the fact that the ancient authors whose works survive are almost all upper class and politically aware. This is reflected in their interest in religion on a grand, societal scale, which leaves us relatively well informed about public festivals but with very little evidence about how the average, and by that I mean nonelite, Roman man or woman interacted with the gods. This bias can be seen quite clearly in the paucity of information we have about religious rites observed within individual Roman households.

Another factor is the moral, didactic, and artistic aims of the works we have. Most modern readers would not dispute the claim that poets may distort an account of a rite or event to suit the themes and imagery of a poem, but we have traditionally been less eager to acknowledge the same potential for distorted presentation in prose writers, especially historians.[13] Yet the primary goal of ancient historiography is not the presentation of a scientifically objective account of past events. Rather, Roman historians frequently aim to provide their readers with moral tales (*exempla*) to be imitated or avoided,[14] and stories of sexual and religious propriety or transgression lend themselves to this kind of presentation. Thus, we have a host of stories, like that of Claudia Quinta and the Magna Mater, in which a woman's virtue is tested within a religious context. Ancient writers are concerned that their narratives be plausible and apparently free of bias; the modern notion of historical truth is not their highest objective. Even so, it is unlikely that most, let alone all, ancient historical accounts have been manufactured wholesale, although it is probable that many of the accounts available to us have been subject to some manipulation and distortion, including anachronism. Evidence gleaned from other types of writing, such as the letters of Cicero to Atticus that report events that actually happened, is more reliable but still should not be taken as offering a clear, uncomplicated view of the past. In sum, ancient literary accounts are based in fact, but those same accounts are shaped by other factors that must be considered critically.

A further complication of the reliability of our literary sources is the issue of contemporaneousness. Most extant accounts of the Roman

Republic were written at the end of that period, in the second half of the first century B.C.E., or even later, in the imperial period. The question has been raised, with justification, as to whether our sources could actually know what happened in previous centuries.[15] Again, caution is warranted, but we need not treat these texts as if they were complete confections. The authors whose works have come down to us relied on older sources, now lost, that had come down to them. In addition to literary accounts no longer available to us, those authors and their sources had access to the raw materials of history, including official documents and public inscriptions. Sufficient evidence demonstrates a fairly wide-ranging use of literacy in archaic Rome and Latium, particularly though not exclusively for religious purposes, and the habit of inscribing and then displaying public records is also documented from an early period.[16]

In the end, despite the problems they present, literary sources remain the most important resource for any study of the Roman Republic. The discussion that follows proceeds under the assumption that extant ancient literature can and does yield reliable information, at least in outline, about events in the distant past, certainly as far back as the period around the second Punic War, when Latin literature first makes its mark. That said, this study strives to identify and disengage the various cultural and artistic factors that may be at work in any given passage. Furthermore, while some of the case studies in this book date to the very early period of the Republic, thus making them suspect in the eyes of some, those case studies do not form the bulk of the discussion and the larger arguments of the study are not based solely on them. Thus, it is hoped that even those less sanguine about the reliability of our sources will find the conclusions drawn here to be based generally on acceptable foundations.

EPIGRAPHIC AND ARCHAEOLOGICAL EVIDENCE

One way to expand our understanding of the religious activities of Roman women is to include the full spectrum of literary evidence, rather than focusing on a few famous incidents. We can move even closer to our goal by introducing epigraphic and archaeological material into

the discussion. In the past, these two categories of evidence have not been fully exploited. However, great strides have been made toward the full integration of literary and material sources, most notably in Beard, North, and Price's monumental *Religions of Rome* (1998), which weaves together arguments drawn from many different categories of evidence rather than deploying physical material solely to illustrate an argument ultimately based on literary accounts.

The neglect of nonliterary evidence is unfortunate. While inscriptions and physical evidence often confirm the literary tradition, there are numerous occasions where those types of evidence present a picture very different from that found in literary texts. This is particularly so in the case of Roman religious practice and is in part a function of the discrepancy between the elite social status of most Roman authors and the lower status of the majority of Romans who set up inscriptions or left behind other tangible signs of their existence. This distinction makes the integration of written and material evidence essential for the study of any nonelite group in Roman society, including women. Archaeological and epigraphic evidence are the only materials left to us by Roman women themselves. Thus, in the absence of a body of female-authored literature, physical objects and inscriptions provide the raw materials for this kind of historical inquiry. Like literary sources, these raw materials must be handled critically since they, too, are not transparent windows to the past.

The difference between Roman religion as it appears in literary sources and as evidenced by physical material is often quite remarkable. For instance, archaeology and epigraphy preserve traces of religious offices and practices not mentioned by ancient authors. The most significant example of this is the nearly complete absence of any literary record of the widespread and long-lived practice of offering to the gods terracotta votives molded into the shape of parts of the human body. It is generally thought that these simple offerings, found throughout Italy and spanning several centuries, were popular among the lower classes who could not afford to bring the gods anything more significant. The silence of our sources about this practice again illustrates the

fact that ancient authors focus on religion on the public level; they are not concerned about what the masses were doing on their own behalf.

Physical material occasionally offers evidence that is contradictory to statements made by ancient authors.[17] One such instance is the issue of female worship of Roman Hercules, discussed in chapter 2. Drawing on accounts in Plutarch, Aulus Gellius, Macrobius, and other writers, modern historians had long thought that women were excluded from participation in the cult, despite a significant number of inscriptions attesting to female worship of the god. The authority of the literary sources led to the dismissal of those inscriptions as late forgeries, even though the stones are in no way otherwise suspect.

The integration of epigraphic and archaeological material into a consideration of female religious experience expands the geographical and temporal parameters of the discussion. Roman literature did not begin to appear in earnest until the third century, and most of what survives dates no earlier than the later Republic. In addition, Roman literature focuses almost exclusively on Rome itself, disregarding much of Latium and the rest of Roman Italy. Fortunately, this circumstance can be remedied to some extent by looking to epigraphic and archaeological evidence from areas outside the city, a significant amount of which is older than the literary sources.

Many individual aspects of Roman religious praxis were observed not only in Rome itself. Even before the cultural assimilation that accompanied Roman expansion in the Italian peninsula, a religious koine existed in west central Italy, as is evidenced by the presence of similar (but not necessarily identical) priesthoods in various towns and by the appearance of votive deposits, that is, collections of items consecrated to various deities. Votive deposits of a type peculiar to this region began to develop in the late fifth or early fourth century and appear in significant numbers by the late fourth century.[18] These deposits are filled with terracotta heads, anatomical representations, and figurines. They are distinct from deposits of north central and eastern Italy, in which bronze items are common, and from the deposits of southern Italy and Sicily, which do not generally include anatomical representa-

tions or votive heads.[19] These votive deposits are of particular interest to us here for two main reasons: the deposits help to define the wider religious milieu in which Rome existed; and anatomical votives constitute the earliest evidence that permits real consideration of the issue of the gender of the worshipers who frequented a particular site.

Broader geographical parameters offer context and points of comparison for the evidence from Rome itself, but the inclusion of more material does not completely remedy problems posed by the nature of the evidence. Great gaps remain in the evidence for religious practice in the Roman Republic, thus making it difficult, if not impossible, to trace the development over time of most aspects of religious life. Forcing a diachronic interpretation on such disjointed evidence can lead to unfounded conclusions, such as the assertion that the goddess Ceres did not develop a particular association with women until the third century—an argument based on the fact that at this time female worship of the goddess first appears in extant literary sources.[20] A more convincing interpretation of this circumstance is that Ceres had always been popular among women and that the sudden record of female activity in the goddess's cult in the third century is due to the concurrent development of Latin literature. In order to avoid difficulties such as this, the present study generally takes a synchronic approach, a method helped by the conservative nature of religious observances and of the Romans themselves. Religious rituals are by definition sacred and therefore resistant to alteration, even if the interpretation of them is subject to ever-changing social and political circumstances. Furthermore, the Romans, a people who prided themselves on their scrupulous maintenance of ancient forms, are very likely to have tried to preserve the details of ritual observance over centuries.[21]

The Background

It will be helpful to consider the full range of religious activities observed in the Roman Republic before considering to what extent these activities were open to female participants. Worship of the gods and

maintenance of the *pax deorum* was central to the Roman way of life at every level of society, in every sphere of activity. This is most obvious in the frequency of public festivals (*feriae*) in which the people took part throughout the year, often more than once a month.[22] Some public festivals were observed by the people at large, such as the March festival of Anna Perenna, when families went to the goddess's grove outside the city to picnic, or the Floralia celebrated in April with games and bawdy theatrical entertainments. Sometimes extraordinary religious events, particularly the expiation of prodigies, required the participation of the people of the city and outlying areas. These occasions involved prayers and gifts for the gods. The central element of many of these festivals and other celebrations in honor of the gods was a blood sacrifice, usually a pig, sheep, or cow, though on rare occasions other animals such as a dog or fish were required. The details of sacrifice were prescribed according to the type of animal to be offered, including size, gender, color, and age. Other kinds of offerings included incense, wine, milk, and material items such as statues and precious metals.

Public festivals often involved the participation of most Romans, but some regular rites were performed by a select few as spectators may have looked on. We know that people lined the streets in mid-February to watch the Luperci, a group of nearly naked male priests, make their annual run through the city, and crowds must have come out to see the dancing processions of another group of priests, the Salii, and their sacred shields in February and March, and possibly again in October. Even more restricted, but still observed on behalf of the people (*pro populo*), were rites like the December ritual of the Bona Dea, held at the house of a senior magistrate and observed by the Vestal Virgins and the leading ladies of the city.

In the private sphere, there were festivals celebrated by individual households. For example, each year in late December or early January, families celebrated the Compitalia by offering sacrifice and walking the circuit of the *compita* (crossroad shrines) around their property, and in February they traveled out of town to the tombs of their ancestors to make offerings to them on the Parentalia. Religious ritual was also

a part of everyday life in the Roman household. Daily offerings were made to the household gods, and rites of passage, such as the birth of a new child or a wedding, always had a ritual component.

The distinction between public rituals (those observed on behalf of the Roman people by public officials or other specially selected designates) and private rituals (usually taken to mean those observed in a domestic context) is not always as clear as one might think.[23] For instance, some private observances also had a public aspect, as is the case with the two family festivals just mentioned. The movable festival of the Compitalia, though observed by individual households, was announced each year by public magistrates (the praetors) in Rome, and the crossroad shrines in urban areas were maintained by groups organized just for this purpose, *collegia compitalia*, rather than private property owners, as they were in rural areas.[24] Likewise, the Parentalia seems to have been primarily a family holiday, though it had its public aspect in a ceremony observed by a Vestal Virgin on the first day of the festival.

Another blurring of the distinction between public and private worship comes in the form of private acts of worship in public sanctuaries. Judging by the vast amount of material yielded by votive deposits and written dedications, it seems that individual worshipers, and occasionally private groups such as professional guilds, regularly offered thanks to the gods for help with quotidian concerns: physical maladies, fertility, business ventures, and travel. This kind of mixing of public and private is well illustrated by the range of offerings made to Fortuna Primigenia at Praeneste, who received offerings from groups of goldsmiths, cattle or sheep dealers, and money changers, as well as from a woman in thanks for (as a request for?) successful childbirth.[25]

Overview

This book begins with treatments of each of the three main categories of evidence for women's religious activities — literary, epigraphic, and archaeological. The division among categories of evidence is not abso-

lute, however; there are several points at which the discussion of one type of material is integrated with other sources of information, most beneficially in the treatments of epigraphic and archaeological material. This organization around different types of evidence may seem somewhat mechanical, but several of the most important arguments made in the pages that follow are closely related to the different kinds of material under investigation. Literary sources have certain limitations that can, to some extent, be compensated by the inclusion of inscriptions and archaeological material. Furthermore, all the evidence points in the same general direction, that is, toward the idea that Roman women were more fully engaged in the religious life of their families and communities than we often think of them as having been.

Since readers are most likely to be familiar with literary evidence, I begin the discussion there. Chapter 1 examines the ideas and methodologies that underlie the exploitation of literary evidence for the study of Roman religion and Roman women. Rather than offering a comprehensive survey of written sources for women's religious activity, this chapter takes up a series of case studies that illustrate some of the preconceived ideas with which literary evidence has been approached. For example, recent treatments of Juno Sospita and Juno Regina have been influenced by the assumption that female involvement in the cult of a particular divinity is a clear indication that the divinity must be concerned with traditionally feminine issues.[26] This assumption has led scholars to privilege certain texts and thus to see these two goddesses as "women's deities" rather than as the powerful political and military divinities they were. Similar approaches to the story of the temple of Fortuna Muliebris have resulted in the subjugation of any possible civic implications of the tale to metaphorical interpretations that emphasize fertility concerns.[27] Furthermore, the tendency to disregard evidence for female participation in public, politically significant observances, such as expiatory rites ordered by Roman officials, has contributed to the notion that women were usually relegated to less important, private rituals.

Chapter 2 focuses on epigraphic evidence, that is, inscriptions carved

on stone or into metal or clay. To be sure, cults catering to tradition-
ally feminine affairs were popular among women worshipers, as a ma-
jority of inscriptions make clear. There is also, however, significant epi-
graphic evidence of female worship of gods not generally concerned
with domestic matters (e.g., Jupiter and Hercules), as well as evidence
of male worship of deities whose cults have been thought to attract
a primarily, if not exclusively, female clientele. This suggests that Ro-
man religious practice was less rigidly divided along gender lines than
is commonly thought. Epigraphic material also provides evidence for
large-scale financial involvement of women worshipers in the resto-
ration and maintenance of cult sites, indicating that the actions of
women in the imperial period, most notably the empress Livia, were
not unprecedented. In addition, inscriptions provide enough evidence
for female religious involvement on a (quasi-) professional level (as
priestesses, *magistrae*, and *ministrae*) to allow for further consider-
ation of the requirements for female public religious service. Chap-
ter 2 also presents a new model for Roman public priesthoods: rather
than a monolithic view where male priesthoods define the category and
female priesthoods are necessarily viewed as exceptions to it, a tripar-
tite classification that acknowledges the different structures of male,
female, and joint male and female priesthoods is more applicable to
the Roman situation. The chapter concludes with a discussion of the
Bacchic scandal of 186. In light of the expanded view of female reli-
gious activity, Livy's claim that the gender of the participants in the
Italic cult of Dionysus prompted the Senate's restriction of cult activity
must be viewed with skepticism.[28] There is epigraphic and literary evi-
dence that Dionysiac worship had been gender-inclusive in the Helle-
nistic period, if not earlier. Furthermore, the inscription recording a
series of decrees issued by the Senate in response to the scandal, the so-
called *Senatus Consultum de Bacchanalibus*, suggests that Roman au-
thorities were concerned particularly with curbing male involvement
in the cult. Gender played a role in the resolution of the crisis,[29] but as
a function of wider social and political concerns.

Chapter 3 examines the evidence of votive deposits and in particu-

lar, focuses on the anatomical representations that help to define the religious koine that existed in the regions of Etruria, Latium, and Campania from the late fifth century onward. After an introduction to some of the modern interpretive debates about these items, such as whether anatomical votives should be seen as expiatory gifts or thank offerings, the discussion turns to a quantitative analysis of the typological makeup of Etrusco-Latial-Campanian votive deposits.[30] In addition to revealing, in a general way, the gender of worshipers who frequented a given site, this type of analysis has implications for our understanding of Roman religious practice on a broader scale. It is here that the argument for the greater gender-inclusive nature of Roman religion finds its most forceful articulation.

Moving away from discussion of female participation in public, collective rites and of individual acts of worship outside the domestic realm, chapter 4 draws on all categories of evidence to reconstruct the role women played in religious observances within the home and then relates the importance of women within the sphere of domestic religion to their role in public religion. The extant evidence for domestic religion is meager at best, and the subject has not received extended treatment for a century or so.[31] Yet, it is possible to glean a few details of female participation from literature, and, as in other areas under investigation, the literary picture can be enhanced further through the analysis of material evidence. One particular argument made here is that women were not interdicted from handling the materials of sacrifice, and that the case for female exclusion from sacrifice in general is not based on firm foundations.[32]

Chapter 5 concludes this study with a consideration of the criteria by which women were admitted to some rites, excluded from others, and occasionally selected for religious honors, including priesthoods. Similarities between the female role in domestic ritual and the duties of the Vestal Virgins suggest that both female priests and female worshipers were entrusted with tasks essential to the maintenance of the relationship between gods and mortals. This corresponds with the expanded role of women argued for in earlier chapters, and it differs

from the commonly held idea that while priestesses (especially those of Vesta) were essential to Roman religious practice, women worshipers still composed only a marginal element. An examination of the relevant literary evidence also suggests that the requirements and mechanism for the selection of individual women for regular official religious service (priesthoods) were mirrored by the requirements of, and selection process for, choosing other women for extraordinary religious duties, such as the dedication of a statue. In both professional and nonprofessional capacities, women were vital participants in the religion of the Roman Republic.

To conclude, this book aims to supplement and expand our understanding of the religious life of Roman women. The study of Roman history in general has been likened to the exploration of "a cavern of vast and unmeasured dimensions, much of it impenetrably dark, but here and there illuminated by a few flickering candles."[33] I hope to be able to shine additional light into some of the darkened corners.

ONE

LITERARY EVIDENCE

Literary evidence provides the basis for most modern studies of Roman women and Roman religion. Thus, as a prelude to exploring ways to expand our perception of female religious activity, it is worthwhile to examine the presumptions with which these sources have been approached and the methodologies to which they have been subject. To this end, instead of a comprehensive survey I will take up several case studies of female religious involvement: the worship of Juno Sospita, expiation of prodigies, and the foundation of the temple of Fortuna Muliebris.

Until relatively recently, ancient accounts were treated rather uncritically. For example, Fowler's description of the religious chaos in Rome in 213 is a close paraphrase of Livy's text: "Private priests and prophets, vermin to be found all over the Graeco-Roman world, had captured for gain the minds of helpless women."[1] The sentiment be-

hind this statement is not far removed from Balsdon's pronouncement, offered as explanation for a perceived excessive female attraction to eastern cults, "that women, as a sex, are more gullible than men, may be true . . . more important is the fact that women, as a sex, are more religious than men."[2] Neither Balsdon nor Fowler speculates about the validity of their sources' purposes and biases.

More recent works, however, have stepped away from taking ancient authors at their word. For example, Pomeroy sees Augustan moral propaganda in Livy's presentation of events of social (including religious) importance.[3] Likewise, Kraemer points out that extant literary accounts of exclusively female festivals were written by male authors who were forbidden to attend them and rightly advises caution in dealing with such evidence.[4] Two important gains of such studies are, first, the identification of several stereotypical ideas found in ancient literature, such as the alleged excessive religiosity and gullibility of women; and, second, the demonstration that traditionally feminine concerns (fertility, childbirth, etc.) did, in fact, constitute an important component of the larger Roman religious framework.

The focus of ancient and modern accounts of female religious activity has been the exclusively female public festivals that formed part of the regular religious calendar of Rome. This focus is in large part a by-product of the widespread, yet tacit, assumption that women were concerned almost exclusively with issues of fertility, childbirth, and the continued well-being of their children, and that their religious habits were therefore restricted to that limited sphere. Some scholars have taken things one step further by universally applying the ancient association of women with fertility rituals to all accounts of female religious activity, even in cases where such an application is unwarranted, such as the cult of Juno Regina (discussed below). As a result, several corollary ideas that unnecessarily limit our perception of female religious participation have become fairly common. Among these notions are skepticism regarding tales of politically significant female religious activity and the presumption that female involvement in a particular cult is an indication that the deity at its center is a "women's deity."

In the discussion that follows, it will be argued that the link between women and fertility ritual is neither necessary nor certain. The cases taken up here include both frequently studied rites and one often neglected category of female religious experience, participation in the expiation of prodigies. In each case, setting aside the basic assumption that female involvement is a clear indication of fertility ritual allows unexplored elements to rise to the surface.

Before proceeding, it is necessary to point out a common confusion in studies of Roman religion: the blurring of the distinction between rites and cults. Many scholars, following the example of Latin Christian authors, frequently use the terms "rite" and "cult" interchangeably.[5] For the purposes of this study, however, these terms are used with the different, specific meanings they have in classical authors.[6] Henceforth, "rite" (or ritual, celebration, or observance) will indicate an individual act of worship, repeated regularly or not, such as a sacrifice or festival; "cult" will refer to the sum total of rites — festivals, sacrifices, and other forms of worship — observed in honor of a particular deity.

At the root of the confusion between rite and cult lies the assumption that restrictions and requirements applied to a specific ritual automatically extended to the cult as a whole. For example, the common impression that the cult of the Bona Dea was exclusive to women is based largely on accounts of the goddess's December ritual, an overnight observance restricted to matrons (*matronae*) and Vestal Virgins held at the house of a senior Roman magistrate.[7] The extrapolation from rite to cult and the resultant conflation of the two terms can be seen in the conclusion to Staples's treatment of the Bona Dea: "In summary, the *cult* of the Bona Dea established the nature of the boundary between male and female. Male and female were polar opposites whose converging had to be ritually mediated. At the same time there was an acknowledgement that the opposed elements existed within a common context and were interdependent. Finally it seemed to suggest a way in which society might be served by such an interdependent existence. It was indeed a *rite pro populo*" (emphases added).[8] Aside from certain

gender-exclusive elements, however, there is ample evidence that the cult of the Bona Dea, as a whole, did not always enforce a strict division between male and female: epigraphic material demonstrates that men also participated in the cult.[9] There is no reason to assume that, in general, cults were subject to all the restrictions enforced at the individual rites that were part of the cults themselves.

Problems of Interpretation

The case of Juno Sospita demonstrates how underlying presumptions can skew our understanding of ancient religious practice—how a military and political deity comes to be seen as a "women's goddess" and how much reliable evidence that might expand our understanding of female religious behavior is ignored in favor of sensational, moralistic tales.[10]

As far as can be determined, Juno Sospita's association with Rome began with the treaty between Rome and Lanuvium at the conclusion of the Latin War in 338. Rome granted limited citizenship to Lanuvium (*civitas sine suffragio*) and returned to the city control of its cults (*civitas data sacraque redita*), with the caveat that Lanuvium agree to share the temple and sanctuary of its chief deity, Juno Sispes (Sospita) Mater Regina, with the Roman people.[11] Thereafter, consuls of Rome went to Lanuvium each year to offer sacrifices to the goddess, who was eventually established at Rome also. In addition to a shrine on the Palatine hill, she received a temple in 194 in celebration of the victory over the Gauls three years earlier.[12] One of Juno Sospita's temples in Rome was restored a century later, in 90, just as another struggle over the integration of various Italic peoples—the Social War—was being waged. The restoration served as a reminder of an earlier Roman victory in a similar conflict.[13]

The evidence of the literary sources that Juno Sospita was the chief deity of Lanuvium is supported by the prominence of her sanctuary there, as attested by archaeological remains.[14] That she continued to be important to Lanuvium and Rome on an official level under the Empire is further evidenced by the gender and position of those who

set up dedications in her honor. While the only published dedication to the goddess dating to the republican period was set up by a freedman for unknown reasons (*ILS* 3097), from the period of the Roman Empire we have dedications to Juno Sospita from a Lanuvine dictator who paid for gladiators and games in Juno Sospita's honor (*ILS* 5683), a Lanuvine (?) *rex sacrorum* (*ILS* 6196), the emperor Hadrian (*ILS* 316), and a soldier (*ILS* 9246 — dedicated to both Juno Sospita and Hercules Sanctus).[15] Her interest in military matters is further illustrated by her appearance as she is depicted in statuary and on coins (figs. 1, 2, 3): she wears her goatskin as a helmet and often carries with her a spear and shield.

In addition to Juno Sospita's unquestionable interest in political and military matters, some scholars attribute to the goddess competence in more typically feminine affairs.[16] This argument is largely based on two items: epigraphic evidence that the goddess sometimes bears the epithet *mater* (mother), and Propertius's account of a particular rite in which women took part. As to the first point, Palmer has pointed out that *mater* can be an honorific title and is not necessarily an indication of divine concern for fertility issues (as in the case of Vesta Mater); several gods (including Jupiter and Mars) are addressed as *pater* (father) without any seeming parallel concern for male potency.[17]

The assumption that the participation of women worshipers in a particular cult is an indication that the deity concerned is necessarily a "women's deity" has led some scholars to point to Propertius 4.8 as evidence that Juno Sospita had a particular interest in female fertility. In the poem, Propertius describes an annual ritual at Lanuvium, during which a *virgo* (line 6) was chosen to make a food offering to the snake that lived in a cave sacred to Juno. Cynthia, the narrator's ladylove, uses the rite as a pretext to go to Lanuvium for a rendezvous with another lover (lines 15–16).

> Disce quid Esquilias hac nocte fugarit aquosas,
> cum vicina novis turba cucurrit agris.
> Lanuvium annosi vetus est tutela draconis,
> hic ubi tam rarae non perit hora morae,

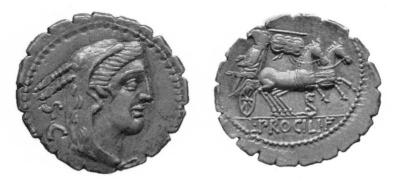

Figure 1. Denarius of Procilius (enlarged to show detail).
(Courtesy of the Yale University Art Gallery, inv. no. 2001.87.116)

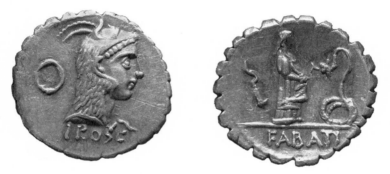

Figure 2. Denarius of Roscius (enlarged to show detail).
(Courtesy of the Yale University Art Gallery, inv. no. 2001.87.384)

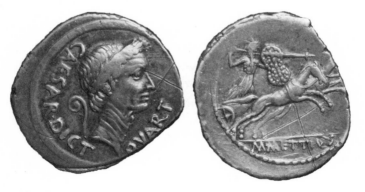

Figure 3. Denarius of Mettius (enlarged to show detail).
(Courtesy of the American Numismatic Society, inv. no. 1944.100.3628)

qua sacer abripitur caeco descensus hiatu,
 qua penetrat virgo (tale iter omne cave!)
ieiuni serpentis honos, cum pabula poscit
 annua et ex ima sibila torquet humo.
talia demissae pallent ad sacra puellae,
 cum temere anguino creditur ore manus.
ille sibi admotas a virgine corripit escas:
 virginis in palmis ipsa canistra tremunt.
si fuerint castae, redeunt in colla parentum,
 clamantque agricolae: "Fertilis annus erit!"
huc mea detonsis avecta est Cynthia mannis:
 causa fuit Iuno, sed mage causa Venus.
(Propertius 4.8.1–16; ed. Fedeli)[18]

[Listen to what panicked the watery Esquiline last night, when the neighborhood crowd ran about in the new fields. Lanuvium is the charge of an ancient serpent; here is a place where an hour is not wasted on so rare a respite, where a sacred slope is broken by a dark opening, where a virgin enters (Beware all such journeys!), a tribute for the fasting serpent, when he demands his annual meal and a hiss winds its way up from the deepest earth. The girls sent down to such sacred things grow pale when they think their hands have been brushed by a serpentine tongue in the dark. The snake snatches the morsels offered by the virgin as the basket shakes in her hand. If the girls are chaste, they return to their parents' embrace and the farmers shout "It will be a fruitful year!" My Cynthia was carried there by cropped ponies. [She claimed] her reason was Juno, but a better reason was Venus.]

Propertius has chosen to use the Lanuvine rite in this poem because certain of its elements resonate with the themes and imagery he wishes to emphasize in the poem. The military aspect of the goddess, reinforced by her martial appearance, matches the military imagery used to describe Cynthia. For example, Cynthia's trip to Lanuvium is a "triumphus" (line 17); the narrator's transfer of affection from her to

Phyllis and Teia is a switching of camp ("castra movere" [28]); the scene that unfolds upon Cynthia's return is at least as dramatic as the sacking of a city (56); peace is achieved only when the narrator approaches Cynthia as a suppliant ("supplicibus palmis") and accepts the terms of the "foedera" (71) that she lays down. Furthermore, the poet's inclusion of the ritual in the cave at Lanuvium, as a test of a woman's purity, points up the theme that lies at the very heart of the poem: Cynthia's and the narrator's mutual infidelity.

Propertius 4.8 contains no hint that Juno Sospita is concerned with female fertility and childbirth. Admittedly, the goddess's interest in agricultural fertility is made clear (line 14), but divine competence in one of these areas does not necessitate competence in the other. For example, Cato (*Agr.* 141) instructs his readers to address prayers for a good harvest and healthy family to Mars Pater, a deity unconcerned with traditionally feminine affairs. Furthermore, the republican denarius of L. Roscius Fabatus (fig. 2), depicting Juno Sospita dressed in her military garb on one side and a woman making an offering to a snake on the other, suggests that the goddess's martial aspect was not divorced from the ritual in the cave.[19] Thus, Juno Sospita's appearance in Propertius's poem owes more to martial imagery shared by the goddess and Cynthia and to the theme of purity than to any concern for Cynthia's fertility.

A comparison of modern treatments of two different ancient accounts of the refurbishment of one of Juno Sospita's Roman sanctuaries, in 90, will illustrate the tendency to focus on evidence that buttresses currently held ideas about the religious experience of Roman women. The better-known version comes from Julius Obsequens who, in his summary of Livy's account of 90, says that Juno Sospita came to Caecilia (who is not further identified) in a dream and told her that she, Juno, was fleeing Rome because her precincts (*templa*) had been defiled. Caecilia persuaded the goddess to stay and, upon wakening, set about restoring a temple defiled by the filthy bodily functions of matrons — "aedem matronarum sordidis obscenisque corporis coinquinatam

ministeriis" and where there was discovered the lair of a dog and her offspring.[20] The exact nature of the matronal bodily ministrations is subject to debate: some assume that Obsequens is talking about matronal prostitution, whereas others think he means that the ladies were using the temple as a latrine.[21] The language of Obsequens's summary is not explicit.[22] Any interpretation must remain provisional, though it can still be argued that the tale does not demonstrate regular female worship of the goddess: it might just as well indicate that Juno Sospita's temple had become a popular meeting place for illicit liaisons (cf. Ov., *Ars* 1.73–79). There is no explicit support here for the notion that Juno Sospita was a particular favorite of women worshipers, and Propertius's poem only makes clear their inclusion in one of her rituals.

The sensational and moralizing nature of Obsequens's version is pointed up by comparison with the more contemporary references to the same event found in Cicero's *De Divinatione*. The orator, relying on an account by Sisenna (1.99) and his own recollections (1.4), recounts that the Senate ordered the consul of the year to restore Juno Sospita's temple during the Social War because of a vision seen by Caecilia Metella, daughter of Q. Caecilius Metellus Balearicus.[23] Cicero's emphasis on the involvement of the Senate and his attribution of the refurbishment to the consul, L. Julius Caesar, rather than to Caecilia herself makes clear that the event was more politically significant than it appears in Obsequens's version.

In general, the contemporary religious situation, and more specifically the relevance of Caecilia's dream to current political circumstances, has been overlooked in modern histories of the Social War.[24] There can be no doubt, however, that the Romans immediately understood the importance of the dream: the Senate, the ultimate religious as well as political authority in Rome,[25] treated the vision with all seriousness, entrusting the refurbishment project to no one less significant than the consul of the year. The timing of Caecilia's vision — during the Social War — may have contributed to the gravity of the Senate's response. The vision was not an isolated incident but occurred at a time when many portents were brought to the attention of Roman officials.[26]

As during the Hannibalic War, Roman political instability during the Social War was reflected in the unusual numbers of portents reported at the time: chaos on the political level was paralleled by chaos in divine matters. The prevalence within contemporary prodigy reports of Juno Sospita and her hometown of Lanuvium, where mice were reported to have gnawed some sacral shields, underscores uncertainty about Roman dominance in Latium.[27] The close relationship between military and religious concerns is further underlined by the fact that the consul charged with the restoration of Juno's temple was actively involved in the prosecution of the war in the area south of Rome, the very region where Lanuvium is situated. Furthermore, Cicero's version of this episode demonstrates that there were times when women, at least those of senatorial status, could act not only as participants in but also as instigators of public religious activity. The civic importance of Caecilia's dream indicates that women were not unfamiliar with the goddess's military and political aspects.

Expiation of Prodigies: Supplicationes

Cicero's tale of the refurbishment of Juno Sospita's temple is just one of many episodes that suggest women played a wider role in the religious life of Rome than is often allowed. While the majority of relevant accounts are too brief and incomplete to be of much importance individually, taken together they present a significant challenge to the common view of female religious experience. One important group of references documents female involvement in the expiation of prodigies. Perhaps the most tantalizing is a short reference in Festus (232–34L, s.v. "piatrix"), and Paulus's redaction of it (233L), to a religious official called a *piatrix*. A *piatrix* was a priestess who specialized in expiations, and who was also called *saga, simpulatrix,* or *expiatrix*.[28] Since *piatrices* are not mentioned by other authors with an interest in official Roman religion, it is reasonable to assume these women dealt primarily with private religious matters and were not maintained by the Roman government for its own needs.

Far more common than this single mention of the *piatrix* are references to female involvement in public expiatory exercises, especially in celebrations of a particular rite called a *supplicatio*. Each year the Senate, under advisement of the priestly colleges, determined the proper expiatory actions to be taken in response to prodigies reported the previous year. Delegates were then chosen to oversee preparations and to organize popular involvement. One common expiatory exercise was the *supplicatio*, in which the people filled temples throughout the city to offer prayers, sacrifices, and libations. In the republican period, the ritual was reserved for situations of great civic importance and could be used for several different ends. *Supplicationes* were organized to palliate divine anger (sometimes manifested as a famine or epidemic), to request aid in the face of grave danger, such as a threatened sacking of the city, or to offer thanks for help already received.[29] The ritual was designed to effect instant change in the immediate circumstances facing Rome. It was not a tool to be used to ensure the long-term perpetuation of the city through continued agricultural or human fertility.

It is surprising that the *supplicatio* has generally been left out of considerations of the religious activities of Roman women since the rite was often attended by all adult Romans, male and female.[30] Although we cannot know for certain whether women were always included in *supplicationes* — our sources are rarely explicit about the categories of worshipers who took part — it is clear nonetheless that the *supplicatio* could be all-inclusive. On at least three occasions, adult women are said to have participated in public *supplicationes* alongside men: during the third Samnite War in 296, after the disastrous battle against the Carthaginians at Lake Trasimene in 217, and after the Roman victory over Hasdrubal's army in 207. In 190, a group of ten young women (*virgines*) and ten young men (*ingenui*) were chosen for a special role in the *supplicatio* held that year.[31] Whether these instances represented regular practice or exceptions to it cannot be recovered, though it is worth noting that the sources do not indicate that there was anything unusual about the *supplicationes* in which women took part. In all likelihood, there was some fluidity in the constituency that celebrated pub-

lic *supplicationes*: sometimes men alone, sometimes men and women together, and in one instance women alone.[32]

After the loss of Tarentum to Hannibal in 212, two prophecies of a seer named Marcius were made public (Livy 25.12.2–15; Macr., *Sat.* 1.17.27–28). The prophecies had been recorded at an earlier time but had just recently come to the attention of the urban praetor as he carried out the Senate's order, issued the previous year in an effort to stem the tide of religious hysteria washing over the Roman people (Livy 25.1.6–13), to confiscate all prophetic books, prayers, and any written instructions for the conduct of sacrifice. In retrospect, one of Marcius's prophecies was thought to have predicted the disastrous Roman defeat at Cannae in 216. Thus the Romans turned their attention to the second, which claimed that victory over the enemy could be ensured if several conditions were met: games should be held in honor of Apollo under the direction of the praetor, both public and private funds should be collected, and sacrifices should be offered in accordance with Greek custom. The Senate, on the advice of the board of ten priests for overseeing sacred matters (*decemviri sacris faciundis*), ordered the Apolline games to be held, gave the praetor funds for the purpose, and gave the *decemviri* two victims to be offered to Apollo and Latona *graeco ritu* (in the Greek manner).[33] Livy's description of the games bears quoting in full:

> Ludos praetor in circo maximo cum facturus esset, edixit ut populus per eos ludos stipem Apollini quantam commodum esset conferret. Haec est origo ludorum Apollinarium, victoriae, non valetudinis ergo ut plerique rentur, votorum factorumque. Populus coronatus spectavit, matronae supplicavere; volgo apertis ianuis in propatulo epulati sunt celeberque dies omni caerimoniarum genere fuit. (Livy 25.12.14–15)

> [When the praetor had seen to it that the games were to be performed in the Circus Maximus, he ordered the people to collect a donation for Apollo during the games, each giving as much as was

appropriate. This is the origin of the Apolline games, vowed and performed for the sake of a victory, not for health as many people think. The people watched [the games], adorned with garlands; the matrons held a *supplicatio*; the whole crowd dined with open doors, outside, and the day was taken up with every sort of celebration.]

The matronal *supplicatio* was not one of the stated provisions of Marcius's prophecy. This circumstance, combined with the apparently unique nature of the ritual,[34] has led some to the conclusion that it was not part of the official action ordered by the praetor in his capacity as the Senate's designate, but rather was a spontaneous action by women. Wissowa and Latte do not include it in their (admittedly brief) discussions of public *supplicationes*. Nor does Lake include the celebration in her catalog of public *supplicationes* in Livy.[35] Halkin, who has conducted the most extensive survey of Roman public *supplicationes*, includes the rite of 212 in his introductory chapter (without reference to the gender of the celebrants) but, without explanation, excludes it from his catalog of public *supplicationes* known from ancient sources.[36]

Those who see the *supplicatio* as an unofficial action give priority to Macrobius's account of the expiations of 212 that closely follows the Livian version with the significant exception that Macrobius does not include the matronal observance. Macrobius's omission of the *supplicatio* may be explained by the fact that by the time he wrote the *Saturnalia* in the fifth century c.e., the character of the *supplicatio* had changed. It was no longer a public ritual ordered by the Senate to avert a crisis, restore the balance between men and gods, or give thanks for divine favor bestowed. By Macrobius's time, the *supplicatio* had long been monopolized by the emperors as a thanksgiving ritual observed in honor of their military victories or any other happy life event.[37] To a late imperial audience, the celebration of 212, regardless of the gender of the celebrants, would have seemed out of place in its Livian context.

Halkin appears to place the matronal *supplicatio* in the same category as other literary episodes he identifies as exclusively female unofficial *supplicationes*. These identifications, however, do not stand up

under scrutiny, again leaving the rite of 212 without context. Two of Halkin's four *supplicationes* of a "caractère privé," the panics of 211 (as Hannibal and his forces draw dangerously close to Rome) and 49 (on the eve of war between Caesar and Pompey), are not identified by ancient authors as *supplicationes* (or as any other ritual). These descriptions of crowds of women appearing in the streets and temples of Rome with their hair loosed, tearing at their cheeks and hair, and beseeching the gods to protect them appear to be dramatic embellishments designed to heighten the reader's sense of imminent danger.[38] Even if the accounts of these two crises are based on factual reports, they still do not constitute reliable evidence of impromptu, unofficial *supplicationes*. It is natural that a population should seek refuge and comfort in holy places during a crisis, but this does not constitute the observance of a particular rite. The third unofficial supplication cited by Halkin is a collective ritual observed in 396 that is explicitly identified by Livy as an *obsecratio*, a rite sometimes claimed to be synonymous with the *supplicatio* though this identification has no merit.[39] The last possible *comparandum* is Livy's description of the women of Rome flooding into the temples and shrines to wear down the gods with prayers and vows ("suppliciis votisque fatigare deos" [27.50.5]) after the Romans defeated the Carthaginians in a battle in 207. Yet this passage, too, does not provide conclusive evidence that the matrons of Rome observed an unofficial *supplicatio*, since *supplicia* is a nontechnical term for entreaties or prayers.[40]

When all else fails, look at the text. Of the rites of 212, Livy says that the *matronae supplicavere*, using the verbal form of the noun *supplicatio*. Elsewhere in Livy, *supplicare* is used in very specific circumstances. Often, it describes the action taken after a *supplicatio* has explicitly been recommended by the *decemviri* (34.55.4, 36.37.5, 40.37.3). In other instances where the historian does not record the official declaration of a *supplicatio*, the verb is followed by a phrase such as "circa fana omnia deum" (around all the sanctuaries of the gods [24.23.1; cf. 30.21.10]), which further describes the action of such a ritual. Thus *supplicare* appears to have a technical religious significance, and so,

it is reasonable to conclude that Livy's phrase, *matronae supplicavere*, means that the married women of Rome observed a particular rite under official supervision. This conclusion is supported by Livy's text, where the matronal *supplicatio* falls between two unquestionably official elements of the celebration: the *populus* adorned with garlands in observance of the Greek rite, as mandated by Marcius's prophecy, and a festive meal of the type that commonly followed Roman public sacrifices.[41] The official status of the matrons' supplication as part of the official expiatory action is assured by this bracketing.

Still, the question remains: why did the Romans add an exclusively female *supplicatio* to the already extensive, and expensive, requirements of Marcius's original prophecy? The answer may lie in the requirement that the sacrifices be conducted in the Greek manner (*ritu graeco*), usually taken to mean with one's head uncovered and while wearing a garland. It has been suggested that another aspect of the Greek rite is the exclusion of women.[42] Thus the different activities for men (observing the sacrifices *ritu graeco* to Apollo and Latona) and women (supplication) may be seen as a Roman adaptation of a foreign religious element: by directing the *matronae* to take part in a separate activity, the Senate ensured proper observance of the *ritus graecus* as well as the traditional Roman practice of mobilizing the entire adult population of the city in times of crisis. The extraordinary effort made to include women worshipers in the expiatory rites of 212 demonstrates the importance of those worshipers to the immediate preservation of Rome as a political and military entity.

Expiation of Prodigies: Rites of Juno Regina

Female participation in the annual expiation of prodigies was not limited to occasional inclusion in *supplicationes*. More commonly the expiatory efforts of women worshipers were channeled into rites that honored Juno Regina, the goddess brought to Rome from Veii by the dictator M. Furius Camillus after his defeat of that city in 395. In order to expedite the fall of Veii, Camillus enticed Juno Regina to relocate

to Rome with the promise that she would be given a temple worthy of her greatness: "te dignum amplitudine tua templum" (Livy 5.21.3). The bribe worked: the goddess already had an eye on her new home even before Veii capitulated. Shortly after the Roman victory, Juno Regina was installed at Rome in a temple on the Aventine hill.[43]

After being established in Rome, Juno Regina's temple became a focus of female participation in expiatory rituals. In two consecutive years, 218 and 217, as part of complexes of expiatory rites prescribed by the *decemviri sacris faciundis*, the freeborn married women of Rome made substantial dedications to the goddess (a bronze statue [Livy 21.62.8] and as large a donation from each woman as was appropriate [22.1.18]). The situation of 217 was so dire—Hannibal's troops threatened from the north, and the Roman consul, C. Flaminius, had flagrantly disregarded the religious duties of his office[44]—that *matronae* and the freedwomen of the city were also ordered to make donations to Feronia, a goddess particularly popular among the freed class, and who may have been brought to Rome at the same time as Juno Regina.[45]

The importance of women worshipers to the political and military survival of Rome is further demonstrated by the expiatory activities of 207, when *matronae* and *virgines* participated together in a series of prescribed rituals. In response to a report of the birth of a hermaphrodite at Frusinum, the *pontifices* decreed that a chorus of twenty-seven *virgines* should proceed through the city, singing a specially written hymn.[46] While the chorus rehearsed in the temple of Jupiter Stator, lightning struck Juno Regina's temple. The *haruspices*, Etruscan priests expert in interpreting fulgural signs as well as reading the entrails of slaughtered animals, declared that this new omen pertained to matrons, who should therefore make an offering to the goddess. The curule aediles summoned not only the matrons of Rome, but all those who lived within ten miles of the city, and ordered them to select twenty-five of their number to collect donations. After the *matronae* offered Juno Regina a golden basin and a sacrifice, the *decemviri* offered her another sacrifice and two statues.

Many interpretations of the expiatory rites of 207 focus on the hermaphrodite and the matronal sacrifice, ignoring the virgins and the

lightning strike, and read the event as an honor given to a "women's deity" to ensure a return to the natural state of affairs in a particularly feminine domain—the production of normal, healthy children.[47] There are, however, several difficulties in this reading of events. The fundamental problem is that the matronal sacrifice was not the only, nor even the first, activity prescribed to expiate the hermaphrodite. First, the *haruspices* declared that the hermaphrodite had to be drowned in the sea. Then the priests ordered the organization of the virginal chorus. The matronal sacrifice was only arranged after lightning struck the temple of Juno Regina.

Another interpretation separates the androgyne and lightning omens completely, arguing that the matronal sacrifice had nothing to do with the hermaphrodite.[48] Although this goes too far in its separation of the matrons from the androgyne prodigy altogether, it is appropriate to emphasize the relationship between the matronal sacrifice and the lightning strike at the temple of Juno Regina. After the disposal of the hermaphrodite, the *pontifices* ordered the organization of the virginal chorus, an understandable response since *virgines* stand on the border between healthy childhood and normal motherhood—two concepts perverted by the existence of a hermaphrodite. The additional involvement of *matronae* in part addressed the need to restore order to the feminine sphere, but the particular motivation and form of that involvement also had a resonance with the political and military crises of that year.

Above all else, Juno Regina was concerned with political affairs. In his article "Juno in Archaic Italy," Palmer demonstrates that Juno Regina's epithet most likely means not "queen" but "of the king" and thus highlights her strong associations with the kings who ruled Veii until the late fifth century, perhaps as late as the Roman conquest of the city.[49] When the Romans decided to invite Juno Regina to their city in 395, they were not interested in weakening their opponent by persuading a fertility goddess to abandon her people; the Romans courted the deity charged with the preservation of the Veientine state. The only reason to posit that Juno Regina was concerned with female fertility is the particular involvement of women in her rites. Yet, as we have seen

in the examinations of the rites of Juno Sospita and *supplicationes*, the link between women worshipers and fertility rituals is not as secure as it is commonly thought to be.

In all likelihood, when lightning struck Juno Regina's temple in 207, the Romans interpreted this event as another in a series of prodigies, including the hermaphrodite, thought to pertain to the especially precarious political and military situation facing them that year. Both consuls of the previous year died before elections for 207 could be held. This situation, combined with unrest in Etruria and Hasdrubal's threat to cross into Italy, made the new year loom as a potentially disastrous time ("periculosissimus annus" [Livy, 27.35.5]). The Romans sought to restore order and take control as quickly as possible. In addition to extensive religious activity, of which the virginal chorus and matronal offering were only a part, the annual troop levy was conducted more thoroughly than usual, and the consuls were encouraged to take the field as soon as possible (Livy 27.38.1–12).

On a broad level, sacrifices to a political deity such as Juno Regina should be interpreted as efforts to ensure the immediate preservation of the Roman state as a political and military entity. More specifically, Juno Regina's special relationship to Etruria made her an obvious candidate to enlist in quieting the unrest to Rome's north.[50] The involvement of *matronae* in these undertakings may be explained by their particular importance in the goddess's cult, as can be seen in the rites of 218 and 217. It is possible, though it cannot be demonstrated, that matronal participation in the worship of Juno Regina was a tradition brought with the goddess from Veii. The inclusion of women from outside the city further illustrates the Romans' need to exert control over outlying areas.

The success of the expiations of 207 led to the repetition of the same rites in 200, in response to two other hermaphroditic births.[51] After their second success in 200, it appears that the virginal chorus and matronal sacrifice to Juno Regina became standard elements in the expiation of androgyne prodigies. The pairing of rituals held in response to hermaphroditic births remained unchanged, as far as can be determined, until sometime before 125 when the observance was expanded

to include offerings to Ceres and Proserpina. This expansion may have come about in response to servile uprisings in Sicily, where Ceres was particularly important, and elsewhere in the mid-130s, thus indicating that the political importance of these rites was not lost even after they were standardized.[52] The revised rites were enacted to expiate hermaphroditic omens down to 92, when the last such report is recorded.

From this consideration of female involvement in the expiation of omens, particularly through rites in honor of Juno Regina and the observance of *supplicationes*, it is clear that women worshipers could take part in public rituals that fell outside the regular religious calendar. Furthermore, women were not restricted to less important observances but played an essential role in celebrations with broad civic and political impact. Nor were women relegated to exclusively female rites: men and women participated jointly in some expiatory rituals. The foregoing discussion expands our understanding of female religious activity on a thematic level. The very nature of expiatory rituals is beyond the scope of most studies of women's religious participation. Expiations include rites that, like those of Juno Sospita, can be interpreted as something other than fertility rituals, as well as other observances that *cannot* be interpreted as fertility rituals. Of course, political and reproductive concerns are not mutually exclusive. At the deepest level, the goal of every expiatory action — whether observed by men or women — was to ensure prosperity and success for the Roman people, of which continued regenerative power, both agricultural and human, was an essential part. Nevertheless, the impetus for expiatory actions was most frequently contemporary military or political circumstances. Expiations were meant to address far more immediate and specific concerns than the fundamental concern for long-term success.

Further Rehabilitation: Fortuna Muliebris

Thus far, we have examined some consequences of the assumption that the religious activities of Roman women were restricted to matters of fertility, childbirth, and the raising of children. In the cases of Juno

Sospita and Juno Regina, this assumption has led to the imputation of reproductive significance to rites of political and broader civic importance. By looking at only a portion of the available literary evidence, scholars have overlooked records of female participation in the expiation of prodigies. The standard interpretation of the refurbishment of Juno Sospita's temple that separates that event from the contemporary political situation, and the oversight of the official, exclusively female *supplicatio* of 212 are further symptoms of the same tendency to consider only a portion of the evidence. Another function of the traditional approach is the tendency to discount tales of politically significant female religious activities, such as the founding of the temple to Fortuna Muliebris (Feminine Fortune). Although many psychological and metaphorical interpretations have been offered, the political implications of the story have not been fully pursued.

As a reward for averting a conflict between Roman forces and Coriolanus's Volscian troops in 488, the *matronae* of Rome requested of the Senate that they be permitted to establish, with their own money, a temple to Fortuna Muliebris.[53] The Senate, which had already vowed to grant the women whatever they requested, agreed that a temple to the goddess was the proper way to express the gratitude of the Romans. The Senate, however, refused to allow the women to fund it or found it themselves. Instead, the task was delegated to the *pontifices*. As consolation, the women were given the right to select one of their number to serve as priestess and to conduct the initial sacrifice in the new temple. The women accepted the Senate's offer, but in addition to the official celebration on the *dies natalis* (foundation date) of the temple, of their own accord they observed the first anniversary of Coriolanus's withdrawal from the Roman territory. Furthermore, once the temple was built, the women dedicated their own statue of the goddess in addition to the one paid for by the Senate. This second statue is reported to have condoned the women's actions, telling the matrons twice that they had made their dedication in accordance with divine will.[54]

The political element of the tale has not received serious consideration. Some scholars discuss the story of Fortuna Muliebris as evidence

of another deity concerned with feminine matters, but do not comment on the story's close tie to the tale of Coriolanus's attack on Rome. Others take the whole tale into account but then set it aside. Such scholarly skepticism is prompted by several components of the story of Fortuna Muliebris: the dating of the incident to the early period of the Republic, the involvement of quasi-historical figures, the double nature of the celebration, and the two cult statues.

Among those who argue that the account is a later fabrication are Mommsen and Gagé, each of whom focuses on the names of the main characters as a way to explain the creation of the tale. Mommsen argues that Coriolanus, his mother Veturia, and his wife Volumnia were creations intended to enhance the prestige of certain political families (the Marcii, Veturii, and Volumnii, respectively).[55] Gagé interprets the tale metaphorically, seeing the three female protagonists as representatives of three aspects of the goddess and her cult's structure. Valeria, the organizer of the female embassy and whose name can be derived from *valere* (to be strong, to have power), represents the warrior virgin. Volumnia is the quintessential fertile wife and mother. The name of Coriolanus's mother, Veturia, can be derived from the Latin *vetus* (adjective meaning "old"), thus underlining her role as the aged, venerable mother. Gagé sees the double nature of the goddess's celebration and the two cult statues as manifestations of the two different aspects of Fortuna Muliebris — defender of the city and protector of children — that are further pointed up by the prominence of Valeria and Volumnia in the tale of the temple's foundation.[56]

Champeaux follows Gagé's general interpretation of the female characters in the tale as reflections of Fortuna Muliebris's multifaceted nature but disagrees with him on the details. She argues that the goddess was not linked to sacral virginity but had a special interest in matronal matters. She sees Veturia, an authoritative and vigorous mother, and Volumnia, a nurturing and more traditionally matronal figure, as mortal personifications of Fortuna Muliebris's two aspects. Furthermore, because only women who had been married once (*univirae*) were allowed to attend the goddess's statue, Champeaux argues that the

third prominent female figure in the story, Valeria, about whose marital status the sources are silent, could not be a *virgo*, but rather was a married woman and the first historical priestess of the goddess.[57] Offering a variation on a theme, but moving away from the specific arguments of Gagé and Champeaux, Mustakallio prefers to "take the story and the different characters as a representation of the ritualistic action during the cult of *Fortuna Muliebris*": the tale underscores the goddess's maternal and protective aspects. In Mustakallio's view, this feminine, protective cult offered an alternative to destructive male belligerence.[58]

Metaphorical interpretation of this episode has helped to flesh out a deity and a cult that are almost completely unknown from other sources.[59] Of the various interpretations proposed, Champeaux's is the most attractive. She is right to emphasize Fortuna Muliebris's matronal aspect and to argue that the goddess was not a virgin warrior figure. Yet the story has implications beyond revealing the goddess's nature. Whether or not one accepts the accuracy of the details (and I am not certain that the whole tale should be discounted completely), it is reasonable to think that the story made some kind of sense to the early imperial audience for whom Livy and Dionysius, our two sources for this episode, were writing. Thus, the struggle between the women and the Senate of Rome over the foundation of the temple has much to say about the relationship between female worshipers and the Roman religious establishment. Like the episode of Caecilia's vision of Juno Sospita, this tale suggests that it was possible for Romans to accept women, at least those of prestigious lineage, as instigators of public religious action. The story of the temple of Fortuna Muliebris also demonstrates the limits of possible female participation: although aristocratic women could, in theory, affect Roman religious activity at the highest levels, they were never treated as equals of aristocratic men.

Before delving further into the implications of the squabble over Fortuna Muliebris's temple, I would like to take some time to trace out what limited evidence there is to suggest that the story is not a complete confection of the Augustan age. Some support comes from archaeo-

logical evidence that indicates that the conditions our sources claim led to conflict between the Romans and the Volscians—that is, Volscian incursion in the territory of Rome and its allies in Latium—did in fact occur in the fifth century as part of the general migration of peoples from central regions of the Italian peninsula toward the western coastal regions.[60] In addition, the Lapis Satricanus, a large stone block discovered in 1977 by archaeologists from the Dutch Institute at Rome, suggests that the family of one of the main figures in the tale was, as the story claims, prominent in the late sixth and early fifth centuries. The stone, originally set up as part of a religious dedication, was reused in the reconstruction of the temple of Mater Matuta at Satricum, a fact that fixes a terminus ante quem for the inscription on the stone of approximately 500 (the estimated date of the temple's reconstruction). On the stone is an inscription in archaic Latin, or perhaps Faliscan,[61] that records an offering to Mars made by the companions of Poplios Valesios, whose name in classical Latin would be Publius Valerius. Versnel has raised the possibility that this Publius Valerius is the man more commonly known by his cognomen, Publicola, whose sister, Valeria, organized the all-female embassy to Coriolanus.[62] If the Valerius of the Lapis Satricanus is not Valeria's brother, he is surely a close relative.

It is possible that the story of Fortuna Muliebris's temple is a late etiology, similar to other suspect tales of temples founded by women, though it stands apart from those other stories in some important ways. A temple to Carmenta was supposedly founded by women who were victorious in their refusal to bear children until their husbands allowed them to ride in carriages (*carpenta*).[63] Unlike the story of Fortuna Muliebris, this story is not tied to specific temporal or political circumstances nor does it involve identifiable individuals. Furthermore, given the similarity between *Carmenta* and *carpenta*, the etiology of Carmenta's temple is easily understood as a later etymology.

The foundation of a temple to Juno Lucina on the Esquiline is attributed to women by the *Fasti Praenestini*, composed by the Augustan-age scholar Verrius Flaccus. The story is that the temple had been vowed by a woman, either the wife or daughter of a man named Albius, in return

for divine protection during childbirth and that afterward it was dedicated by a group of *matronae*.[64] Another source, the elder Pliny, records neither of these details, though he dates the foundation of the temple specifically to 375 (*Nat.* 16.235).[65] While there is nothing inherently suspect about the matronal dedication of the goddess's temple, such a dedication would stand as the sole instance in which a temple was vowed and dedicated by an individual who never held an official magistracy. In general, the right to dedicate a new temple was clearly reserved for magistrates who had been granted the privilege by the appropriate authority.[66] On rare occasions, private male citizens were permitted to dedicate temples that either they or their ancestors had vowed, but in each case the dedicator had previously held political office.

There is inscriptional evidence (discussed in the next chapter) that women could restore or contribute to the adornment of a public temple on their own, and from the tale of Caecilia's vision of Juno Sospita it appears that senatorial women could prompt the Senate to similar action through the efforts of their senatorial relatives. Because there is no firm evidence that, in the republican period, a woman or group of women was permitted to found a public temple, it is perhaps best to understand female involvement in the temple of Juno Lucina, a goddess whose cult was traditionally thought to have been established in the regal period, as financial involvement in the refurbishment or expansion of an already existing site.[67]

To return to Fortuna Muliebris, the story of her temple makes clear the limits on female participation in the construction of public religious sites: women were not to be involved in the establishment of new public temples, that is, temples built on behalf of the people and maintained at public expense.[68] This stricture is further reinforced by two episodes in which women are reported to have established religious sites, or to have attempted to do so. First, a shrine was established by a woman, Verginia (Livy 10.23.1–10), after she was shunned by the other patrician women convening at the shrine of Patrician Chastity (Pudicitia Patricia) during a public *supplicatio* (observed by men and women). There was disagreement over whether Verginia had a

right to attend since she had married a plebeian—no matter that Verginia's plebeian husband, L. Volumnius Flamma Violens, was holding his second consulship at the time.[69] In response to the argument, Verginia founded a shrine to Plebeian Chastity in her own home. There is no evidence that this new site was a public shrine—that is, that it was supported by public funds. The second relevant episode is the Vestal Licinia's voluntary donation of a public altar, shrine, and celebration for the Bona Dea in 123. Her generosity was refused by the Senate on the grounds that it had not been first approved by the people (Cic., *Dom.* 136); there is no evidence that the donation was ever accepted.

The story of the temple of Fortuna Muliebris, whether historical or not, is in many ways in keeping with documented Roman practice. Politically significant action by large groups of women was not unheard of in later ages. For instance, on several occasions groups of Roman *matronae* voluntarily stepped forward to offer aid to the city or to influence magistrates. In 395, when Rome did not have money to fulfill the vow of a tithe paid to Apollo at Delphi in the aftermath of the fall of Veii, matrons offered their own gold and all their baubles. In return, the Senate voted them the privilege of riding in carriages.[70] A few years later, in 390, the matrons of Rome again offered their gold, this time to help pay the ransom for the city demanded by the occupying Gauls. For this voluntary effort, the Senate gave the *matronae* a vote of thanks and allowed them the right of having eulogies delivered at their funerals—an honor previously reserved for men.[71] Firmly within the historical period, in 195, women from Rome and outlying areas gathered in the city to demand (successfully) the repeal of the *lex Oppia*, which had severely restricted female displays of wealth.[72] In 43, Hortensia led a group of wealthy women to protest the triumvirs' imposition of a tax on their estates. They succeeded in persuading the generals to scale back the tax on women and to introduce a tax on wealthy men as well.[73]

The question remains, Why did the *matronae* who sought to found a temple to Fortuna Muliebris feel they were entitled to this unprecedented honor? It is possible that such a demand seemed reasonable (either in reality or simply within the logic of the story) because their

mission to Coriolanus had been ratified by the Senate, itself a unique event.[74] The Senate's rebuff of the matronal request and its subsequent decision to delegate the task of establishing the temple to the *pontifices* simply maintained the status quo. It also served to revitalize the Senate's authority, which had been undermined by the failure of two earlier embassies to effect a truce with Coriolanus. The matrons' unofficial celebration of the first anniversary of their diplomatic success, their dedication of a second cult statue, and the tale of the statue's pronouncement thus can be seen as expressions of matronal displeasure with the restriction of their participation in the official monumentalization of the cult rather than as late explanations for specific aspects of cult ritual.

Conclusion

The evidence of ancient literature is essential to the study of the religious habits of Roman women. It provides details of rites that have not left a physical record and may offer roughly contemporaneous interpretations of events. Unfortunately, for too long our attention has tended to focus on only a portion of what the literary record has to tell. This circumstance is a product of the presumption, fueled by the very literature to which it is applied, that Roman women were almost exclusively interested in matters of a traditionally private, feminine nature. We have seen, however, that increasing the kinds of literary evidence under investigation allows a more expansive picture of female religious participation to come into focus. In addition to recording extensive female involvement in rites of a personal or domestic nature, ancient literature also provides glimpses of women participating in the public religious life of Rome. As a group, the women of Rome frequently took part in expiatory exercises, such as *supplicationes* and rites to honor Juno Regina. Individual women also performed public religious duties, as priestesses and as laywomen. The tales of Caecilia's dream of Juno Sospita and of the struggle over the foundation of a temple to Fortuna Muliebris demonstrate that women worshipers

of senatorial status could influence the actions of Roman religious authorities, while making clear some of the limitations placed on their involvement. This more comprehensive account of the religious activities of Roman women is supported and enhanced by the other evidence to which we now turn our attention.

TWO

WOMEN IN THE
EPIGRAPHIC RECORD

The previous chapter discussed how the interpretation of female par-
ticipation in Roman religion has been confined by the assumption that
female involvement in a particular cult is a certain indication that the
cult was concerned primarily with matters of fertility. Of course, con-
cerns about marriage, fertility, and childbirth were of great importance
to women worshipers and were addressed in many of the rites they
observed. Female religious experience, however, was not limited to
these traditionally feminine, private matters. By reexamining the evi-
dence of ancient literature without the encumbrance of certain precon-
ceived ideas, the disregarded political and broader civic significance
of many exclusively female religious actions comes to the foreground.
In addition, our understanding of the female role in Roman religion
is enhanced by the inclusion of material commonly disregarded, such

as reports of public expiatory activity, because this evidence further demonstrates the importance of women worshipers to official, public, all-inclusive religious activities. This chapter explores how this more comprehensive picture of Roman women's religious experience is supported and expanded further by the inclusion of epigraphic evidence.

Epigraphic material has much to offer for the recovery of the habits of women worshipers in the Roman Republic, even though relatively few inscriptions can be firmly dated to that period. A survey of republican inscriptions in various editions and supplementary volumes of *CIL* 1,[1] Degrassi's *Inscriptiones Latinae Liberae Rei Publicae*, and volumes of *L'Année Épigraphique* from the publication of Degrassi's work until the present yields approximately 70 relevant inscriptions. To this small group can be added slightly fewer than 200 undated inscriptions gleaned from Dessau's *Inscriptiones Latinae Selectae* and other, relevant volumes of *CIL*. In order to keep the discussion focused on the republican period, the arguments laid out here are based on the evidence of firmly dated inscriptions; undated inscriptions and those of imperial date are adduced as supporting material.

The small number of female-authored dedications should not automatically be interpreted as evidence of greatly restricted religious activity. Rather, this circumstance is due in large part to the paucity of republican sacred inscriptions in general. Although no complete set of statistics is available, it is possible to gauge the rough proportions of different epigraphic categories. The entire corpus of Latin inscriptions from the Republic numbers fewer than 4,000, compared with an estimated total of 250,000 or more for Latin inscriptions from the Republic and Empire combined. Of these 4,000 republican inscriptions, only about 600 (15 percent) are religious dedications.[2] Furthermore, many relevant inscriptions beyond those 4,000 remain undated because they have not received attention since their initial publication notices. Still, many others have never been published. Yet despite the difficulties that beset the researcher who would use epigraphic material, all is not without hope. Epigraphic evidence remains useful for the present inquiry, especially when it is recognized that extant inscriptions are likely to

be representative of groups of inscriptions, now largely lost, within the larger republican epigraphic record: given the formulaic nature of Roman inscriptions, it is improbable that each inscription we have is a unique, isolated instance of lapidary expression. Inscriptions provide invaluable evidence for the way Romans perceived themselves and wanted to be perceived by their contemporaries and the generations that followed. Although statistical analysis of epigraphic material must always be heavily qualified, and the picture of antiquity drawn from inscriptions must always be to some extent impressionistic, quantitative analysis, used on the very broadest of scales, remains a useful tool.[3]

Another factor contributing to the small number of relevant inscriptions is the fact that although female names appear in the epigraphic record from the earliest period,[4] women do not appear in inscriptions regularly until the second century, about a century after male worshipers do.[5] The late adoption by women of the epigraphic habit was a result of various social and cultural factors, among which may have been developing opinions on the appropriateness of female displays of public beneficence and of female participation in public life in general,[6] increased interest in self-advertisement and expressions of cultural identity by local elites,[7] and the increased wealth enjoyed by Italy in this period.[8] This last factor is reflected in the order in which different social groups enter the epigraphic record. The order follows the general social and, presumably, financial pecking order of Roman society. As I have mentioned, freeborn men are the first individuals to be named in inscriptions on a regular basis, appearing in significant numbers in inscriptions dated to the third century.[9] Freeborn women appear about one hundred years later. Shortly thereafter, freedmen and freedwomen almost simultaneously begin to set up inscriptions of their own. Slaves almost never appear individually in republican inscriptions but are included in group or collegial dedications.[10] This last point is especially suggestive of the role of financial considerations in setting up inscriptions.

Inscriptions that pertain to the present inquiry generally fall into one of several categories. The first group comprises dedications set up

by worshipers—women alone or men and women together. A subset of dedicatory inscriptions records acts of large-scale religious beneficence, such as the refurbishment of a shrine, by a woman or a group of women. Religious dedications attest the popularity of some traditionally feminine cults (e.g., Juno Lucina and Mater Matuta) among not only female worshipers but male worshipers as well. In addition, this material also demonstrates female participation in cults that addressed concerns falling outside of the private, domestic sphere.

Another category of inscriptional evidence is composed of sepulchral and other inscriptions that identify a woman as having held an official or quasi-official position within a particular cult. These inscriptions indicate that more women were involved in Roman religion in an official capacity than is suggested by literary sources, and they allow for conjecture, touched on here and then discussed at greater length in chapter 5, about the relationship between social and marital status and public religious service. This consideration of female public priesthoods (priestesses of Vesta, Ceres, and Liber, as well as the *flaminica* and *regina sacrorum*) as a group provides context for these offices that are usually seen as incongruous with the traditional view of Roman public priesthoods that defines those offices by the status and activities of male priests.

The most famous inscription pertaining to female religious activity in the Roman Republic, inscribed on a bronze plaque found at Tirolo in Bruttium, is commonly called the *Senatus Consultum de Bacchanalibus*, though it is actually a paraphrase of the Senate's original decree in response to the Bacchic scandal of 186. This chapter concludes with a discussion of the importance of gender in the events of that year as they are portrayed in this document and in Livy's literary account.

Dedicatory Inscriptions and the Expansion of Gender Roles

At first glance, the epigraphic record appears to support the standard picture of women's religious activities. Of extant, female-authored dedications that name deities, goddesses generally thought to appeal to a largely female audience receive the greatest number of dedications

from women: Diana of Nemi, Juno Lucina, and Mater Matuta. Due to a plethora of inscriptions from Sulmo, a large number of dedications to the Paelignian goddess Anaceta Cerria, about whom little is known, also survives.[11] Other deities who receive dedications from women in significant, albeit lesser, numbers include the Bona Dea, Fortuna, and Feronia.[12]

The apparent corroboration of inscriptional evidence with the traditional view of women's religious activities is not perfect, however. While inscriptions demonstrate the popularity of certain stereotypically feminine cults among women worshipers, they also provide a great deal of evidence to suggest that the religious activities of women extended beyond these cults to the worship of gods not thought of as "women's deities," such as Jupiter, Apollo, and Hercules.[13]

Inscriptions challenge the authority of literary evidence in other ways as well. The absence from the epigraphic record of some goddesses identified as women's deities in ancient literature serves as a reminder that ancient authors are not necessarily reliable observers of actual female religious activity. For example, Plutarch says that Roman women paid particular honor to the goddess Carmenta (*Mor.* 278B = *RQ* 56), yet she is conspicuously absent from religious dedications of both republican and imperial Rome.[14] In fact, the only inscription from Rome pertaining to her cult is a dedication to several deities by an imperial *flamen carmentalis* (*CIL* 6.31032).

More notably, inscriptions also supply ample evidence that cults traditionally thought to appeal only to women, such as those of the Bona Dea, Juno Lucina, and Diana, also attracted male worshipers.[15] In many instances, the popularity of a given cult among worshipers of one gender over the other is in all likelihood due to "the selectivity of the dedicant, not of the deity":[16] the predominance of one gender or the other among devotees of a certain god was more often due to personal preferences rather than official cult restrictions on who might attend the god's rites.

Most inscriptions do not reveal the circumstances behind their dedication. Where reasons are given, one can see that men and women often

made dedications in the ways one might expect. Men frequently appear in religious dedications in an official capacity (magisterial position), and their private—that is, not publicly mandated—dedications often pertain to business concerns, as in these examples from Tibur and Rome:

Felicitatei / T(itus) Cauponius T(iti) f(ilius) / C(aius) Aufestius C(aii) f(ilius) aed(iles).
(*CIL* 1².1481 = 14.3538 = *ILS* 3700 = *ILLRP* 89)
[Titus Cauponius, son of Titus, and Gaius Aufestius, son of Gaius, as aediles made this dedication to Felicitas.]

Forti For[tunai] / lanies. Ma[gistreis] / L(ucius) Maeci(us) M(aeci) l(ibertus) S[– – –] / Teupil(os) Q(uinti) Iuni Sal[vi s(ervos)].
(*CIL* 1².979 = 6.168 = *ILLRP* 98)
[The butchers gave this gift to Fors Fortuna. Lucius Maecius S . . . , freedman of Lucius Maecius, and Teupilos, the slave of Quintus Junius Salvus, serving as magistrates.]

On the other hand, women, whose lives were largely defined by familial concerns, frequently make dedications on behalf of their loved ones—presumably as thanks or requests for a return to good health—as shown in one inscription from Nemi and two others from Rome:

Poublilia Turpilia Cn(aei) uxor / hoce seignum pro Cn(aeo) filiod / Dianai donum dedit. (*CIL* 1².42 = 14.4270 = *ILS* 3234 = *ILLRP* 82)
[Publilia, wife of Gnaeus Turpilius,[17] gave this statue as a gift to Diana on behalf of her son, Gnaeus.]

Iunoni Lucin(ae) / Sulpicia Ser(vi) f(ilia) pro / Paulla Cassia / f(ilia) sua / d(onum) d(edit) l(ibenter) m(ereto).
(*CIL* 1².987 = 6.361 = *ILS* 3103)
[Sulpicia, daughter of Servius Sulpicius, gave this gift on behalf of her daughter Paula Cassia, willingly and deservedly to Juno Lucina.]

Voluptas / Rutuleia Bonae / Deae d(ono) d(at) pro Her / mete.
(*CIL* 6.30853 = Brouwer 1989, 39, no. 28)
[Voluptas Rutuleia gives this as a gift to the Bona Dea on behalf
of Hermes.]

The meaning of another inscription, probably from Praeneste, is less
obvious:

Orcevia Numeri / nationu(s) cratia / Fortuna Diovo fileia /
Primogenia / donom dedi.
(*CIL* 1^2.60 = 14.2863 = *ILS* 3684 = *ILLRP* 101)
[I, Orcevia, wife of Numerius, gave this gift to Fortuna Primigenia,
daughter of Jupiter, for the sake of a (successful) childbirth.]

The difficulty in interpreting this dedication arises from the word *natio*.
Some scholars believe the dedication pertains to fertility among the
herds.[18] This interpretation draws upon a definition for *bona natio* as
a successful breeding season among the herds found in Paulus's sum-
mary of a corrupt definition in Festus's abridgment of Verrius Flac-
cus's dictionary (164L and 165L). Paulus defines *natio* as a "genus homi-
num, qui non aliunde venerunt, sed ibi nati sunt" (a race of men who
did not come from elsewhere, but were born in that place), and the
meaning of *natio* as birth among herd animals is only secondary ("in
pecoribus quoque" [and also among the herds]). Other scholars read
Orcevia's offering as either a request or thanks for her own successful
parturition.[19] This stronger interpretation is supported by Cicero's ety-
mology of the name of the goddess, "Natio: partus matronarum tueatur
a nascentibus Natio nominata est" (it is she who, because she watches
over the parturition of matrons, is named *Natio* from those being born
[*N.D.* 3.47]). Some additional support for this reading comes from a
recent study of commercial interests of prominent Praenestine families
that concluded that the Orcevii owed their wealth to pottery produc-
tion, not farming.[20]

While women frequently made dedications for traditionally femi-
nine reasons, other categories of female-authored dedications that fall

within the stereotypically feminine realm have implications beyond it. A small bronze spike bearing the following inscription was found in the grove of Diana at Nemi:

> Diana mereto / noutrix Paperia. (*CIL* 1².45 = *ILS* 3235 = *ILLRP* 81)
> [To Diana, Paperia the wet nurse (gave this) with good reason.]

That Paperia's dedication was tied to concerns about her livelihood is suggested by the fact that she identifies herself as a *nutrix*, or wet nurse. This dedication was found alongside a bronze breast, perhaps providing more support for this interpretation.[21] If the spike and the breast were indeed offered together, we might reasonably conclude that Paperia intended her offering as a request or thanks for continued lactation, an undeniably feminine concern. Her status as *nutrix*, however, gives her dedication added meaning — by ensuring lactation, Paperia also ensured continued employment. Here, maternal and economic concerns overlap.[22] Although this dedication is unique among republican inscriptions, it is probable that Paperia's dedication is representative of a significant group of inscriptions that is now lost to us: wet nurses were commonly employed by Roman families, and ample epigraphic evidence from later periods suggests that Roman women who were employed in this and other capacities outside the home proudly identified themselves by their job titles in inscriptions.[23]

While most female-authored dedications pertain to private matters, there are also a few instances of public female religious activity. As we saw in the previous chapter, women sometimes participated collectively in public religious actions, as in the annual expiation of prodigies.[24] This kind of involvement was not limited to the women of Rome itself; there is a lapidary record of group dedications set up by the *matronae* of Pisaurum to Juno Regina and Mater Matuta and by the *matronae* of Eretum to Fortuna at Praeneste:

> Iunone Reg(ina) / matrona / Pisaurese / dono dedrot.
> (*CIL* 1².378 = 11.6300 = *ILS* 2980 = *ILLRP* 23)
> [The matrons of Pisaurum gave this as a gift to Juno Regina.][25]

Matre / Matuta / dono dedro / matrona / M(ania) Curia, /
Pola Livia / deda. (*CIL* 1².379 = 11.6301 = *ILS* 2981 = *ILLRP* 24)
[To Mater Matuta, the matrons gave this gift. Mania Curia and
Pola Livia gave this.][26]

[– – –d]ederont Aeret(inae) matron(ae) m(erito). (*CIL* 1². 3047)
[The matrons of Eretum gave this gift with good reason.][27]

In addition to these inscriptions, a group dedication from Cora, now
lost, may have also had wider civic significance:

Paul(la) Toutia M(arci) f(ilia) et / consuplicatrices.
(*CIL* 1².1512 = 10.6518 = *ILS* 6273 = *ILLRP* 301)[28]
[(Set up by) Paula Tutia, daughter of Marcus, and her fellow
worshipers (?).]

It is not certain whether the term *consuplicatrices*, which appears only
here, indicates a group of women (and men?) ordered by public magis-
trates to make an offering on behalf of their town or, as appears more
likely, refers to a private group of devotees of a particular cult.[29]

Thus far, we have seen that women most commonly made offerings to
gods usually described as women's deities and that they did so for tradi-
tionally feminine reasons. Beyond this, however, inscriptional evidence
also illustrates that female religious experience was not limited to mat-
ters of the private, domestic sphere. Epigraphic material also suggests
that male worshipers took part in "women's cults" and addressed fa-
milial concerns to the gods. An inscription from Norba records a man's
dedication to Juno Lucina:

P(ublius) Rutilius M(arci) f(ilius) / Iunonei Loucina / dedit
meretod / Diovos castud. (*CIL* 1².360 = *ILS* 9230a = *ILLRP* 163)
[Publius Rutilius, son of Marcus Rutilius, in accordance with
Jupiter's restriction gave this to Juno Lucina deservedly.]

In the absence of any indication that P. Rutilius honored the goddess in any official capacity (*pro populo*), it should be assumed his motivation was of a personal nature. The exact meaning of the phrase *Diovos castud* is uncertain. It appears in only one other published inscription (*CIL* 1².361 = 6.357 = *ILS* 3101 = *ILLRP* 161), also a dedication to Juno Lucina.[30] Latte and Degrassi believe the phrase refers to a prohibition on sexual intercourse during pregnancy,[31] although there is no ancient evidence to support this interpretation. A stronger argument is offered by R. Palmer, who posits that Jupiter's restriction (*castus*) may be similar to that of Ceres — that is, a restriction on eating certain foods.[32] Aulus Gellius, in his catalog of the numerous *castus* imposed on the priest of Jupiter (the *flamen Dialis*; 10.15.12 and 19), says that he was forbidden to eat bread leavened with yeast and could not even touch a goat, raw meat, or beans. If Jupiter's priest did not eat these items, it is probable that they were not offered to the god. Rutilius may have observed these same dietary restrictions before making his dedication to Juno Lucina, though why Jupiter's restrictions were observed in honor of this goddess must remain a mystery.

Rutilius's dedication may be linked with another found in the same place at Norba. The second inscription was set up perhaps by the very same Rutilius[33] on behalf of his son:

Iunone Locina / dono pro / C(aio) Rutilio P(ubli) f(ilio).
(*CIL* 1².359 = *ILS* 9230 = *ILLRP* 162)
[(Given) as a gift to Juno Lucina on behalf of Gaius Rutilius, son of Publius Rutilius.]

It is tempting to take these dedications together and read them as an expression of a man's concern for the health of his wife or unborn child, and his subsequent gratefulness at the birth of a son. The similar appearance of the bronze plaques that bear these two inscriptions (which can be seen at *ILLRP Imagines* nos. 81 and 80) may suggest that the two inscriptions were intended to form a pair. Inscriptions from a given sanctuary, however, often look alike. Although Rutilius's first dedica-

tion (*CIL* 1².360) is the only surviving dedication of its type from the republican period,[34] it is unlikely that it was unique. From Ovid (*Fast.* 2.437–38) and from Pseudoacron's scholia on Horace, *Odes* 3.8.1, we learn that both married men and married women worshipped Juno Lucina on her festival day: "Kalendis Martiis Matronalia dicebantur, eo quod mariti pro conservatione coniugii supplicabant, et erat dies proprie festus matronis" (The Kalends of March used to be called the Matronalia because on that day, married men were accustomed to pray for the preservation of their marriages, and that day was properly a holiday for matrons). Men prayed for the continuation of their marriages—a concern that, by commonly applied criteria, falls into the realm of the traditionally feminine. Just as worshipers of both genders could approach gods with an interest in political or financial matters, so too could they address their concern over private, familial matters to those gods under whose care such issues fell.

Participation on a Grander Scale: Republican Precedent for Imperial Practice

Now that we have addressed the breadth of female religious involvement, that is, the types of cults and rites in which women participated, we turn to a consideration of the depth of that involvement. The bulk of physical evidence for religious activity in the republican period consists of relatively small donations and, in a later period, brief written dedications. Even in the earliest period, however, wealthy worshipers of both genders used grand donations to advertise themselves and their families. For example, a large group of statues (seventy to one hundred pieces) from the sanctuary of Minerva at Lavinium offers some stunning examples of expensive dedications from as early as the fifth century.[35] In addition to several representations of the goddess, the deposit includes many portrait busts and numerous life-size representations of worshipers of all ages, both male and female. Some of the figures are represented with bare heads, some with heads veiled appropriately for worship. Nearly all the statues are posed in the act of offering, that is,

with one or both hands extended, often holding gifts for the goddess.[36] The wealth of the dedicants is evident not only from the size and exceptional artistic execution of the statues, but also from the jewelry worn by many of the female figures. Female busts are often adorned with earrings and necklaces. Some female statues are laden with jewelry: necklaces, armbands, bracelets, earrings, rings, and brooches. One especially ornate figure wears all of these.[37]

It has been proposed that the appearance of so much jewelry on female statues and busts dating from the mid-fourth century onward is due to the return of gold to the *matronae* of Rome, who had voluntarily contributed their jewelry to Rome's ransom from the Gauls (Livy 5.50.6–7 and 6.4.2).[38] While it is possible that the ornateness of the statues of this period reflect increased wealth among the Romans and their allies, an exclusive relationship between the appearance of the jewels and the political events of the early fourth century seems unlikely. One statue from Lavinium dated to the middle of the fifth century,[39] nearly a century before the Roman conflict with the Gauls, is adorned with necklaces similar to those worn by the fourth-century figures. Furthermore, some statues dated to later periods are arrayed much less extravagantly than those of earlier centuries.[40] Although the wealth or poverty of worshipers may be reflected in the religious dedications they offer, other factors also contribute to the level of extravagance on display: the power of fashion and changing aesthetic tastes should not be discounted.

Whatever the impetus for the extravagance of the Lavinian statues, it is evident that from an early period grand religious offerings could be used to advertise female wealth and importance. Several centuries later, inscriptions began to be used for the same purpose. Three republican inscriptions — from Padula, Ostia, and Rome — attest to extensive renovations sponsored by women worshipers who do not appear to have held any official cult position.[41] The prohibition against women vowing and establishing new public temples (as suggested by the case of Fortuna Muliebris) does not seem to have extended to participation in the upkeep of already existing cult sites:

Ansia Tarvi f(ilia) / Rufa ex d(ecurionum) d(ecreto) circ(a) /
lucum macer(iam) / et murum et ianu(am) / d(e) s(ua)
p(ecunia) f(aciendum) c(uravit).
(*CIL* 1².1688 = 10.292 = *ILS* 5430 = *ILLRP* 574)
[Ansia Rufa, daughter of Ansius Tarvus, by order of the decurions
(local officials), ensured that a brick wall and (another) wall
and a gate were built around the grove. She paid for it with
her own money.]

Octavia M(arci) f(ilia) Gamalai (uxor) / portic(um) poliend(am) /
et sedeilia faciun(da) / et culina(m) tegend(am) / D(eae) B(onae)
curavit. (*CIL* 1².3025 = *AE* 1973.127)
[Octavia, daughter of Marcus Octavius, wife of Gamala, saw to it
that the Bona Dea's portico was adorned, benches were set up,
and the kitchen was given a roof.]

Publicia L(uci) f(ilia) / Cn(aei) Corneli A(uli) f(ili) uxor / Hercole
aedem / valvasque fecit eademque / expolivit aramque / sacram
Hercole restitu(it) / Haec omnia de suo et virei ⟨fecit⟩ / faciundum
curavit. (*CIL* 1². 981 = 6.30899 = *ILS* 3423 = *ILLRP* 126)
[Publicia, daughter of Lucius Publicius, wife of Gnaeus Cornelius,
son of Aulus Cornelius, built this temple of Hercules and the doors,
and she adorned it. And she restored the altar sacred to Hercules.
All these things she did with her own and with her husband's
money. She oversaw that it was done.]

The wealth of these three women is evident. Ansia paid for the walls
and door out of her own resources (*de sua pecunia*), a project sig-
nificant enough to have required authorization by local magistrates.
Even though Ansia does not include the name of the deity whose pre-
cinct she enhanced, the religious nature of her donation is indicated by
the term *lucus* (grove). For the Romans, groves were sacred spaces.[42]
Octavia does not claim to have paid for things herself, but her wealth
is assured by the status of her own and her husband's families. She was

probably the kinswoman of the early first-century senators Marcus and
Lucius Octavius Ligus,[43] whose family was prominent in Forum Clo-
dii, a town on the shore of Lake Bracciano north of Rome. Her hus-
band's family, the *gens Lucilia Gamala*, was part of the local aristocracy
at Ostia, where the inscription was found and where Octavia probably
moved after her marriage. Publicia and her husband, neither of whose
family is known for certain,[44] were wealthy enough to pay for extensive
construction and refurbishment of a sanctuary. I return to this last in-
scription later on.

By announcing their financial commitment in this way, women like
Ansia, Octavia, and Publicia emulated the advertisements of public
beneficence commonly set up by wealthy men, as private individuals
or as public officials. Examples include the following inscriptions from
Castel di Sangro and Airola:[45]

> M. Caicilius L(uci vel Cai) f(ilius) / L(ucius) Atilius L(uci) f(ilius) /
> praef(ecti) / pontem, peila[s] / faciundum / coirave[re].
> (*CIL* 1².1759 = 9.2802 = *ILS* 5896 = *ILLRP* 552)
> [Marcus Caecilius, son of Lucius (Gaius?) Caecilius, and Lucius
> Attilius, son of Lucius Attilius, as prefects,[46] oversaw that the bridge
> and the piers were built.]

> [L(ucius) Scri]bonius L(uci) f(ilius) Lib(o) / patronus /
> [basi]licam de sua / [pec]unia dedit.
> (*CIL* 1².1745 = 9.2174 = *ILS* 5528 = *ILLRP* 568)
> [Lucius Scribonius Libo, son of Lucius Scribonius, as patron,
> gave this basilica out of his own funds.]

Upper-class women and men promoted themselves and their families
through large-scale donations for the common good. While men most
commonly funded utilitarian public works like a retaining wall,[47] an
improved road,[48] or a sewer,[49] women seem to have focused most of
their energies on the quasi-public space of religious sanctuaries dur-
ing the republican period. The exclusion of women from full-fledged

participation in public life was reflected in the limitations on their pub-
lic generosity. Eventually, however, the restrictions relaxed: over time,
wealthy women came to enjoy greater visibility through a wide range
of public benefactions of varying grandeur. For example, inscriptions
record that in the period of transition from the Republic to the Princi-
pate, women from several prominent families in Paestum not only re-
furbished several temples, but one of them, named Mineia, also spon-
sored the restoration of the basilica in the town forum. Mineia's public
munificence was even commemorated by a special local coin issue.[50]
Later imperial structures, such as the *porticus Octaviae* in Rome,[51] Eu-
machia's edifice at Pompeii,[52] and Alfia's restored bathhouse at Marru-
vium,[53] have their antecedents in Ansia's gate, Octavia's benches, and
Publicia's polished doors. The empress Livia's building and refurbish-
ment projects were not unprecedented; they were not the only models
available for female euergetism at Rome or among the *domi nobiles*.[54]

The Refurbishment of Hercules' Temple: Prejudice and Praxis

Publicia's refurbishment of the temple and altar of Hercules, recorded
in the inscription discussed above, raises important questions about
female involvement in the worship of the god.[55] The inscription's very
existence contradicts the commonly accepted view that women were
banned from worshiping Hercules in Rome.[56] The god had a great
many cult sites in the city, including temples of Hercules Magnus Cus-
tos and Hercules Musarum in the Circus Flaminius, as well as the tem-
ple of Hercules Olivarius (discussed below) and the Ara Maxima of
Hercules Invictus in the Forum Boarium.[57]

Upon close examination of the ancient sources, it is possible to draw
a picture of female participation in the cult of Hercules that resolves an
apparent contradiction between the literary and epigraphic evidence.
While it is possible to read the literary sources as indicating a univer-
sal ban on female participation, such a reading is not *necessitated* by
the language of the ancient authors. In addition, the existence of many
female-authored inscriptions set up in Hercules' honor further under-

mines the likelihood of a complete interdiction on women worshipers in the god's cult. In the end, the difficulty in this matter proves to be a modern one. Rather than arising from direct contradictions in the ancient sources, the problem stems from an erroneous methodological practice common in studies of Roman religion, that is, the assumption that restrictions on an individual rite must extend to the general cult.

Although Publicia's inscription is the only surviving female-authored dedication to Hercules among Republican inscriptions, its existence is surely owed to the inclusion of women in some aspects of the worship of the god. That women took part in the cult in the imperial period is made clear by several dedications set up by women alone or by men and women together in later centuries. Among these are dedications to Hercules Invictus, the god of the Ara Maxima and other cult sites of the Forum Boarium. The following is a sample of imperial dedications to Hercules from Rome:

Numisia Afrodi / te pro salute fili / maei et meorum / donum Herculi / posui. (*CIL* 6.286)
[I, Numisia Aphrodite, gave this gift to Hercules on behalf of the health of my son and my family.]

Herculi / Invicto / Primus Aug. lib. / cum Aelia / Felice sua / d(onum) d(edit). (*CIL* 6.327)[58]
[Primus, freedman of the emperor, along with his wife, Aelia Felix, gave this gift to Hercules the Undefeated.]

[*On left side and front of marble base*]: Pomponia / Buteonis / H(erculi) V(ictori) D(efensori) arg(enti) p(ondera) X / testamento / d(edit). [*On right side of base*]: H(erculi) V(ictori) D(efensori) / arg(enti) p(ondera) X / Pomponia Zmyrn(a) / testamento d(edit). (*CIL* 6.333)
[Pomponia, wife of Buteo, gave to Hercules the Conqueror and Defender from her will ten weights of silver. To Hercules the Conqueror and Defender, Pomponia Zmyrna gave from her will ten weights of silver.]

Scholars who believe that women did not worship Hercules at all dismiss as late forgeries these inscriptions and many others. See, for example, Mommsen's commentary on the following dedication from Rome from this period:

Herculi pugili / Marcia Irene / d(onum) d(edit). (*CIL* 6.337)
[Marcia Irene gave this gift to Hercules the Boxer.]

Mommsen writes: "Mihi titulus suspectus est, cum propter pugilis cognomen, quod deum facit non solum gladiatorum patronum, sed gladiatorem ipsum, tum quoniam mulieres Herculem non colunt" (This inscription appears suspect to me on account of the epithet "boxer," which makes the god not only the patron of boxers, but a boxer himself, and because women do not worship Hercules).

Mommsen's objection on the basis of the god's cognomen—that it makes Hercules a boxer rather than the god of boxers—is without merit. The god certainly bore other professional epithets. That Hercules was also worshiped in the form of *Hercules Olivarius* (the olive merchant) is made certain by an entry in the regionary catalog, a fourth-century C.E. listing of major monuments and buildings in Rome divided into the fourteen regions of the city established by the emperor Augustus. In addition, a statue base uncovered in the immediate vicinity of the round temple of Hercules in the Forum Boarium bears part of an inscription: "[----]o Olivarius opus Scopae minoris."[59] Coarelli has proposed that the cognomen is a popular epithet, recalling the trade organization that donated the statue to the temple of Hercules Victor.[60] He proposes the following restoration of the fragmented inscription, which can be accommodated by the length of the stone: "[Hercules Victor cognominatus vulg]o Olivarius opus Scopae minoris" (Hercules the Conqueror, popularly called the Olive Merchant; a work of the younger Scopa). To a limited extent, the reconstruction is plausible, as the inscription dates to a much later period (third century C.E.) than the statue (late second or early first B.C.E., based on the identity of the sculptor), and therefore could record both official and well-established popular names of the god. The phrasing

Coarelli proposes, however, is unparalleled elsewhere in Rome, so this specific reconstruction should not be given too much weight though the general point is well taken. More secure comparanda come from the Aventine sanctuary of Jupiter Dolichenus in the form of two dedications set up in 150 C.E. by the *collegium Herculis Metretariorum*, a group dedicated to the worship Hercules of the measurers.[61] Similarly, Hercules Pugilis may have received a popular cognomen because of attention directed to his cult by members of that particular profession. This is reasonable since, although Hercules is most often represented as a wrestler, there is literary evidence of his prowess as a pugilist.[62] There is no reason to doubt the validity of Marcia's dedication on the basis of the god's epithet and, as we shall see, there is no real support for Mommsen's other objection: that women did not worship Hercules.

While it is possible that individual dedications are forgeries, it remains unlikely that female-authored dedications to Hercules, as a group, are false. Forged inscriptions, like those collected in *CIL* 6.5, usually (though not always) purport to have been set up by famous persons (consuls or emperors, or by their slaves or freedmen), refer to well-known historical events, or draw on famous passages of ancient literature. The inscriptions with which we are concerned here were all offered by otherwise unknown folk and do not refer to any events of public importance. Furthermore, the editors of *CIL* themselves can find no physical indications of fabrication on any of these inscriptions, as is openly admitted in the commentary on this imperial inscription from Rome:

Herculi Iuliano / Iovi Caelio / Genio Caeli montis / Anna sacrum.
(*CIL* 6.334)
[Anna consecrated this to Hercules Julianus, Caelian Jupiter, and the Genius of the Mons Caelius.]

The editor grudgingly admits: "Titulum exstitisse cum certum sit nec quicquam in eo contineatur quod sit contra sermonis proprietatem vel antiquitatis certa indicia, a dubitatione abstinendum esse iudico."

[Since it is certain that this inscription existed, and that there is nothing contained in it which is contrary to proper wording or to certain indications of antiquity, I conclude that it must be withheld from doubt.]

Objections to the legitimacy of female-authored dedications to Hercules are based primarily on literary evidence. Beginning with the text most familiar to many readers, we turn to Macrobius who, in the first book of his *Saturnalia*, paraphrases Varro's etiology of the exclusion of women from the worship of Hercules:

> Unde et mulieres in Italia sacro Herculis non licet interesse, quod Herculi, cum boves Geryonis per agros Italiae duceret, sitienti respondit mulier aquam se non posse praestare quod feminarum deae celebraretur dies, nec ex eo apparatu viris gustare fas esset. Propter quod Hercules facturus sacrum detestatus est praesentiam feminarum, et Potitio ac Pinario sacrorum custodibus iussit ne mulierem interesse permitterent. (1.12.28)
>
> [And here too (i.e., in Varro) is the reason why in Italy women may not take part in the rite of Hercules. For, when Hercules was bringing the cattle of Geryon through Italy, a woman replied to the thirsty hero that she could not give him water because the day was the festival of the Goddess of Women (the Bona Dea) and it was unlawful for a man to taste what had been prepared for her. Hercules, therefore, when he was about to offer sacrifice, forbade the presence of women and ordered Potitius and Pinarius, who had charge of his rites, not to allow any woman to take part.]

The restriction of female participation in the Hercules cult is clear, but Macrobius's language does not reveal its precise nature. The author tells us that women did not participate in a *sacrum*—a very general term used to refer to a consecrated item, a temple, a sanctuary, an individual rite, a festival, or an entire cult.[63] Even within this very passage, *sacrum* is used in a rather general sense: Macrobius refers to Potitius and Pinarius as the *custodes sacrorum*. Members of these two patrician

families maintained control over the cult of Hercules—making sacrifices to the god and arranging the festival meals afterward—from the time the cult was established in Rome until they were replaced with public slaves by Appius Claudius Caecus during his censorship in 312.[64]

Further elucidation is offered by Aulus Gellius in a passage on the ways Romans swore oaths: "In veteribus scriptis neque mulieres Romanae per Herculem deiurant neque viri per Castorem. Sed cur illae non iuraverint Herculem non obscurum est, nam Herculaneo sacrificio abstinent" (In old writings, Roman women do not swear by Hercules nor do men swear by Castor. Yet it is no mystery why those women did not swear by Hercules, for women refrain from sacrificing to Hercules [11.6.1–2]).[65] The *sacrum* in which Roman women did not participate was a sacrifice (*sacrificium*). Further information is provided by Plutarch, who hints that the restriction pertained only to sacrifices offered at one cult site when he asks why women did not partake of or taste the items sacrificed on the larger of two altars of Hercules in Rome: Διὰ τί, δουὶν βωμῶν Ἡρακλέους ὄντων, οὐ μεταλαμβάνουσι γυναῖκες οὐδὲ γεύονται τῶν ἐπὶ τοῦ μείζονος θυομένων (*Mor.* 278E–F = *RQ* 60). The Greek indicates that women were prohibited from the entire rite of sacrifice at one altar: they neither participated in the offering of the sacrifice (οὐ μεταλαμβάνουσι) nor joined in the feast afterward (οὐδὲ γεύονται). The text also implies that women took part in sacrifices offered at the other, smaller altar. In the *Origo Gentis Romanae*, a fourth-century C.E. history of Rome from the arrival of Saturn and Janus in Italy through the time of Romulus and Remus, the altar from which women could not eat is explicitly identified as the Ara Maxima (6.7).[66] Unfortunately, just after identifying the Ara Maxima, the *Origo* obscures the nature of the interdiction on female participation by saying that after women were forbidden to take part in ritual meals at the site, they were completely banned from "ea re divina" (this sacred thing). It is not at all clear whether the author of the *Origo* intended his reader to understand *res divina* as rites at the Ara Maxima specifically or the cult of Hercules in general.

Fortunately, there is no confusion about the nature of the restric-

tion on female participation as it is described by Propertius, in poem 4.9, our earliest source on this question. In this poem, Propertius offers the same story as Macrobius to explain the restriction on women worshipers, indicating that he, too, has Varro as his source. There is also a detail in the Propertius passage that, though missing from Macrobius, can reasonably be attributed to Varro himself and which makes clear the exact nature of the limitation on female activity in the cult. After Hercules has been turned away by the priestess of the Bona Dea, the hero breaks down the door of the goddess's sanctuary and commands:

Maxima quae gregibus devota est Ara repertis,
 ara per has inquit maxima facta manus
haec nullis umquam pateat, veneranda puellis
 Herculis aeternum ne sit inulta sitis.
(Propertius 4.9.67–70; ed. Fedeli)

[May the Greatest Altar (Ara Maxima), which I have vowed on account of my herds being recovered, the altar made greatest by these hands of mine, may it never lie open to worship by any women, lest the thirst of Hercules go unavenged forever.]

Hercules' injunction is specific: women are not permitted to worship at the Ara Maxima, the center of the public cult of Hercules and, according to legend, the oldest cult site of Hercules in Rome. The rites celebrated at the Ara Maxima were unusual within the cult of Hercules. For instance, only these were conducted *ritu graeco* (in the Greek manner—that is, with unveiled heads at sacrifice).[67] Given the unique nature of the celebrations at the altar, it is reasonable that if women were excluded from any one particular site, it was the Ara Maxima. Furthermore, such a circumstance is consistent with Plutarch's statement that women did not participate in the sacrifices offered at the larger of the altars of Hercules.

One additional ancient reference has been overlooked in this debate. In a digression on the rites observed at the Ara Maxima, the *Origo Gen-*

tis Romanae states that in addition to bribing the Potitii and the Pinarii to relinquish their control of the cult of Hercules to public slaves, Appius Claudius Caecus, censor in 312, also bribed them to allow women to take part.[68] Although it is unlikely that Claudius used bribery or that he was personally responsible for admitting women into the worship of Hercules, this passage has historical value. The tale is probably woven together out of three threads: first, Claudius was responsible for at least one major change in the administration of the cult (the transfer of control of the rites from private families to public slaves); second, there was some sort of restriction on women worshipers of Hercules; third, despite a restriction at some time or place, our author knew that women could worship the god. If women had never taken part in any rites to honor Hercules, the *Origo*'s statement would be meaningless. And it is worth pointing out that this passage implies female worship of Hercules through several centuries of the republican period.

There can be no doubt that there was a restriction on female participation in the worship of Hercules. Of course, the literary evidence does not preclude the possibility of a universal exclusion of women from the cult: the sources are explicit only about a ban on women from some sacrifices. On the other hand, the evidence does not require the conclusion that women were completely forbidden to take part in the rites of the god. The literary sources leave open the possibility that women worshiped Hercules and even imply as much (I am thinking here of the Plutarch and *Origo* passages). The epigraphic and archaeological evidence makes this certain. In addition to the many extant female-authored dedications to the god, a votive deposit from Praeneste, including much republican material and positively identified through two inscriptions as belonging to Hercules, includes many breasts and uteri, strongly suggesting that female concerns could be addressed to him.[69]

To return to the particular case of Publicia's refurbishment of a temple of Hercules, evidence suggests her involvement in the cult was not anomalous. A significant number of inscriptions record female worship of Hercules in later periods, and female worship during the Re-

public is suggested by the archaeological evidence from Praeneste. Furthermore, we need not assume, as has been suggested, that Publicia participated in the god's cult as a kind of default, that is, that her refurbishment of Hercules' temple was the result of some sacral incapacity on the part of her husband.[70] Her attachment to the cult may have come through her own family's particular affiliation with Hercules: a denarius of the monetal C. Publicius, dated to 80, shows Hercules slaying a lion.[71] There is no reason to doubt that Publicia honored the god in her own right.

In the end, the popularity of the idea that women were excluded from Hercules' cult can be attributed partly to widespread assumptions about the interests of Roman women. The same conflict between those assumptions and ancient evidence for the activities of Roman women is not limited to the cult of Hercules but has been demonstrated in the cases of several other cults as well. Recent studies of the cults of Silvanus and Mithras, two other deities thought to have appealed only to male worshipers, demonstrate through an analysis of epigraphic evidence that the gods' attention was also sought by women.[72] The converse of this circumstance is also true. Brouwer has noted that there is much evidence that the Bona Dea, the "women's goddess," was also worshiped by men, and Bouma has demonstrated extensive involvement of male worshipers in the cult of Mater Matuta at Satricum.[73] All this suggests that as scholars continue to integrate epigraphic and archaeological evidence into examinations of individual cults, the number of cults thought to cater to worshipers of only one gender or another will dwindle.

In the Service of the Gods: Sacerdotes, Magistrae, and Ministrae

Epigraphic evidence can enhance our perception of female religious involvement as it helps to resolve questions raised, but not answered, by ancient literature. Inscriptions are particularly valuable for an investigation into female religious involvement at an official level because, as

we will see in chapters 4 and 5, literary sources provide only a few tantalizing details about the role of priestesses (*sacerdotes*) in Roman religion. Even these references are generally restricted to public priestesses, most notably the Vestal Virgins, though occasionally passing mention is made of less prominent officials like the *piatrix*, the priestess specializing in expiations whom I discussed briefly in the preceding chapter. In many cases, epigraphic material is the only source of information for categories of officials other than *sacerdotes*, such as *magistrae* and *ministrae*. From an analysis of inscriptions recording female religious officials, we are reminded that more women were involved on a (semi)professional level than the few who served as Vestals and *flaminicae*, the priestesses most fully discussed in the ancient literary sources and modern scholarship. Female *sacerdotes* officiated at observances in honor of a variety of deities, and as *magistrae* and *ministrae* women took part in the daily maintenance of cult sites and the organization of cult activities. Finally, inscriptions demonstrate that occasionally women served as colleagues to male cult officials, and thus provide further evidence that Roman religion did not impose as rigid a division along gender lines as is commonly accepted.

Most epigraphic evidence for female cult officials comes from tombstones. The inclusion of honorific titles in epitaphs reveals the pride women and their families took in such distinctions. We have records of priestesses of Ceres, the best-represented group, from Rome, Atina, Sulmo, Torre dei Passeri, and Formiae.[74] Tombstones from Bovianum and Teate Marrucinorum memorialize priestesses of Venus.[75] As evidence of regional variation, from Casinum and the area around Sulmo come tombstones of three *sacerdotes Cereris et Veneris*, indicating that the goddesses were linked closely enough to share a cult and priestess.[76] A priestess of Liber is known at Aquinum.[77] Imperial inscriptions also record priestesses of Juno Populona, Isis, the Magna Mater, and various deified women of the imperial household.[78] One imperial-age inscription records the existence of a priestess of Minerva, whose death at the age of nine suggests her title may have been honorific rather than practical.[79] Contrary to what one might expect, neither Vestal Virgins nor

flaminicae appear in the epigraphic record of the republican period, although they are present in inscriptions from the Empire. This circumstance should be attributed to the small number of women who held those positions relative to the general population and to the low survival rate of early inscriptions from Rome (where these priestesses resided).

While it is possible that a sanctuary may have employed only a single priestess, some cults of which we are informed by literary sources were maintained by multiple priestesses. The college of Vestals numbered six, and Varro mentions multiple priestesses of Liber.[80] Imperial inscriptions naming priestesses include several that indicate more than one priestess at a time served certain gods. For instance, a woman is sometimes identified as a *sacerdos prima* or *summa* (head priestess) or as a *sacerdos secundo loco* (second in command), implying the existence of colleagues.[81] One woman from Beneventum is even identified by the man who set up the dedication as his *consacerdos* of the Magna Mater (*CIL* 9.1540 = *ILS* 4186 = *CCCA* 4.40, no. 100; early third century C.E.). Other imperial inscriptions identify women as *sacerdotes quindecimvirales* (members of the board of fifteen priestesses) for Ceres and other, unidentified deities;[82] it may be that in many of these cases priestly colleges expanded over time in the same way as the famous group of priests for overseeing rites (*sacris faciundis*), which we know expanded from two to ten to fifteen members over the course of the Republic.

Cult officials other than priestesses are also known from dedicatory inscriptions. A group of four *magistrae* from Minturnae made an offering to Venus (?) and two *magistrae* of Diana from Aquinum donated a statue base.[83] Imperial inscriptions record a *ministra* of servile status, who was perhaps acting as *magistra* of the Bona Dea, and a pair of *ministrae* (one of free and one of freed status) who built a temple for this same goddess with their own funds.[84] Other imperial inscriptions record a *ministra* of the Magna Mater at Corfinium and a *ministra* of Salus from the area around Amiternum.[85] The epitaph of the *ministra Salutis* records her death at age thirty and her service to the goddess for thirteen years. A priestess and a *ministra sacrorum pu[blicorum]*

of Juno Populona are known from Teanum.[86] The precise distinctions among the different categories of *sacerdos, magistra*, and *ministra* cannot be recovered.

In rare instances cult positions were filled by men and women together. It has been thought that an inscription from Cosa, now known only from a manuscript, records a joint dedication by *magistri* and *magistrae* (identified as *matronae*) to an unknown deity, possibly Mater Matuta.[87] The only sure evidence for heterogeneous religious officials in the Republic is neither a tombstone nor a dedication, but an inscription, discussed at length below, that records several decrees of the Roman Senate issued in response to the Bacchic scandal of 186, the most extensive account of which affair is preserved in Livy.[88] This document, often called the *Senatus Consultum de Bacchanalibus*, provides clear evidence that both men and women had served as *magistri* in the cult and implies that both had served as priests prior to the scandal: "sacerdos nequis vir eset; magister neque vir neque mulier quisquam eset" (no man shall be priest; nor shall any man nor any woman serve as *magister* [line 10]).[89] Women still will have served as *sacerdotes* after the decree was issued. Other cults may have also employed officials of both genders, though not in the same capacities: it appears that priestesses of Ceres were aided in their duties by male *magistri*.[90] We have already mentioned the imperial dedication (early third century C.E.) set up at Beneventum by a priest of the Magna Mater and a woman identified as his *consacerdos* (*CIL* 9.1540 = *ILS* 4186 = *CCCA* 4.40, no. 100).

Although it is not possible to determine the precise division of responsibilities among various cult officials, a few general conclusions can be drawn. Priests of individual cults seem to have been responsible for the oversight of cult activities—that is, making sacrifices and organizing festivals.[91] Cicero (*Balb.* 55) tells us that Greek women were selected to be priestesses of Ceres in Rome so that they might teach and perform the Greek ritual: "Graecum illud sacrum monstraret et faceret." These Greek women were made citizens so that they might perform the rites on behalf of the people ("sacra pro civibus civem facere") and so that they might pray with a truly Roman frame of mind

("mente domestica et civili"). From Varro we know that priestesses of
Liber offered sacrifices at the Liberalia on behalf of worshipers who
paid for the service (*L.* 6.14). In addition to fulfilling their duties at
the temple of Vesta, the Vestal Virgins played important roles in sev-
eral annual rituals that fell outside the cult of Vesta itself, such as the
December celebration of the Bona Dea and the rite of the Argei.[92]

Cult magistrates and ministers, regardless of gender, appear to have
been responsible for the care and maintenance of the sacred property
of the cults with which they were associated.[93] There is also evidence
that *magistrae* and *ministrae* interacted with the worshipers who fre-
quented the sanctuaries they tended. Two undated inscriptions from
Rome and Vibo name the officials who served the deity at the time of
the dedication:

Felix publicus / Asinianus pontific(um servus) / Bonae deae agresti
Felic(ula) / votum solvit iunicem alba / libens animo ob luminbus /
restitutis derelictus a medicis post / menses decem bineficio domi-
naes medicinis sanatus per / eam restituta omnia ministerio Can-
niae Fortunatae. (*CIL* 6.68 = *ILS* 3513 = Brouwer 1989, 53, n. 44)[94]
[Felix Asinianus, public slave of the *pontifices*, fulfilled his vow to
Bona Dea Agrestis Felicula willingly and with good cause, (sacrific-
ing) a white heifer on account of his eyesight having been restored.
Abandoned by doctors, he recovered after ten months by taking
medicines, by the aid of the Mistress. Through her, all things were
restored during Cannia Fortunata's tenure as *ministra*.]

Q(uintus) Vibull(u)s L(uci) f(ilius) Q(uinti) n(epos) C(aius) Cin-
cius C(ai) f(ilius) Paul(us) IIIIvir I(ure) D(icundo) / signum Proser-
pinae reficiundum statuendumque arasque / reficiundas ex s(ena-
tus) c(onsulto) curarunt HS DCC⌊XX mag(istrae) fuere Helvia
Q(uinti) f(ilia) Orbia M(arci) f(ilia). (*CIL* 10.39)
[Quintus Vibullus, son of Lucius and grandson of Quintus, and
Gaius Cincius Paulus, son of Gaius, members of the board of four
men with judicial authority, under the direction of the Senate, saw
that the statue of Proserpina was repaired and erected and that the

altars were repaired, all at a cost of 770 sesterces. Helvia, daughter of Quintus Helvius, and Orbia, daughter of Marcus Orbius, served as magistrates.]

By naming the *magistrae* and *ministrae* under whose supervision the events took place, these inscriptions illustrate the importance of cult officials other than *sacerdotes* to the daily operation of religious places.

Social and Marital Status of Cult Officials

The social standing of women who held various positions within cults represents a cross section of Roman society. The best-represented group in the epigraphic record, freeborn women, generally held more prestigious positions (*sacerdotia*) than women of freed or slave status, who were more likely to serve as *magistrae* and *ministrae*. The names of all female *sacerdotes* known from republican inscriptions are those of freeborn women. Moreover, there is reason to conclude that *sacerdotes* generally came from more affluent families: there is no indication that any of the relevant tombstones comes from a group tomb, suggesting that there were always funds sufficient for individual graves.[95] Entrance to the positions of *magistra* and *ministra* was less restricted. The *magistrae* of Venus at Minturnae include one freeborn woman, two freedwomen, and two slaves. The difference of status is reinforced by the order in which the women are listed in the inscription: the names of the freeborn woman and freedwoman precede the slaves.[96] The *ministra* of the Bona Dea at Praeneste was of servile status.

The marital status of most cult officials is not included in the epigraphic record, but it is certain that the *magistrae* of the unknown deity at Cosa were *matronae*, as were imperial *magistrae* of Mater Matuta from Praeneste.[97] The priestesses of Vesta were famous for their celibacy, but priestesses of some other deities appear to have been able to maintain normal family lives. The sons of Helvia, priestess of Venus from Bovianum, set up a tombstone for their mother with their own funds: "Helviae / Mesi f. / sacerdot(i) Vener(is) / filei de suo" (*CIL*

1^2.1751 = 9.2569 = *ILLRP* 273). The priestesses of Dionysus were *matronae*.[98] As discussed in the previous chapter, Champeaux and Boëls-Janssen offer a convincing argument, based on literary evidence, that priestesses of Fortuna Muliebris were also married women, rather than the celibate *virgines* that Gagé envisioned.[99] As will be discussed in greater detail below, the matronal status of those women serving as either *flaminica* or *regina sacrorum* was essential to their office. The marital status of another group of priestesses, officials of the cult of Ceres, is less clear.

Priestesses of Ceres

Although scholarly opinion is unanimous that Ceres' attendants were celibate for the tenure of their office,[100] the ancient evidence is not conclusive. The locus classicus for priestesses of Ceres at Rome, Cicero's *Pro Balbo* 55, does not mention any restriction on marital or sexual status. Ovid tells us that worshipers of Ceres abstained from sex for nine nights around the time of the goddess's annual festival, but the poet does not reveal whether Ceres' priestesses observed either the same or more stringent requirements.[101] Family relationships in general were conspicuously downplayed at the festival. As evidence that Ceres is ill-disposed toward marriage, Servius says that at the rites of Ceres, no one mentions fathers or daughters: "et Romae cum Cereri sacra fiunt, observatur ne quis patrem aut filiam nominet, quod fructus matrimonii per liberos constet" (and at Rome, when they celebrate the festival of Ceres, the rule is observed that no one should mention a father or daughter, because the benefits of marriage are established through children).[102]

Perhaps the strongest evidence for the celibacy of priestesses of Ceres comes from Tertullian's *De Monogamia* (17.3–4), where the priesthood is part of a catalog of pagan cults that rival Christianity in the importance they place on chastity. Tertullian claims that priestesses of Ceres are women who, with their husbands' consent, dissolve their marriages and live as celibate widows in service of the goddess. Since Tertullian

elsewhere specifies that he refers to the cult of African Ceres (*Cast.* 13), however, this evidence must not be applied automatically to Roman Ceres. Both of Tertullian's references to the celibate priestesses of Ceres appear in similar catalogs of pagan priests and cults that observed either marital or virginal chastity: the *flaminica, pontifex maximus,* Vestal Virgins, priests of the Egyptian bull (Apis), and priestesses of Ceres, Achaean Juno, Apollo at Delphi, and Scythian Diana. The only difference between the two lists is that the catalog at *Cast.* 13, in which Tertullian specifies priestesses of African Ceres, also includes the *flamen dialis* and the attendants of Minerva. Given the nearly identical nature of the lists, it is reasonable to assume that both references are to the cult of African Ceres. The goddess's African cult differed from her Hellenized Italic cult in several important ways, and there is little evidence to indicate that requirements demanded of her African priestesses were relevant to their Italic counterparts.[103]

A little more light (but only a little) may be shed on the matter by relevant inscriptions. Nearly all inscriptions pertaining to priestesses of Ceres from the republican period are tombstones that include only the name of the priestess and her title—for example, "Munniai C. f. / sacerd(oti) Cer(eris)"—thus yielding no clues about the priestess's marital status.[104] The singular exception to this rule is a tombstone for Caesia, daughter of Novius Caesius. Caesia was commemorated by Quintus Caesius, son of Quintus, who identifies himself as her *nepos* (*CIL* 1².3110 = 10.6103; now at Gaeta).[105] It is not certain if *nepos* is intended here as "nephew" or "grandson," as both meanings are attested in the republican period.[106] It is very likely, however, that Quintus was the priestess's nephew. The similarity of his name and his father's name to hers and the absence of any indication of freed or servile status suggest that Caesia was his agnatic aunt. Thus this stone, too, fails to provide evidence of either marriage or motherhood for a priestess of Ceres.

A survey of the indexes for *Inscriptiones Latinae Selectae* (*ILS*), Dessau's representative collection of inscriptions from all over the Roman world, and for the volumes of the *Corpus Inscriptionum Latinarum* (*CIL*) covering Rome and southern Italy (6, 9, and 10) indicates that im-

perial inscriptions recording the lives of priestesses of Ceres generally follow the pattern of their republican counterparts, rarely recording more than a name and an office. There are three, however, of imperial or uncertain date that record familial relationships—from Formiae, possibly Amiternum, and Pompeii:

Sallu[s]/tiae Sat/urninae / sacerdoti / deae / Cereris / fili.
(*CIL* 10.6109)
[Her sons (set up this stone) for Sallustia Saturnina, priestess of the goddess Ceres.]

D(is) M(anibus) / M(arco) Caesi(o) M(arci) f(ilio) Pal(atina tribu) Magni / IIvir I(ure) D(icundo) IIvir Q(uin)Q(uennalis) IIII / Tamudiae M(arci) f(iliae) Severae / sacerdot(i) public(ae) Cerer(is) / M(arcus) Caesius Magnus / Caesia Severa Parenti/bus / D D bis. (*CIL* 9.4200)[107]
[To the gods below for Marcus Caesius, son of Marcus Caesius Magnus, registered in the Palatine tribe, member of the board of two men with judicial authority, and [who served] four times as a member of the board of two men elected for five years, and for Tamudia Severa, daughter of Marcus Tamudius, who was a public priestess of Ceres. Marcus Caesius Magnus and Caesia Severa twice gave this as a gift for their parents.]

M(arco) Alleio Luccio Libellae patri aedili / IIvir praefecto quinq et M(arco) Alleio Libellae f(ilio) / decurioni vixit annis XVII locus monumenti / publice datus est. Alleia M(arci) f(ilia) Decimilla sacerdos / publica Cereris faciundum curavit viro et filio.
(*CIL* 10.1036 = *ILS* 6365)
[For Marcus Alleius Luccius Libella the father, (who served as) aedile, member of the board of two men and prefect for five years, and *quinquennalis*, and for Marcus Alleius, son of Marcus Alleius Libella, who was a decurion and who lived for seventeen years, the place for this monument was given publicly. Alleia Decimilla,

daughter of Marcus Alleius and public priestess of Ceres, oversaw
that this was set up for her husband and son.]

These inscriptions confirm that priestesses generally came from promi-
nent families: most of the men mentioned here held high positions
in local government, implying distinguished social status for them-
selves and their female relatives.[108] It is possible in the first two inscrip-
tions and certain in the third that the priestess was a widow during
at least part of her tenure of office. None of these inscriptions reveals
whether the priestess maintained a regular relationship with her chil-
dren once she became an official in Ceres' cult. Thus Tertullian may be
right to point out that women were released from the bonds of mar-
riage (though perhaps not from all interaction with their families) be-
fore taking up the priesthood of Ceres. Even so, it is difficult to imagine
their husbands willingly agreeing to divorce for this purpose, as Tertul-
lian claims. The priesthood is more likely to have appealed to widows
or to older women who had never been married. The appearance of fa-
milial relationships in these three later inscriptions could also be due
to chronological or geographical variation. Tertullian may have been
correct about the priesthood as it existed in Rome, but not as it was in
other cities within Italy or perhaps not as it was in all time periods.

While the question cannot be resolved definitively, the evidence sup-
ports the idea that priestesses of Ceres were unmarried, at least dur-
ing the tenure of their office. This requirement would have made the
priesthood attractive mainly to women who did not already have fami-
lies of their own: more likely widows or women who had never mar-
ried rather than the amicably divorced women Tertullian envisioned.
Furthermore, even if priestesses of Ceres were unmarried, we need not
assume that any familial ties they may have had were cut completely
when they took up their office. The continuing importance of familial
links for the Vestals, who were definitely removed from a traditional
family setting, is visible in the stories of Claudia, daughter of Appius
Claudius Pulcher, consul of 143, and Licinia, the cousin of the triumvir
M. Licinius Crassus and the consul of 62, C. Licinius Murena. Claudia

ensured there would be no interference with her father's unofficial (illegal) triumphal procession by riding in his chariot with him.[109] Licinia was accused (unsuccessfully) of incest with one cousin, Crassus, because she spent much time in his company and lent her support to another's (Murena) candidacy for the consulship of 62 by relinquishing her seat to him at gladiatorial games.[110]

Context for Sacerdotes Publicae

The relationship among female public priesthoods — those of Vesta, Ceres, the *flaminica*, the *regina sacrorum*, and perhaps the priesthood of Liber[111] — has not received much consideration. Such neglect is unfortunate, as the existence of both common and conflicting elements among these various female offices establishes a context for individual groups of officials, such as the Vestal Virgins, who, because of their femininity and their inability to hold magisterial positions, do not fit easily into the category of public religious officials as it is commonly defined, that is, by the requirements of male priesthoods.[112] By focusing on the activities of, and requirements applied to, male public priests, namely the *pontifices*, augurs, and decemvirs, and treating the different female priesthoods as isolated exceptions, we have lost sight of how the issue of gender was dealt with by the Romans at the level of public, official religious service.

Although questions about the living and financial arrangements, as well as the legal status, of public priestesses other than the Vestals cannot be answered, there is sufficient material from which to draw some conclusions about the concept of female religious officials in Roman thought. At the most basic level, the designation of the priesthoods of Vesta, Ceres, and Liber, and the offices of the *flaminica* and *regina sacrorum*, as public positions suggests that some female religious officials could act in their own right on behalf of the Roman people. This contradicts the notion that women (whether as worshipers or as priestesses) were restricted to participation in rituals of a private, domestic nature.[113]

Consideration of female priesthoods as a group also brings to light the absolute nature of the relationship between the normal feminine roles of wife, mother, and daughter, and the role of female public religious official. Young girls selected to become Vestal Virgins were removed from their parents and siblings, and adult women who chose to serve as priestesses of Ceres seem to have weakened or severed relationships with their husbands and children. Another manifestation of this apparent conflict between commonplace female activities and public religious service is the restriction placed on the sexual activities of public priestesses. Maintenance of virginal chastity was essential to the priesthood of Vesta. Renunciation of matronal status and subsequent celibacy may have been required for priestesses of Ceres. Although nothing certain is known about the marital or sexual status of priestesses of Liber, their advanced age suggests that they were no longer functioning in a normal uxorial or maternal capacity. Thus, it seems likely that priestesses of Liber also remained celibate for the tenure of their office. In contrast to these offices, those of the *flaminica* and possibly *the regina sacrorum*, the wives of the *flamen Dialis* and the *rex sacrorum*, respectively, were defined by the priestess's marital status. Strict maintenance of matronal chastity was required: divorce was not allowed.[114]

Thus far we have moved from the traditional monolithic view of Roman public priests, which cannot entirely accommodate the Vestal Virgins and other female priests, to a dichotomous view that acknowledges different classifications for male and female religious officials, in which men can maintain normal social and political lives, but women cannot. But this straightforward division along gender lines raises other problems. What can be said of the *flaminica* and the *regina sacrorum*, both of whose matronal status — essential to their priesthoods — stands in contrast to the required unmarried or celibate status of other public priestesses?[115]

This seeming difficulty may be remedied by adding a third category of public priesthood: maintenance of Rome's relationship with the gods required the services, in an official capacity, of married couples

and of individual men and women. The necessity of both husband and wife for the flaminate is made clear by the requirement that the *flamen* relinquish his office if his wife should precede him in death. Although our sources do not say so explicitly (further evidence of the gender imbalance in ancient literature), we should assume that the *flaminica* also had to resign should she become a widow. Furthermore, husband and wife shared ritual responsibilities and were subject to the same cumbersome dietary and other restrictions.[116] The husband's priesthood made him a member of the pontifical college, and this at least raises the possibility that his wife was a member, also.[117] The fundamental importance of the *flaminica* to her husband's tenure of office and the fact that she shared his ritual obligations are evidence that the wife was not merely her husband's subordinate adjunct nor was she a necessary accessory, like the cap or ritual knife that were the hallmarks of his office.[118] Rather than discussing the *flaminica* and the *flamen* as two separate entities,[119] the flaminate should be viewed as a single priesthood that required the services of a married couple. The same approach should be taken with regard to the *rex* and *regina sacrorum*. Although little is known about the specific requirements and duties of these offices, their very titulature implies a priesthood structured along lines similar to the flaminate.[120]

It is possible to accommodate the disparate *collegia* of Roman public priests by restructuring the categories we use to discuss them. In the schema proposed here, the requirements of male public priests are no longer held as definitive for all public religious officials, but rather serve to define only one group of priesthoods against others. The category of female priesthood is distinct from, not simply an exceptional subset of, Roman priesthoods. Female priesthoods are defined by the gender of the officials and by their marital and sexual status. A third division of priesthood is distinguished by the requirement that a heterogeneous married pair serves together. In this way, the apparent anomalous natures of the individual priestesses, such as the Vestal Virgins, and of married priestesses, such as the *flaminica*, are given a context they otherwise lack.

The Bacchic Scandal of 186 B.C.E.

Even the expanded view of Roman priesthoods just described cannot accommodate what we know about the priests who were involved in one of the most famous historical episodes of female religious activity: the Roman Senate's repression of Dionysiac worship in 186. The events of that year have received much attention, and the subject remains one of the most intractable problems in the study of Roman religion.[121] According to our main source, Livy's account in book 39 (8.1–19.7), widespread observance of Bacchic rites was brought to the attention of the people and the Senate of Rome by the consul of the year, Sp. Postumius Albinus. Postumius himself had been alerted to the situation through the efforts of Aebutius, a young man of equestrian rank, and his freedwoman paramour, Hispala Faecenia. Accusations of crime and conspiracy among cult followers immediately ensued, and restrictions on cult celebrations were issued by the Senate. The Senate's mandates were so vigorously enforced that seven thousand people were punished; more were put to death than were jailed. Interpretation of the events of 186 is greatly complicated by Livy's hostility to the subject and the inconsistency of detail within his account.[122] Further complications arise from the fact that literary and archaeological evidence contradicts several elements of Livy's story, such as his contention that the Bacchic rites had only recently been introduced to Italy and that they were unknown to most Romans.[123]

The extant paraphrase of the Senate's decree, the so-called *Senatus Consultum de Bacchanalibus*, preserved in an inscription found at Tirolo in Bruttium,[124] does not resolve many of the questions raised by Livy's account even though it confirms much of what the historian says about the Senate's actions. The inscription documents the official response to the crisis, but it does not reveal much about the circumstances under which it was issued.[125] In addition to deficiencies in our sources, explanation of the events of 186 is hampered by the fact that the Bacchic scandal is almost completely without earlier comparanda, standing as an unparalleled instance to date of Roman governmental

intervention against religious activity. In its scope and its aggression, the Senate's reaction to Dionysiac rites far exceeds other instances of senatorial curtailment of religious activity deemed inappropriate and dangerous to Rome, such as the confiscation of religious writings and the ban on sacrifices conducted in a foreign fashion enforced in 213 and the expulsion of Chaldean astrologers and Jews in 139.[126]

Many explanations of the events of 186 have been offered; few are completely convincing. The present discussion does not offer a comprehensive analysis of the scandal, but rather traces through both the ancient evidence and some modern scholarship the attention paid to the issue of gender. In the end, despite Livy's claim, the gender of those involved in the cult was not a primary motivation behind the Senate's action. Certainly gender was at issue in the Bacchic scandal, but a closer examination of the situation reveals that its role in the crisis arose from an issue of greater importance to the Senate: the activities of members of the political class, that is, citizen and allied men.

According to Livy, the lascivious nature of the Bacchic rites outraged Roman sensibilities and thus provoked the Senate's action. Livy identifies the root of this licentious behavior three times — once in the frame of his narration, and then through the characters of Hispala Faecenia and the consul Postumius — reinforcing the reader's impression that the gender of the cult's participants caused the scandal. In his introduction, Livy affirms that the Bacchic rites were first introduced into Italy by a lowborn Greek (*Graecus ignobilis*), who imparted the secret religion to both men and women. The resulting combination of darkness, wine, men, and women led to all sorts of offensive behavior:

> Cum vinum animos incendisset, et nox et mixti feminis mares, aetatis tenerae maioribus, discrimen omne pudoris exstinxissent, corruptelae primum omnis generis fieri coeptae, cum ad id quisque, quo natura pronioris libidinis esset, paratam voluptatem haberet. (39.8.6)
> [After wine had inflamed their spirits, and when night, and men

mingling with women, and the young with their elders, had smoth-
ered every mark of modesty, corruption of every sort was under-
taken for the first time, since in this each one had at hand whatever
pleasure toward which his natural desire was more inclined.]

Among the crimes in which the initiates engaged, first and foremost
in Livy's mind are the "stupra promiscua ingenuorum feminarumque"
(rampant debauchery among freeborn men and women [39.8.7]). Hi-
spala Faecenia's description of the Bacchic rites is almost identical: the
mingling of men and women under the "noctis licentia" (lawlessness
of night) led to all forms of crime and "stuprum" (illicit sexual activity
[39.13.10–14]). Livy's Postumius offers a slight, but significant varia-
tion on this theme when he places ultimate responsibility for the scan-
dal on women participants in the cult. A female majority among the
initiates, Postumius claims, is the source of the problem ("is fons mali
huiusce fuit"), which was exacerbated by the inclusion of debauched,
feminized men whose senses had been dulled by wine and nocturnal
activity (39.15.9 and 12–14).[127]

In light of the ample literary evidence of rites and cults that appealed
to male and female participants, as well as physical evidence demon-
strating wider female involvement in almost every aspect of religious
observance, the active participation of women and men together in the
rites of Dionysus cannot have been the unique experience Livy presents
it as being. Nor does the involvement of women in those rites neces-
sarily make the rites subversive. Some who believe that traditional Ro-
man religion could not entirely fulfill the needs of women worshipers
see a tension between female participation in Roman cults, which re-
inforced the roles and restrictions women observed in their daily lives,
and female participation in foreign rites that offered release from quo-
tidian constraints.[128] In this view, the Senate's response to the Bacchic
scandal was aimed at curtailing female subversion of male control.[129]
This interpretation, however, fails to account for male participation in
the cult, which, from the evidence of both Livy and the *Senatus Con-
sultum*, appears to have been extensive at all levels of society and at

all levels within the cult, and ultimately to have been the focus of the senatorial response.

Another proposal is that alleged innovations in the cult's structure introduced shortly before 186 contributed to its unsavory reputation and to the resulting hostility toward it.[130] Most significant of these innovations is the admission of men to rites from which they had previously been excluded; the ensuing debauchery scandalized the Roman sense of appropriate male decorum.[131] It is unlikely, however, that men had ever been excluded completely from participation in the cult in Italy. Livy explicitly states that the Bacchic rites were first introduced to both men and women in Etruria (39.8.5), and Bacchic imagery and titulature appear on the sarcophagi of Etruscan men in the fourth and third centuries.[132] Furthermore, Euripides' *Bacchae* raises the possibility that, from the earliest times, male worshipers (in the figures of Kadmos and Tiresias) observed Dionysiac rites apart from the famous, exclusively female *orgia*, and perhaps even that men could be included in the *orgia* as well.[133] Certainly by the Hellenistic period men were admitted to the rites, as is evident from epigraphic evidence.[134] Since Dionysus's Italic cult is generally thought to have developed out of the Hellenistic cult,[135] the Italic version likely shared its antecedent's gender-inclusive policy.

It is unlikely that Roman religious sensibilities were offended by the idea of men and women worshiping alongside one another since it appears that Romans spent more time with the opposite sex in religious settings than is often acknowledged. Furthermore, the *Senatus Consultum de Bacchanalibus* explicitly contains provisions that allow men and women to worship together, albeit under close restrictions:

Homines plous V oinvorsei virei atque mulieres sacra ne quisquam / fecise velet, neve inter ibei virei plous duobus, mulieribus plous tribus / arfuise velent nisei de pr(aitoris) urbani senatuosque sententiad, utei suprad / scriptum est. (19–22)
[No one shall perform these rites in a group of more than five people altogether, both men and women, and there shall not be

more than two men and three women present, unless by approval of the urban praetor and the Senate, as it is written above.]

Dionysiac cult activities may indeed have been scandalous, but the fact that women and men worshiped together was not so offensive that the Senate felt the need to forbid it completely.

While with regard to worshipers, gender-inclusive cults were not uncommon in Roman religious experience, a context for the mixed gender of *sacerdotes* and *magistri* as found within Bacchic cult is more difficult to find. The *Senatus Consultum de Bacchanalibus* implies that prior to 186, men and women had served in both of these capacities:[136]

Sacerdos nequis vir eset; magister neque vir neque mulier quis-quam eset; / neve pecuniam quisquam eorum comoine[m h]abuise velet; neve magistratum / neve pro magistratu[d] neque virum [neque mul]ierem qui⟨s⟩quam fecise velet. (10–12)
[No man shall serve as priest; nor any man nor any woman serve as the master [of the cult]; nor shall anyone of them have a com-mon fund; nor should anyone appoint a man or woman as master [of the cult] or to serve in the place of a master.]

Apparently, only women were permitted to hold the priesthood after 186, and no one of either gender was permitted to act as *magister* or *promagister*—offices perhaps made obsolete by the prohibition against common funds (line 11) and by restrictions on the maintenance of places of worship:

Neiquis eorum [B]acanal habuise velet; seiques / esent, quei sibei deicerent necesus ese Bacanal habere, eeis utei ad pr(aitorem) ur-banum / Roman venirent, deque eeis rebus, ubei eorum v[e]r[b]a audita esent, utei senatus / noster decerneret, dum ne minus sena-tor⟨i⟩bus C adesent ⟨quom e⟩a res cosoleretur. (3–6)
[None of them shall have a Bacchanal (a cult place), and if there are those who claim that it is necessary to have a Bacchanal, they should

come to Rome, to the urban praetor, and when their case has been
heard, our Senate should decide these matters provided that not
fewer than 100 senators are present when the issue is considered.]

Priesthoods such as the flaminate specifically required the services of
a married couple; there is no evidence for men and women who were
not married to each other (as may be the case here) serving in paral-
lel capacities within the same cult during the Republic.[137] For the most
part, cults were maintained by officials of only one gender or the other,
although in rare cases, for example, the cult of Ceres, it is possible that
female *sacerdotes* were aided in their efforts by male *magistri*.[138] Despite
the lack of evidence for mixed-gender groups of officials in other cults,
it is difficult to see how the inclusion of both men and women within
the official structure of Bacchic cult could have been the primary mo-
tivating factor behind the Senate's oppression of the cult per se,[139] al-
though there is no denying that the Senate was concerned enough to
remove men from administrative positions.

The mixed gender of those involved in Bacchic cult, as worshipers
or as officials, does not lie at the root of the crisis of 186. The inclu-
sion of both male and female worshipers in certain rites was not a
novelty within Roman religious experience, and there is little reason to
believe that such inclusion was a late innovation in the Italic form of
Dionysiac cult. Furthermore, the prevalence of female worshipers in
Bacchic ritual does not necessitate that those rituals were subversive.
How then to account for Livy's emphasis on the gender of the culprits,
and on female involvement in particular? One partial explanation is
that a reputation for debauchery, wildness, and violence, all things to
which women were thought especially prone, was attached to Diony-
siac celebrations in Italy prior to the crisis of 186, as can be seen in
several references in the comedies of Plautus — for example, *Aul.* 408–
12 where the *Bacchae* (female worshipers of the god) and their *Bac-
chanal* (cult site) are obvious synonyms for "crazy people" and "mad
house."[140] In addition, Livy (and perhaps his sources as well) may have
played up sexual elements in the story to enhance the account's comic

elements.[141] Another reason for the prevalence of gender as an issue is that sexual impropriety, another stereotypical feminine foible, was a common element in allegations of revolutionary activities, along with allegations of corruption of the youth, mingling of social classes, and nocturnal meetings.[142] This can be seen in Cicero's and Sallust's descriptions of the Catilinarian conspiracy, which may have even influenced Livy's portrayal of the Bacchic scandal.[143] Sallust's Catilinarian conspirators have obvious similarities to Livy's Bacchants:

Nam quicumque [inpudicus adulter ganeo] manu ventre pene bona patria laceraverat, quique alienum aes grande conflaverat quo flagitium aut facinus redimeret, praeterea omnes undique parricidae sacrilegi convicti iudiciis aut pro factis iudicium timentes, ad hoc quos manus atque lingua periurio aut sanguine civili alebat, postremo omnes quos flagitium egestas conscius animus exagitabat, ii Catilinae proxumi familiaresque erant . . . sed maxume adulescentium familiaritates adpetebat: eorum animi molles etiam et fluxi dolis haud difficulter capiebantur. (*BC* 14.2–5; cf. Livy 39.8.7–8 and 18.3–5)

[For whoever had no shame, or was an adulterer, or squandered his family wealth by gambling, carousing, and lechery, or who had gone into great debt in order to escape punishment for scandalous conduct or for a crime, and moreover all those from everywhere who, having been convicted by the courts of murdering their parents or of committing sacrilege, feared the sentence for their deeds, and finally all those whom a guilty conscience, destitution, or shame stirred up — these were nearest and dearest to Catiline . . . but he especially sought out close relations with the youth, whose tender, and even fickle, minds were captured by trickery without any difficulty.]

The association between these crimes and conspiracy was long-lived in the Roman mind; in a much later period, similar accusations were lodged against Christianity, a "superstitio prava et immodica" (an

immoderate and twisted superstition) in the opinion of Pliny the Younger.[144]

Another Line of Inquiry

Gender is at issue in the two major sources for the Bacchic scandal of 186, but in very different ways.[145] While Livy emphasizes the mingling of genders and the wild, excessive behavior of female worshipers, the *Senatus Consultum* makes clear the Senate's concern about the participation of men, particularly those of the political class. Men were banned from the Bacchic priesthood,[146] whereas women were permitted to continue serving in that capacity (line 10). Rites might not be observed by groups of more than five people, no more than two of whom could be male (lines 19–22). Furthermore, men of Roman, Latin, and allied status were prohibited from interaction with the Bacchae (lines 7–9), female worshipers of the god whose own activities were curtailed but not forbidden. Presumably, male slaves and foreigners were not subject to the same restrictions.[147]

The focus of the *Senatus Consultum* on the activities of men of the political class suggests that the primary motivation behind the repression was concern about the involvement of Roman and Italian men (not women, at least not in equal measure) in potentially subversive activities.[148] The stipulations regarding group size and interaction with the Bacchae could only be circumvented if the parties concerned pleaded their case before the urban praetor and not fewer than one hundred senators — indicating that the Senate felt the need to be aware of exactly who was involved in Dionysiac activities, presumably with a special, but not exclusive, interest in its own members and the local elite in Italian towns.

One implication of the Senate's desire to identify the enemy within its own class and within groups that might pose a threat to the Senate itself is that involvement on the part of any wealthy freeborn Roman, Latin, or ally (whether male or female) would immediately mark the men of that family as unsatisfactory for political advancement. This is

perhaps suggested by the absence of the Sempronii Rutili, the family of
Aebutius's stepfather, from the political scene of the early second cen-
tury until the time of Julius Caesar,[149] though such an absence might
be accounted for in a number of other ways (decline in financial status,
simple defeat at the polls, etc.). The Senate's message was clearly under-
stood outside of Rome as well. Although Dionysiac themes are com-
mon in Etruscan funerary imagery from wealthy graves of the fourth
and third centuries, they are almost entirely absent from those of the
second.[150] That the politically disenfranchised were permitted to con-
tinue worship of Dionysus, albeit in a greatly restricted fashion, further
underlines the political nature of the crisis of 186. Additional support
for this interpretation comes from the fact that some of those arrested
as the leaders of the conspiracy were men of wealthy and politically
active, but not the most powerful, families.[151] The political aspect is
pointed up even further by the complete absence in either the *Senatus
Consultum de Bacchanalibus* or Livy's account of any mention of pub-
lic religious authorities.[152]

The political element of the Senate's motivation indicates that the
search for an explanation of the events of 186 should be directed be-
yond Livy toward consideration of the political and social situation of
Rome in the early second century. Some have seen the crisis as an ad-
verse reaction to the Hellenism made popular in Rome by the Scipi-
onic circle.[153] Others believe that the Roman Senate feared subversion
of its control by foreign (Italian or otherwise) elements under the cover
of a cult that held secret meetings.[154] Another explanation is that the
cult offered worshipers a unique opportunity to belong to a collec-
tive other than Roman society in its traditional form; the cult posed a
threat to societal control over the actions of individuals.[155] It has also
been suggested that the Senate's actions were an attempt to bring the
wild rites of Dionysus into line with the traditional Roman cult of Liber
and the Aventine triad.[156] Our sources raise the tantalizing possibility
that the events of the year are tied in some way to the military situa-
tion of the years leading up to 186. A praetorian army was dispatched
to Bruttium, the region where the *Senatus Consultum de Bacchanali-*

bus was discovered, in 191 and remained there until 188, ostensibly to protect the coastline during the war with Antiochus III. Another army was sent to Etruria for unknown reasons in 190 and remained through the next year.[157] The presence of troops in a region is an indication of Roman uncertainty about the stability of the area, but in this case it is impossible to demonstrate a connection between the Roman military presence and Bacchic activity specifically.[158]

Whatever its cause, the repression of Dionysiac ritual served as a demonstration of senatorial authority and Roman dominion over Italy.[159] A recent explanation for the Senate's need to reaffirm its preeminence is very attractive: the Roman elite perceived a political threat from increasing organization among local aristocrats in Etruria and Campania, and this opposition was developing under the cover of the organization of Dionysus's cult.[160] Although evidence is scanty, there is sufficient archaeological and epigraphic material to suggest that not only was the Bacchic cult popular among aristocratic Etruscan families (as is already implied by Livy 39.8.3 and 39.9.1), but that it had also received official, public recognition in certain cities (most notably Vulci and Volsinii). Public interest in Dionysus may have been fostered by assimilation of the Etruscan civic deity Fufluns to the Greek god, perhaps at the instigation of aristocrats desirous of imitating the Athenian example.[161] Hence, Roman intervention was directed at a cult of not only long-standing private significance but also long-lived civic and political importance. The popularity of the Bacchic cult among wealthy Etruscans may well have contributed to the consolidation of a new aristocratic class in that region, as it had in Campania—a circumstance that would certainly have been perceived as a threat to the authority of the Roman Senate.[162] If this is indeed what happened, then the Bacchic cells of the early second century were functioning in an analogous way to certain religious colleges which appeared to be working against the Republic ("quae adversus rem publicam videbantur esse")[163] that were suppressed by the Senate in 64. The interpretation of the Bacchic cult as a unifying factor among upper-class Etruscans makes sense of Livy's assertion that the disease of Bacchic cult had spread to Rome from

Etruria: "huius mali labes ex Etruria Romam veluti contagione morbi penetravit" (39.9.1). It also provides context for the Senate's preoccupation, as expressed in the *Senatus Consultum*, with the identification of Bacchic participants within the upper levels of society in Rome and elsewhere.

Gender was not as important as it appears in Livy's account of the scandal of 186. Female involvement on its own did not necessarily indicate subversive cult activity, nor was the idea of men and women worshipping together anything revolutionary in Roman religion generally, or (probably) in the cult of Dionysus. The Senate's lukewarm interest in curbing female participation in the cult is manifest in several provisions of the *Senatus Consultum de Bacchanalibus*.[164] Instead, the Senate was concerned with reordering the structure of the cult and eliminating participation in it by members of the political class. Ostensibly this prohibition applied only to men, but in practice it must have extended to all the members of politically prominent families. In the repression of Bacchic ritual, class and social standing, not gender, were the primary criteria by which the Senate selected individuals for identification and restriction.

Conclusion

The examination of epigraphic material in this chapter supports in several regards the conclusions drawn earlier. First, the religious activities of Roman women were not restricted to rites of a private, domestic nature. While epigraphic evidence makes clear the importance of certain traditionally feminine cults in the lives of women worshipers, inscriptions also show that a broader range of opportunities for religious involvement was available to those same worshipers. The epigraphic record provides ample evidence of female worship of gods whose primary spheres of influence were financial, political, and broader civic concerns. Conversely, inscriptions also demonstrate that men worshiped deities thought to cater to a primarily female audience. That Roman women and men were able to approach the gods with con-

cerns that do not fall into the traditional categories of feminine (private) matters and masculine (public) concerns, respectively, suggests a certain elasticity in gender roles within Roman religious practice.

Inscriptional evidence also supports the conclusion that female participation was not a marginal component of Roman religious practice, but rather was an important element in the maintenance of proper relations between the Romans and their gods. From ancient literature come several accounts of collective female activity as part of officially organized, public religious actions, such as the dedications offered by the matrons of Rome to Juno Regina. Inscriptions documenting collective dedications by the *matronae* of other Italian towns are more immediate records of the same type of event. The importance of women to official Roman religious practice is further evidenced by the number of *sacerdotes, magistrae,* and *ministrae* recorded in inscriptions, and by the variety of cults in which those women served.

By looking at public female religious officials as a group, we have seen that, rather than being isolated anomalies within the official religious framework of Rome, individual public priestesses constitute an identifiable category distinct from male public priests. Different requirements for priestesses whose offices are dependent on their husbands' (the *flaminica* and the *regina sacrorum*) suggest the flaminate and the office of the *rex/regina sacrorum* should be considered separately from other priesthoods that require the services of only a single individual. Finally, all of the foregoing discussion provides a backdrop for a consideration of the role gender played in the Bacchic scandal of 186. In light of the expanded view of female religious activity argued for here and despite the claims of Livy's narrative, it is unlikely that the gender of the worshipers involved was the primary motivation behind the Senate's action.

THREE

THE EVIDENCE OF
VOTIVE DEPOSITS

Thus far we have focused on the ways Roman women could take part in the religious life of their cities and towns. We have seen how female participation was a critical element in public rites and festivals, how priestesses and their families proudly advertised their religious offices, and how individual women made prominent, public declarations of their religious euergetism. We have also looked at some epigraphic evidence for more private religious activity. Continuing in that vein, we turn now to a consideration of votive deposits, groups of gifts brought by the Romans and their Etrusco-Italic neighbors to the gods. These collections of items were formed in antiquity, most often, it appears, when votive offerings were cleaned out of a sanctuary and then either intentionally buried (hence their designation as deposits) or cast onto a refuse pile. Study of the votive deposits from a given sanctuary can shed

light on the spheres of influence of the deity worshiped there, as well as give some indication of the type of worshiper who frequented the site.

Votive material has not been fully exploited in the study of Roman religion. Indeed in the past, votive deposits were absent from the great handbooks on the subject.[1] Archaeologists have paid more attention to this material than have historians, but their interest has been primarily in the more artistic pieces, such as pottery, statues, figurines, and portrait busts. Other categories of offerings, such as figures of swaddled infants, animal figurines, and especially the mass-produced (and thus, we presume, less expensive) anatomical representations that will receive extended consideration here, have been generally ignored. Fortunately, interest in Italic votive religion has flowered in the past thirty years, and now treatments of the subject can be found in some introductions to Roman religion in addition to numerous specialized studies.[2] Because this material remains unfamiliar to many readers, some time will be spent here laying out several of the most important interpretive debates surrounding it before turning to a consideration of what votive deposits might reveal about the role of gender in Roman religion. If the attention spent on background issues seems something of a digression from our primary goal of establishing the limits of female involvement in Roman religion, it can be countered that offering votives to their gods was a practice in which a great many women took part. Thus, an understanding of Roman votive habits is an essential element in understanding female religious activity in the Roman world.

Before moving forward, it will be well to address the question of terminology. We do not know what the Romans called the groups of votives periodically buried or otherwise disposed of. In fact, we have very few mentions of the practice of burying votives—quite amazing given the fact that Italic people had been doing so for centuries before, and continued to do so for centuries after, Romans began producing literature. Even more astonishing is the fact that we have just a handful of references to the long-lived and widely popular practice of offering anatomical representations in a Roman or Italic context.[3] The paucity

of literary references to these practices is further evidence of the well-defined focus of ancient authors on religion at only the highest public level.

Some scholars prefer to refer to a collection of votives as a *favisa*, the term Aulus Gellius used to describe the underground chambers and cisterns where outdated gifts to the gods were stored.[4] It appears that the term was not widely used by the Romans: Gellius's source is a letter from Varro explaining the practice to his contemporary, Servius Sulpicius, who, despite his learning, did not know what a *favisa* was. Varro himself says in the letter that he had never come across an explanation of *favisa* in all his reading. The only other ancient reference to *favisae* comes from Paulus's epitome of Festus's summary (78L, s.v. "favisae") of the Augustan-age scholar Verrius Flaccus, in which the definition of a *favisa* as a repository for sacred material is only secondary to another definition of the term as a water-filled trench that surrounds a temple. An alternative is the term *stips* (plural *stipes*), but this too presents difficulties since to the ancient Romans a *stips* was a small offering of money, a type of dedication often missing in collections of votives.[5] In order to avoid using an ancient term that has a technical meaning inappropriate to the matter at hand, throughout this chapter I use the modern phrase "votive deposit" to describe groups of votives, regardless of whether they were ritually buried (and thus a proper deposit), part of a refuse pile, apparent discards tossed into a river, or found in situ.

The Religious Koine of West Central Italy

Long before Roman political and cultural hegemony was established in the Italian peninsula, Rome was part of a cultural (including religious and artistic) koine that developed in west central Italy by the sixth century.[6] This koine is documented in various ways including the practice, shared by Romans, Latins, Etruscans, and other ethnic groups in the region, of presenting to the gods gifts different in material and type from those being offered in regions further north and south. In the area of west central Italy—extending northward into Etruria as far as

Volsinii and Vulci, eastward through Latium into parts of Umbria and Sabine territory, and toward the south as far as Campania[7] — people brought to their temples and shrines enormous numbers of terracotta heads, statuettes, figurines, and anatomical representations (models of individual parts of the human body, both internal and external). To the north, worshipers preferred to offer gifts of bronze anatomicals; to the south and in Sicily, votive heads and anatomical representations are generally absent from deposits.[8] Of the different types of votives present in Etrusco-Latial-Campanian deposits, anatomical terracottas are the most common and also the most distinctive aspect of the koine, so much so that their presence outside this region has been interpreted as clear evidence of the Romanization of a given area.[9]

Several theories have been put forward to explain both the explosion in popularity of anatomical votives in the fourth century and the subsequent decline of the practice by the end of the Republic. It has been suggested that their sudden appearance in large numbers in the fourth century should be attributed to an economic revival in the region at this time and to the transfer of sanctuaries from the control of the aristocratic class to the fast-growing popular classes, who would, of course, prefer less expensive offerings.[10] While it is commonly agreed that Rome enjoyed an economic recovery after the Gallic sack of the city in 390,[11] it is not clear that there was in fact a new, popular control of religious sites. Admittedly, there was a change in the constitution of priestly colleges at Rome during that time, though this could hardly be considered a shift toward popular control. The board that oversaw public sacrifices (*sacris faciundis*) was expanded from two to ten members and was evenly divided between patricians and plebeians. Later, at the end of the fourth century, the *lex Ogulnia* allowed plebeians admission to two other priesthoods, the pontificate and augurate.[12] These concessions on the part of patricians, however, should not be interpreted as a transfer of power to the popular classes. The plebeians who came to share priestly and political power were not members of the proletariat: "non infimam plebem . . . sed ipsa capita plebis" (not the lowest of the plebs . . . but its leaders [Livy 10.6.4]).

A more popular explanation links the spread of the votive practice

peculiar to west central Italy to Rome's conquest of Veii in 396 and its subsequent domination of the rest of the region.[13] The argument is generally made along these lines: the earliest anatomical votives come from Veii and Lavinium, two cities with ample and early contact with the Greek world, from which Italic anatomical votives are thought ultimately to derive.[14] Romans adopted the practice after they took control of Veii and subsequently exported it to the rest of the region as they consolidated control. This argument is thought to be supported by a perceived correlation between the location of Roman and Latin colonies and deposit finds. A variation of this argument focuses on the supposed spread of the cult of Aesculapius through Roman expansion.[15]

This explanation of the anatomical votive phenomenon as a result of Greek influence in central Italy and its spread as a by-product of Roman expansion has become commonplace, though it has come under some fire. The ultimate Greek origin of Italic anatomicals is called into question by evidence of anatomical votives in Italy as early as the sixth century,[16] that is, prior to widespread Greek influence in the regions that are the focus here (especially in the mountainous areas) and long before the importation of Aesculapius to Rome. Although these early Italic anatomicals are bronze rather than terracotta, and although they come from regions further north (northern Etruria) and east (along the Adriatic), there are "strong affinities in design" between them and the Etrusco-Latial-Campanian items, whereas the Greek anatomicals are of a markedly different style and rarely include representations of internal organs, which were popular in Italy.[17] Fay Glinister rightly suggests that the fourth-century Italic practice may be in large part a development of an indigenous tradition.[18] As to the idea that the presence of anatomical terracottas is a sure sign of Roman influence in a given area, Glinister points to a rapidly growing body of evidence for the contemporary use of terracotta anatomical votives in areas outside west central Italy (in the Appenines and along the Adriatic) and to the difficulties in pinpointing the chronology of votive deposits. It now appears that the anatomical votives of west central Italy are a more widely Italic phenomenon.[19]

For reasons about which we can only speculate, people through-

out the Italian peninsula (particularly its central region, both east and west) began offering terracotta anatomical votives to their gods in great numbers in the late fourth century. These remained the predominant type of offering until their popularity began to wane in the early first century; they were almost completely supplanted by written dedications by the Augustan period. Here, too, scholarly opinion is divided as to the cause. Some argue that the decrease in the popularity of anatomical votives in the last century of the Republic was due to the spread of Greek medical knowledge throughout the Italian peninsula.[20] Others attribute the shift away from anatomical and other terracotta votive types to a dramatic shift in the social status of worshipers at rural sanctuaries.[21]

Both of these proposals are unlikely. There is very little to suggest that Greek doctors and their learning were widely available or highly esteemed in republican Italy. Furthermore, even if practitioners were available in larger urban areas, there is no evidence that they traveled to the remote rural regions where the majority of votive deposits have been found. The argument from social status stands on an equally unstable foundation. It is assumed that as small landowners were displaced from the Italian countryside by aristocratic villas and *latifundia*, popular attendance at sanctuaries declined. If this were the case, one might reasonably expect to find a surge in the presence of anatomical votives at urban shrines, where the displaced farmers now brought their concerns. Yet, instead of a shift in the geographical distribution of anatomicals, it appears the practice was abandoned in approximately the same period throughout Italy.

A stronger explanation for the decline in popularity of anatomical votives may be found in the fact that from the late Republic onward, the health concerns they expressed are commonly articulated in inscriptions.[22] It is possible that these two types of offerings make up a sort of continuum of expression over several centuries: the same message was conveyed to the gods through different media in different periods. The sentiments that, in an earlier age, might have been expressed by a terracotta female head carved to show new hair growth[23] and a terra-

cotta pair of eyes in later times were expressed by these inscriptions from Placentia and Rome:

Minervae / memori / Tulli Superiana / restitutione / facta
sibi / capillorum / v(otum) s(olvit) l(ibenter) m(erito).
(*CIL* 11.1305 = *ILS* 3135)
[Tullia Superiana fulfilled her vow to Minerva Memor willingly and with just cause, on account of the restoration of her hair.]

Felix publicus / Asinianus pontific(um servus) / Bonae dea agresti
Felicu(la) / votum solvit iunicem alba / libens animo ob lumini-
bus / restitutis derelictus a medicis post / menses decem bineficio
dominaes medicinis sanatus per / eam restituta omnia ministerio
Canniae Fortunatae. (*CIL* 6.68 = *ILS* 3513 = Brouwer 1989, 53–54,
no. 44)[24]
[Felix Asinianus, public slave of the *pontifices*, fulfilled his vow to
Bona Dea Agrestis Felicula willingly and with good cause, (sacrific-
ing) a white heifer on account of his eyesight having been restored.
Abandoned by doctors, he recovered after ten months by taking
medicines, by the aid of the Mistress. Through her, all things were
restored during Cannia Fortunata's tenure as *ministra*.]

The close link between the significance of anatomical votives and the significance of some written dedications is illustrated especially clearly on those occasions when an anatomical representation has been found alongside an inscription (anatomicals themselves are very rarely in-scribed). We have already considered one possible example, the wet nurse Paperia's dedication to Diana (discussed in chapter 2) that was found alongside a bronze breast:

Diana mereto / noutrix Paperia. (*CIL* 1².45 = *ILS* 3235 = *ILLRP* 81)
[To Diana, Paperia the wet nurse (gave this) justly.]

Another, more certain example is the pair of silver ears (now lost) that originally accompanied this dedication of the imperial age from Pla-centia:

Minervae aug / L(ucius) Callidius Primus / Brixellanus ex arg(enti) /
lib(ras) II item L(ucius) Callidius / Primus aures argenteas / v(ota)
s(olverunt) l(ibenter) m(erito). (*CIL* 11.1295)
[To Minerva Augusta, Lucius Callidius Primus Brixellanus gave two
pounds of silver and likewise Lucius Callidius Primus gave two sil-
ver ears. They fulfilled their vows willingly and with good cause.]

The transition from anatomical votives to inscriptions as the me-
dium of choice for addressing medical concerns to the gods shows an
elasticity in the form of worship while the message conveyed by that
worship remained unchanged. This simultaneous continuity and flexi-
bility is a function of the oft-noted paradoxical nature of Roman reli-
gion, most frequently discussed with respect to Rome's rigid adherence
to tradition and its relatively easy acceptance and assimilation of for-
eign deities.

The Meaning of Anatomical Votives

At the most basic level, anatomical votives had a pragmatic purpose:
to seek a cure or to offer thanks for a cure already received. In an age
before medical specialists were common in Roman society and before
written dedications were widely available, the only recourse open to
an individual suffering a physical ailment was to offer an anatomical
votive at a local sanctuary in the hopes of being cured by the god who
inhabited the place.

It is unclear whether worshipers offered anatomical votives when
they suffered afflictions or after they had been cured. At first inspec-
tion, it appears that the votives almost uniformly represent healthy
organs (fig. 4), suggesting they expressed thanks for cures already re-
ceived.[25] It is possible, however, that their healthy appearance may have
as much to do with financial concerns as with actual religious practice:
anatomical votives were generally mass-produced by stamping lumps
of clay—a fact that weighs against widespread representation of spe-
cific ailments.[26] An alternate explanation may be that, because ana-

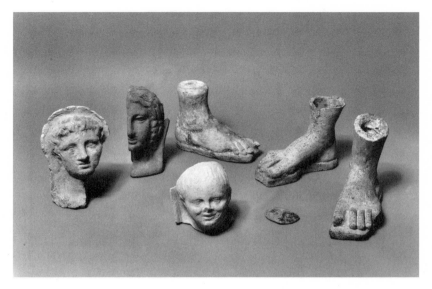

Figure 4. Group of Anatomical Votives. (Courtesy of the University of Pennsylvania Museum; mus. ob. nos. [left to right]: MS5756, MS5757, MS5752, L-64-478, L-64-551, MS1630, L-64-553)

tomicals votives were mass-produced and were probably purchased already made, individual complaints would have been represented (for an extra fee, of course) with paint, traces of which have been found on a significant number of votives from various sites. There is also direct evidence that afflictions were sometimes molded into the clay. For example, a fragment of an arm from the Minerva Medica find is covered with pustules,[27] and it is possible that some representations of male genitalia from Lavinium and elsewhere exhibit signs of disease, although this interpretation is open to debate.[28] A third possibility is that those suffering from illness still offered representations of healthy organs.

Based solely on consideration of their appearance, it is not possible to answer definitively the question of whether anatomical votives were intended as requests for healing or thanks for recovery. A glance at rele-

vant inscriptions that may express the same sentiments in later ages also does little to resolve the question. Some inscriptions, such as Tullia's dedication in thanks for the restoration of her hair or Felix Asinianus's for having his sight restored, were clearly offered in gratitude for relief bestowed. Much more common are dedications offered *pro salute*. These appear to ask for the continuing good health of the dedicant and his or her loved ones — that is, in some sense in anticipation of future health problems. An example is this undated inscription from Rome:

Numisia Afrodi/te pro salute fili / maei et meorum / donum
Herculi / posui. (*CIL* 6.286)
[I, Numisia Aphrodite, set up this gift to Hercules on behalf of
the health of my son and my family.]

Although the phrase *pro salute* does not appear in any inscription of republican date,[29] the sentiment is implied in inscriptions set up by parents on behalf of their children, such as the following from Nemi and Rome (discussed above):

Poublilia Turpilia Cn(aei) uxor / hoce seignum pro Cn(aeo) filiod /
Dianai donum dedit. (*CIL* 1².42 = 14.4270 = *ILS* 3234 = *ILLRP* 82)
[Publilia, wife of Gnaeus Turpilius,[30] gave this statue as a gift
to Diana on behalf of her son, Gnaeus.]

Iunoni Lucin(ae) / Sulpicia Ser(vi) f(ilia) pro / Paulla Cassia /
f(ilia) sua / d(onum) d(edit) l(ibenter) m(ereto).
(*CIL* 1².987 = 6.361 = *ILS* 3103)
[Sulpicia, daughter of Servius Sulpicius, gave this gift on behalf
of her daughter Paula Cassia, willingly and deservedly to
Juno Lucina.]

In the end, the matter must remain unresolved. It seems likely that there was no hard-and-fast rule about when a dedicant should offer an

anatomical votive. Custom may well have varied region to region, cult to cult, family to family, person to person.

In addition to their pragmatic importance, anatomical votives may have had a more metaphorical significance. Ears might represent a request that the god hear a prayer, feet might represent the fact that a worshiper was a pilgrim, heads might represent the placing of the worshiper's whole being under the care of the god.[31] Another school of thought argues that anatomical votives were intended to expiate sins committed by worshipers who saw their physical ailments as punishment. This interpretation has received support from several prominent archaeologists,[32] and it received its most thorough consideration in an article by A. Pazzini, who imagined a Pan-Mediterranean *mentalità primitiva* that conceived of two types of divinity: gods who inflict disease and those who cure it. Drawing on archaeological and literary sources from several ancient Indo-European and non-Indo-European societies, including Egyptian and Semitic cultures, Pazzini believes that the pervasiveness of the custom of anatomical votives in Mediterranean cultures indicates a widespread similarity in religious thought.[33] He goes so far as to argue against the medical significance of anatomical votives because, in his opinion, inscriptional and pictorial representations accomplished the task much more concisely.[34] Furthermore, gods who are not specifically healing deities received anatomical votives; therefore the significance of the votives must extend beyond medical concerns.[35] After a look at the details of Pazzini's argument, we will take up these corollary arguments in turn.

In the expiatory interpretation, a god who has been offended by the conscious or unwitting actions of a mortal demands as recompense a part of the offender's body. The demand is manifested as an affliction of a limb or organ. The mortal, in an attempt to appease the god and avoid further suffering, offers a substitution—a fictile representation of the ailing part of his body—thus transferring the transgression from himself to the anatomical replica. The strongest evidence for this interpretation comes from the biblical story of the punishment inflicted

upon the Philistines by the God of Israel ([KJV] 1 Samuel 5.6–6.12).[36] After taking the Ark of the Covenant, the Philistines find themselves suffering from proctologic complaints.[37] Their priests advise the following remedy: "In proportion to the number of the Philistine chiefs, offer five golden tumors [hemorrhoids] and models of your rats, for the plague was the same for you all as for your chiefs."[38] While some are eager to see this episode as a record of Philistine belief, caution is warranted: it is the only evidence for the use of anatomical votives in Philistine religious praxis.[39]

There is little evidence for a specifically Roman belief in the expiatory power of substitute offerings. One ritual to which proponents of the expiatory interpretation of anatomical votives frequently point is the little-understood rite of the Argei observed in mid-May by the pontifices, *flaminica*, Vestals, praetors, and others who might rightly attend the rites (καὶ τῶν ἄλλων πολιτῶν οὓς παρεῖναι ταῖς ἱερουγίαις θέυμις [D.H. 1.38.3]). This select group walked a circuit of twenty-seven stations or shrines, called Argei, and then proceeded to the Pons Sublicius, where the Vestals cast straw figures, also called Argei, into the river.[40] The bundles of straw have sometimes been interpreted by ancient and modern scholars as substitutes for human sacrifice, intended to cleanse the whole community of its sins.[41] Such an interpretation, however, has not received widespread acceptance. Myriad alternatives have been proposed. It will suffice to note a few other interpretations to demonstrate the range of possible options: the straw bundles represent a consecrated harvest and the ritual is designed to ensure plentiful crops;[42] the Argean ritual is tied to religion observed by the *curia* in Rome and to the practice of augury;[43] the ritual fits into a complex of rites observed in May and thus shares their concerns (private feminine matters, public political issues, or the appeasement of spirits of the dead).[44]

There is no evidence for a Roman belief in the expiatory power of anatomical offerings, nor is it wise to extrapolate Roman beliefs from purported Philistine beliefs as Pazzini would have us do on the basis of the passage from 1 Samuel. Let us now turn to the objections raised against a medical significance for anatomical votives. One of

the arguments is that written dedications are clearer, more articulate expressions better suited to the task of asking for cures than were anatomical votives, and so a medical purpose must have been reserved for inscriptions.[45] Indeed, written dedications asking for cures or offering thanks for healing are plentiful in Latin epigraphic collections.[46] Yet, as we have seen, these two types of offering did not coexist for very long in Roman society: the popularity of anatomical votives began to drop off in the late second and early first century, just as the number of written dedications began to rise. In order for distinct purposes to have been reserved for anatomical votives (expiation of sin) and inscriptions (medical cures) within Roman religious practice, the abandonment of one practice in favor of the other must be explained by the abandonment of one belief for another. This explanation is highly unlikely in light of the conservatism of Roman religious habits and the fact that health is a universal human concern. Furthermore, it should be pointed out that written dedications documenting health concerns addressed by the gods demonstrate a complete absence of contrition, which one might expect to find if Romans believed disease was sent to them by gods they had offended.

Another objection to the medical interpretation of anatomical votives is that, since all gods — not just healing deities — received them, these offerings could not have had a simple medical significance.[47] For example, the deposits of Aesculapius from Fregellae and of Minerva Medica in Rome yield groups of votives that are identical in their typological makeup to others, such as the deposit from Lavinium identified as belonging to Ceres and that from the sanctuary at Gravisca, which included shrines of Demeter and Kore, Aphrodite-Turan, and Hera-Uni.[48] It seems much more likely, however, that the ubiquity of anatomical votives is a reflection of a Roman belief that all gods were capable of healing worshipers.[49] We need not assume that sanctuaries where large numbers of anatomicals have been found functioned as hospitals or medical clinics.[50] Indeed, the soil of Italy has yielded virtually no evidence that medical care in the modern, scientific sense was available at religious sites.

Turning once again to inscriptions for a more articulate expression

of religious concern, it becomes clear that many gods not generally thought to be interested in the health and well-being of their devotees were in fact approached with such matters. Here are a few health-related dedications of the imperial period, the first of unknown provenance, the others from Rome, made to gods who were not what we would call "healing" gods:

> Diti patri et / Proserpinae / sacr(um) / Iulia Flora / pro salutem / suam et suorum. (*ILS* 3970)
> [This is consecrated to Dis Pater and Proserpina. Julia Flora did this on behalf of her own health, and the health of her loved ones.]

> Silvano fecerunt / pro sua salute. (*CIL* 6.580)
> [They did this for Silvanus, on behalf of their own health.]

> M. Lurius Germus / aram restituer(ont) / Iovi Optumo Maximo / ob suam suorumque salu[tem]. (*CIL* 6.30939)
> [Marcus Lurius Germus restored this altar for Jupiter Optimus Maximus on account of his own health and the health of his loved ones.]

All this suggests that Roman gods were not the limited specialists they are often considered to have been, but rather that they had influence in many areas of their devotees' lives.[51] A corollary to this conclusion can also be drawn: the presence of anatomical votives at a given site should not immediately be taken as a clear sign that the site was sacred to a recognized healing god—a point missed by some archaeologists.[52]

The varied interests of the gods is further underlined by the fact that deities whose primary sphere of influence was physical health were not just concerned with medical matters. For example, in the imperial period, Aesculapius and Hygeia received thanks for successful business dealings (*CIL* 6.18, from Rome), and Minerva Memor (?), who was credited with the restoration of Tullia's hair (above), was thanked by another worshiper for his safe return from a trip abroad (*CIL* 11.1303,

from Carbardiacum).[53] The multiplicity of divine interests represented in inscriptions like these points in the same direction as some of the discussion of literary material discussed in chapter 1, where it was argued that several goddesses thought to have an almost exclusive interest in private fertility issues, such as Juno Sospita and Fortuna Muliebris, were also approached by worshipers with concerns of a broader civic nature. Furthermore, deities thought to have appealed exclusively or primarily to a female audience, such as the Bona Dea, were also worshiped by men.

Clearly, Roman worshipers conceived of their gods as having various degrees of influence in several different spheres — a phenomenon A. Comella has called "shades of cult."[54] She points out that a quantitative analysis of the typological makeup of a given votive deposit could possibly provide evidence for the various interests of the deity (or deities) to whom the deposit belonged, as well as give an indication of the relative prominence of some interests over others. Unfortunately, very few deposits are substantially excavated and well published enough to make viable such an enterprise at this time. There is enough evidence, however, to suggest that many of the labels applied to Roman deities, such as "healing god" and "women's deity," should be critically reevaluated and applied with greater caution, if not discarded altogether.

Anatomical Votives and Medical Knowledge

Anatomical votives may reveal something about the state of medical knowledge in Italy in the period of the middle Republic. Of particular interest are representations of isolated internal organs (livers, hearts, uteri) and groups of organs (polyvisceral plaques) that are peculiar to votive deposits of central Italy.[55] Interpretation of these items is rather difficult because of the schematic nature of anatomical votives in general, and the artisans' presumed unfamiliarity with internal anatomy. Archaeologists and physicians have had great difficulty in identifying the organs represented in polyvisceral plaques and open thoraxes

(figs. 5, 6). It has been suggested that artists may have based their work on bovine anatomy, or that of other animals.[56] In addition, many polyvisceral plaques may not have been meant to look like human anatomy, but rather were created as representations of animal innards—permanent images of animal sacrifice.[57] Perhaps polyvisceral plaques were offered in place of blood sacrifice by those too poor to offer an animal on whom their livelihood depended. It is also possible that some of the plaques were meant to express concerns for the health of farm animals: complete figurines of cows and other animals are often found alongside anatomical votives.[58] Representations of pieces of bovine and other animal anatomy have been found at several sites. For example, terracotta cow hooves have been found at Lavinium, Caere, and Tessenanno.[59] Included in a deposit at Lavinium (which otherwise lacks representations of internal organs) were three items that do not appear to be representations of human anatomy and so have been identified as animal tongues, although by what criteria this determination was made is not clear.[60]

Fortunately for the question of the role of gender in Roman religious practice, representations of one internal organ, the uterus, are consistently identifiable. Votive uteri have a flat, pear shape that is usually decorated with muscular striations (fig. 7). These items certainly represent human uteri: pig, sheep, and cow uteri have a very different, bicornate shape.[61] Irregularities in the shapes of terracotta uteri have been identified as maladies of one sort or another. For example, small protuberances represented on some uteri from Ghiaccio Forte, Gravisca, and other sites have been interpreted as tumors.[62] The most common variation is an appendage extending from the mouth of some uteri (fig. 8).[63] The appendage is always singular, although there is variation as to whether it appears on the right or the left. Many explanations have been offered: blister, fibroma, and vaginal cyst among them.[64] Other scholars think these appendages, despite their singularity and their attachment to the wrong end of the organ, are ovaries.[65] An explanation for the presentation of a single ovary, offered by Fenelli and others, is that the single ovary represents a request not for healing but for fertility—more specifically, as a request for a child of one gender or the other.[66]

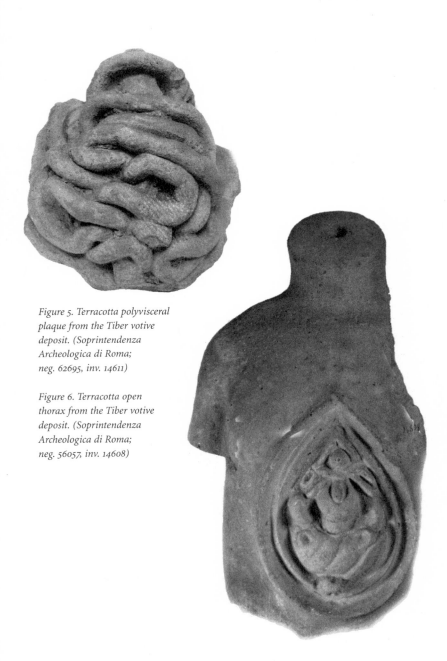

Figure 5. Terracotta polyvisceral plaque from the Tiber votive deposit. (Soprintendenza Archeologica di Roma; neg. 62695, inv. 14611)

Figure 6. Terracotta open thorax from the Tiber votive deposit. (Soprintendenza Archeologica di Roma; neg. 56057, inv. 14608)

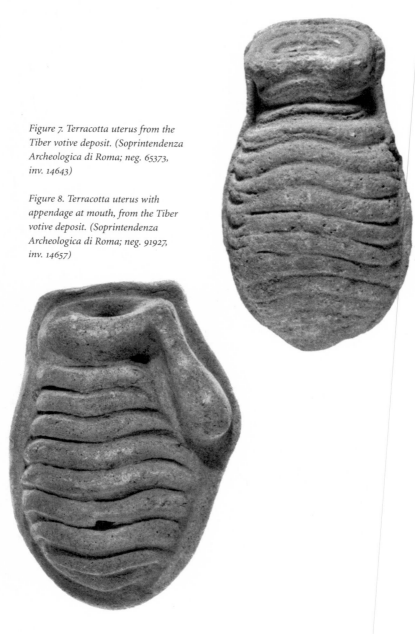

Figure 7. Terracotta uterus from the Tiber votive deposit. (Soprintendenza Archeologica di Roma; neg. 65373, inv. 14643)

Figure 8. Terracotta uterus with appendage at mouth, from the Tiber votive deposit. (Soprintendenza Archeologica di Roma; neg. 91927, inv. 14657)

In support of her position, Fenelli points to the long tradition of the study of gynecology in antiquity, arguing that ancient medical understanding in early republican Italy was developed enough to understand the relationship between the uterus and ovary. Indeed, female anatomy and physiology were subjects of intellectual inquiry from the earliest stages of Greek scientific thought—even before medicine developed into a discipline separate from philosophy. For instance, the Hippocratic corpus contains ten treatises on gynecological issues, some perhaps dating to the early fifth century.[67] The idea that different sides of the body engendered different-sexed offspring (a male child would be conceived if the seed fell onto the right side of the womb and a female child if it fell onto the left) had been put forward already in the fifth century by the philosopher Anaxagoras.[68] Hippocrates subscribed to the idea and was followed by Galen several centuries later.[69] Ancient opinion about the process of gender determination was not unanimous, however: Aristotle was an ardent dissenter.[70]

Despite its attractiveness, there is not enough evidence to support Fenelli's interpretation. First and foremost, ancient gynecological understanding was not advanced enough to comprehend many details of the female reproductive system. Most importantly for the topic at hand, ovaries were not considered entities on their own until they were identified in the third century by the Alexandrian physician Herophilus, who thought they were connected by spermatic ducts (Fallopian tubes) to the bladder.[71] Five hundred years later, in the late second century c.e., Soranus still followed Herophilus's theory.[72] Galen, writing several decades after Soranus, is the first extant source to suggest that ovaries played a role in conception.[73]

Two other objections to Fenelli's argument can be raised. Even if it were possible to establish that ovarian function was understood by physicians in the fourth and third centuries, it is unlikely that the erudite knowledge of doctors in Greece and Egypt filtered quickly into Italy, especially into less cosmopolitan areas. The Romans were slow to accept the medical profession. Although doctors were known in Italy as early as the late third century, the first important and influential

doctor in Italy, Asclepiades of Bithynia, did not arrive until a century later.[74] Thus it seems more likely that if specialized Greek knowledge had somehow reached the Italian countryside in the early republican period, it was met with skepticism and disbelief, rather than immediately embraced and adopted. A more pragmatic obstacle to this interpretation, however, is that the appendages in question are invariably placed at the wrong end of the uterus. To accept Fenelli's interpretation, one would have to assume that the Romans understood the ovaries' importance to reproduction but were not familiar with their position within the body.

Gender and Cult

Anatomical votives provide insight into several aspects of Roman religious practice as it was observed on individual and local levels. For instance, on the level of individual practice, the prevalence of these offerings makes clear the importance of health issues in the daily lives of worshipers, both male and female, and documents the intimacy of the concerns Romans brought to their gods. Furthermore, the ubiquity of anatomical votives in deposits suggests that worshipers felt comfortable addressing these concerns to the full range of divine powers to which they had access.

In terms of localized religious practice, anatomical votives can reveal something of the nature of the deity or deities worshiped at a certain site.[75] A quantitative analysis of the items from the deposit at Gravisca reveals a very high proportion of female genitalia, suggesting that the gods worshiped at that site catered to the traditionally feminine concerns of fertility and childbirth. For comparison, the large find from Ponte di Nona contains relatively few examples of genitalia, though it has yielded a significant number of eyes, a type of anatomical votive often absent from deposits generally. Hence it appears that the god at that site had no particular concern for human (more specifically, female) fertility and seems to have had a more general healing ability, perhaps with a special interest in eyesight.[76] The reader may also recall

from the discussion of female participation in the cult of Hercules in the previous chapter that a deposit positively identified as belonging to the god contains terracotta uteri and breasts. This circumstance corroborates the conclusion drawn from the epigraphic evidence for the worship of Hercules: the god had some interest in feminine matters.[77]

Just as qualitative analysis of individual deposits allows us to draw some conclusions about the nature of individual deities or sanctuaries, comparison of the typological makeup of a great number of deposits may reveal something about the nature of Roman religious practice in general. More pointedly, because some types of anatomical votives are gender-specific, this sort of large-scale analysis allows for some speculation on the role of gender in determining what religious places an individual could visit, and to what gods that person might address his or her concerns. Again, the Praenestine deposit of Hercules is pertinent. The presence of uteri and breasts not only indicates the god's interest in feminine concerns, but it also suggests that women participated in his cult in some capacity. Of course, the votives themselves cannot tell us if women participated in all rites at the sanctuary, or even if women were allowed into the temple on the same days as men.

The analysis that follows is informed by the notion that there is a very general correspondence between the gender represented by anatomical votives in a deposit and the gender of worshipers who may have left them there. Of course, it is possible that the gender of an anatomical votive does not correspond to the gender of the dedicant; for example, a terracotta breast may have been offered by a man whose wife could not nurse their newborn child. In fact, written dedications that record offerings made by a person of one gender for someone of the other, like Publilia's dedication to Diana on behalf of her son, discussed in chapter 2, are quite common. Further complicating the picture is the possibility of joint dedications, such as offerings made by both parents on behalf of a child or by a wife and children on behalf of a husband and father. Written dedications recording circumstances like these are not rare, suggesting that such dedications were also made with anatomical votives in earlier ages.

Even so, the probability of cross-gender (for lack of a better term) and joint dedications does not invalidate the larger conclusion drawn here: that the archaeological evidence of votive deposits suggests something very different from the literary sources and that this circumstance requires explanation. As will be discussed below, a very great number of votive deposits are gender-inclusive, that is, they include both male and female anatomical votives — a circumstance that we would not expect to find on the ground based on the traditional notion that Roman religious activity was largely divided along gender lines. In the case of the cult of Hercules, the notion that all uteri dedicated to the god must have been offered by men is untenable, especially in light of the epigraphic evidence. I would maintain that most (though not all) of those uteri were offered by women: some of them might have been offered by husbands on behalf of their wives, or by husbands and wives together. Yet these two situations also indicate that Roman religion was more flexible in the way it accommodated gender-specific concerns than is usually considered. We do not generally think of Roman men as being concerned with "feminine matters," nor do we often think of Roman men and Roman women worshiping together.

The Numbers

Two important studies by M. Fenelli and A. Comella have between them cataloged the vast majority of votive deposits of the Etruso-Latial-Campanian type and have categorized the different kinds of items found at each site.[78] In addition to a more general breakdown by type (statue, anatomical representation, figurine, etc.), both scholars provide a more specific classification of anatomical votives (hand, foot, ear, etc.). One of the most surprising results of an analysis of the presence of gender-specific anatomical votives in these deposits is the relative paucity of physical evidence for gender-exclusive cult compared with what one might expect given the prominence of gender-exculsive ritual in the literary sources. Roman religious praxis, as it is revealed by archaeological material, meshes quite well with the more inclusive pic-

TABLE 1. *Comparison of Votive Deposits Surveyed by Fenelli and Comella*

	Fenelli 1975	Comella 1981
Total sites in survey	96	161
Total deposits	148	227
Deposits lacking gender-specific votives	87 (58.8%)	160 (70.4%)
Exclusively male deposits (containing phalluses, but no breasts or uteri)	12 (8.1%)	11 (4.8%)
Exclusively female deposits (containing breasts or uteri, but no phalluses)	21 (14.2%)	21 (9.3%)
Total gender-exclusive deposits	33 (22.3%)	32 (14.1%)
Inclusive deposits (containing both male and female anatomical votives)	28 (18.9%)	35 (15.4%)

ture drawn from our earlier considerations of literary and epigraphic evidence. The evidence of votive deposits appears to indicate that men and women worshiped the same gods in the same sanctuaries at least as often as they worshiped different gods in different sanctuaries. In other words, it appears that in Roman religion gender-inclusive cult was at least as common as gender-exclusive cult. In table 1 above, the relative proportions of gender-exclusive and gender-inclusive deposits in the surveys by Fenelli and Comella are laid out. The totals in each category are the result of my own calculations.

There is significant overlap between the two studies in the basic core of sites examined. The difference in the raw number of sites and deposits is largely due to Comella's inclusion, for comparative purposes, of votive deposits that are not of the central Italic type. Two other contributing factors are the fact that Comella's sample is expanded by the

excavation and publication of several new deposits in the years fol-
lowing the appearance of Fenelli's article and disagreement between
Comella and Fenelli as to whether some sites have yielded single or
multiple deposits. Because we are interested here in the general pro-
portional relationships of different types of deposits and not with spe-
cific percentages, it is possible to allow Comella's expanded sample to
stand, even though the inclusion of other kinds of deposits that gener-
ally do not include anatomical votives lowers the relative proportions
of gender-inclusive and gender-exclusive deposits.

Despite the differences in raw numbers, the surveys exhibit the same
proportional relationships among the different categories of deposits.
In both surveys, deposits lacking gender-specific votives of any type are
by far the largest group: 58.8 percent in Fenelli's survey, 70.4 percent in
Comella's. This is probably not a realistic depiction of the situation on
the ground, but rather should be attributed to the poor state of excava-
tion and publication of votive deposits generally. Unfortunately, many
deposits are known from sporadic finds of a small number of items.
The records for many other, larger deposits are too incomplete to be of
much use: older publication notices often simply record the presence of
statuary and portrait busts, dismissing the rest of the deposit as "other
unspecified items." Several large deposits whose contents number in
the thousands have not yet been subject to full quantitative analysis.[79]

Exclusively female deposits appear about twice as frequently as ex-
clusively male deposits. This would seem to support the picture of
female religious activity presented by our ancient authors who focus
on all-female rituals while rarely mentioning exclusively male rites.
The apparent congruence between archaeology and literature is lim-
ited, however. Deposits including anatomical votives of only a single
gender—that is, the sum of exclusively male and exclusively female
deposits—appear *in almost equal proportion* to deposits that include
anatomical votives of both genders (22.3 and 18.9 percent in Fenelli,
14.1 and 15.4 percent in Comella).[80] Hence it appears that, contrary to
the standard portrayal of Roman religious practice in which gender-
exclusive rites predominate, gender-exclusive cult was no more preva-
lent among the Romans than was gender-inclusive cult.

I would take this line of argument one step further: it is entirely possible that as the study of votive deposits continues to expand and develop, it will become clear that gender-exclusive cult was less common than gender-inclusive cult. In the years since Comella's survey, improved understanding and publication of votive deposits has already reduced the number of gender-exclusive deposits even further: at least four additional deposits previously thought to be gender-exclusive are in fact revealed to contain anatomical votives of both masculine and feminine types.[81] The number of gender-exclusive deposits may dwindle even further when the scope of inquiry is expanded beyond anatomical votives to include other offering types that may be indicative of the gender of the worshipers who left them (such as figures of swaddled infants and loom weights for female worshipers, weapons for male worshipers, statuary and portrait busts for all worshipers).[82]

In conclusion, the evidence of votive deposits has important implications for the more general study of Roman religion. Many of the labels used to categorize the gods should be reconsidered. For instance, the existence of anatomical votives within a deposit is not a clear indication that the god to whom the deposit belonged was a "healing god" because a wide range of gods received them. Likewise, the label "women's deity" must be applied much more cautiously, since the archaeological evidence supports the conclusion drawn earlier from epigraphic material that men honored deities thought to appeal to an exclusively female clientele. All this suggests that the multifaceted nature of Roman cult has been blurred by efforts, both ancient and modern, to categorize and systematize the study of Roman religion.

The arguments in this chapter also have implications for the more specialized study of the religious experience of Roman women. Most important, this examination provides strong support for the expanded view of Roman women's religious experience. It is likely that women often worshiped the same gods in the same sanctuaries as did men: temples and sanctuaries open to worshipers of both genders were at least as common as those restricted to one group or the other. This does not, of course, mean that our sources have unduly inflated the impor-

tance and prevalence of gender-exclusive rites. It remains a possibility that women and men were not always permitted to enter a sanctuary at the same time, as in the case of gender-exclusive ritual within cults known to be popular with both male and female worshipers (e.g., the cults of the Bona Dea and Juno Lucina). Ultimately, however, there is no doubt that Roman women enjoyed far more varied and extensive participation in religious ritual than is often considered, and that Roman religion was on the whole less rigidly divided along gender lines than it sometimes appears.

FOUR

HOUSƐHOLD RITUAL

Because Roman women were most strongly associated with the domestic realm, household religious observances would seem the most natural avenue for female religious expression. This does indeed appear to be the case, though efforts to understand and define the female role in domestic ritual are hampered by the fact that evidence for any variety of Roman household religion is meager at best. Literary sources offer only scattered references to domestic ritual, whether observed by men or women. As is the case for women's religious activity in general, the paucity of literary evidence is not an indication of Roman disregard for domestic ritual, but rather it is further testament to our authors' focus on religion at the highest, most public level. Epigraphic material, a useful resource for information about aspects of daily life that do not appear in literary sources, is of little help with regard to domestic rites, in large part because inscriptions were almost universally

created for public consumption. The traces of household observances gleaned from written sources can be supplemented to some extent by relevant archaeological material, preserved at many sites (especially Pompeii, Herculaneum, and Ostia), that consists mostly of household shrines (*lararia*). Yet even this most immediate evidence of domestic ritual cannot answer many basic questions: *lararia* give little indication of who worshiped at them, when, or for what reason. In the introduction to his article on family rituals, Harmon makes a distinction between the relative richness of our sources on public observances and the dearth of material for observances within an individual home: for public festivals, we try to figure out *why* certain rites were observed; for family festivals and daily rituals, we try to figure out *what* rites were observed.[1]

This lack of evidence necessarily complicates the study of domestic ritual. In fact, the subject in general has not received extended consideration since De Marchi's *Il culto privato di Roma antica* (1896–1903) more than a century ago, though several smaller studies have addressed aspects of it,[2] and larger works on Roman religion have given the topic limited treatment.[3] The few thorough discussions of the religious aspects of marriage, childbirth, passage into adulthood, and death that are available leave no doubt that the events that marked a woman's life had strong religious components that required her participation in rituals in her home.[4] This chapter supplements these earlier studies by focusing on the importance of Roman women in the religious lives of their families. The primary question this chapter addresses is, What religious obligations did a woman have within her own home? The sources show two facets of female religious activity: participation in ritual and responsibility for ensuring that all things necessary for domestic rites were available. Once again, the evidence available to answer the question pertains almost exclusively to *matronae*. For the most part, we do not know how the daughters or widowed and childless aunts of a family were expected to participate. We can only speculate that they assumed the matron's responsibilities in her absence.

Household Gods and Rites

Before proceeding to a detailed consideration of the role women took in household rites, it will be useful to review the evidence for the rites themselves and the deities they honored. A great many gods were involved in the day-to-day operations of a Roman household and in important life events. Among these were Janus to watch over the doorway,[5] Juno Lucina and Diana to assist at childbirth as well as a host of other deities to keep watch in the days immediately following,[6] and various gods to help with running the farm.[7] Most domestic rituals, however, were directed toward one of three deities, or groups of deities: the *Penates*, including Vesta; the *Lares*; and the *genius* of the *paterfamilias*. These are the household gods (*dii familiares*).[8] Although we cannot recover their origins, their exact spheres of influence, or the relationship among them,[9] it is clear that all the household gods were charged with the survival and success of the family. Each domestic deity had a public counterpart, thus underlining the close relationship between practices within and outside the home. The primary association of these gods, however, was always with the home: the *Lares* and *Penates* in particular were often used as synonyms for *domus*.[10]

Most rituals observed within the home centered on the familial hearth, where Vesta resided.[11] On the named days of each month (Kalends, Nones, and Ides) and on days of special importance to the family itself, the hearth was adorned with garlands; wine and other delectables were offered on the fire.[12] Vesta is closely associated with the *Penates*,[13] the gods who watched over the *penus*, the storeroom where food (oil, wine, grain, vegetables, etc.) and other necessities were kept.[14] The close link between Vesta and the *Penates* on the domestic level is parallel to their association in public cult. It was sometimes believed that the *Penates* brought by Aeneas from Troy to Rome were housed in Vesta's temple in the Forum.[15]

We are better informed about the *Lares*, who are sometimes confused with (subsumed by?) the *Penates*. The little-known public *Lares*

praestites, perhaps attested on a coin from the Republic,[16] have their domestic parallels in the *Lar familiaris*, who was responsible for protecting the *paterfamilias* and his home,[17] and the *Lares compitales*, who were associated with crossroad shrines (*compitalia*) around the edge of the family's estate and who watched over the fields. In addition to daily offerings, the *Lar familiaris* was honored on holidays and on Kalends, Nones, and Ides of each month.[18] It was to him that the owner of an estate offered reverence upon his arrival at the farm before attending to any business.[19] As for the *Lares* of the fields, their major festival was the Compitalia, celebrated every winter a few days after the Saturnalia.[20] Families would walk the circuit of the shrines, where they displayed a woolen doll for each free person in the household and a woolen ball for each slave.[21]

The *genius* of a family is generally understood to be its procreative life-force, more specifically that of the *paterfamilias*; the *genius* was charged with the long-term preservation of the family and its name (*nomen*).[22] It was worshiped on the *paterfamilias*' birthday and at his marriage.[23] Outside a domestic context, *genii* were often associated with particular places,[24] legions of the army,[25] professional guilds,[26] or the Roman people.[27] In the early empire, public compital shrines around the city came to house images of the *Lares Augusti* and the *Genius Augusti* — the ultimate merging of public and private worship.[28]

There is also a small amount of literary and epigraphic evidence for a female counterpart to the *genius* called a *iuno*, which seems to have functioned in a similar fashion. According to a poem by Sulpicia in the *corpus Tibullianum* ([Tib.] 3.12.1–2), a woman's *iuno* received offerings on her birthday, just as a man's *genius* received offerings on his. Similarly, both the *genius* and the *iuno* could be used in oaths.[29] The two concepts are explicitly linked by Seneca, who asserts that ancient Romans gave every individual either a *genius* or a *iuno* ("singulis enim et Genium et Iunonem dederunt" [*Ep.* 110.1]).[30] Despite this, however, the dichotomy between them may not be as rigid as it appears: dedications to a woman's *genius* (not *iuno*) are known from North Africa in the imperial period.[31]

It is not clear if the idea of individual *iunones* goes back to the earliest period of Roman history or, as seems more likely, if it is a creation of a later age.[32] The concept of a *iuno* is completely absent from early Latin literature, most importantly from the extant comedies of Plautus and Terence, where the vast majority of republican-era references to the *genius* are found.[33] The earliest evidence comes from the Augustan period or shortly thereafter (the references of the *corpus Tibullianum* noted above and two dedications to the *iuno* of Livia), thus suggesting the notion developed over the course of the late Republic.[34] Why this should be the case must remain a mystery.[35] In the end, all that is known is that by the close of the first century, individual women were thought to possess a counterpart to the male *genius* called a *iuno*, and that the worship of the *iuno* was part of household ritual.

Family Participation

The *paterfamilias* was the central figure in domestic ritual. It was he who, each May, appeased the ghosts of his ancestors and led them from his house at the festival of the Lemuria, and it was he who heaped logs upon the fire at the Ambarvalia.[36] It was his *genius* that the family honored. The importance of the *paterfamilias'* role is attested indirectly by the tasks Cato the Elder identifies as properly given to the overseer (*vilicus*) of an estate who acts in his master's stead when the *dominus* is away. Included among these responsibilities is the obligation to see that holidays are properly observed on the farm, implying this is what the *dominus* did when he was available.[37] The *vilicus*'s religious authority was restricted to domestic festivals and to those rites that honored the household gods: "Ne plus censeat sapere se quam dominum. Amicos domini, eos habeat sibi amicos. Cui iussus siet, ascultet. Rem divinam nisi Compitalibus in compito aut in foco ne faciat" (He should not think he knows more than the master. He should consider his master's friends his own friends. He should heed the one to whom he has been instructed to listen. He must not perform any rites except that at the

crossroads on the occasion of the Compitalia or at the hearth [Cato, *Ag.* 5.1]).

The *vilicus* cannot take part in any public observance — an honor, we assume, reserved for the master. That the *dominus* holds final authority in religious matters is clear from Cato's instruction to the *vilicus* to ensure that his female counterpart, the *vilica*, understands that the master is ultimately responsible for rites on behalf of the whole household ("scito dominum pro tota familia rem divinam facere" [143.1]).

The *vilicus* acts as a surrogate for the master in both religious and practical matters when the master is not available to exercise his own authority; a similar relationship existed between the *vilica* and the mistress of the household.[38] Both were responsible for two of the most important centers of domestic ritual: the hearth (*focus*) and storeroom (*penus*).[39] Ovid describes the tasks and responsibilities of a dutiful country wife:

> haec modo verrebat stantem tibicine villam,
> nunc matris plumis ova fovenda dabat,
> aut virides malvas aut fungos colligit albos,
> aut humilem grato calfacit igne focum,
> et tamen assiduis exercet bracchia telis
> adversusque minas frigoris arma parat.
> (*Fasti* 4.695–700)

[And now she swept the house raised up by a post, now she set the eggs to be warmed by the plumes of their mother, or she collected green mallows or white mushrooms. Or she warms the humble hearth with a pleasing fire and, in the same way, she tires her arms with constant loom work and makes ready defenses against the threat of winter.]

Ovid's description matches on many points Cato's description of tasks of the *vilica*, a catalog that highlights her religious responsibilities.[40] In

addition to preparing food and maintaining supplies of perishable and nonperishable items, the *vilica* must tend the hearth, keep it clean, and adorn it properly on holidays and the named days of each month. She must worship the *Lar familiaris* on each of these occasions.

A matron's worship of the household gods of her husband's family began on her wedding day when she set a coin for the *Lares* upon the hearth of her new home and offered prayers to the household *genius*; the *Lares compitales* received another coin from her soon after her wedding night.[41] She also offered prayers to the *Lar familiaris* on certain days each month. It should be borne in mind, however, that she alone was not responsible for his worship. Recall that Cato insists the *dominus* attend to the *Lar* before setting about the business of his estate (*Ag.* 2.1). Furthermore, the opening to Plautus's *Aulularia* implies that daily acts of reverence were the obligation of the *paterfamilias*, who in Plautus's play has neglected his duties. In this instance, the man's daughter has taken her father's obligations on herself (lines 23–25).

Since she shared the *Penates'* responsibility for the family storeroom, the lady of the house (or her surrogate) must have needed their goodwill.[42] A matron's primary responsibility was to provide food for the *familia* and to increase the household's surplus of fruits, grains, and nuts to sustain them through the winter. Although our sources are not explicit about any specific female responsibility for procuring the items necessary for domestic ritual, it is likely that women had some, if not most, of the responsibility in this regard as well. Columella includes the production and preservation of wine (although not necessarily for religious purposes) among the tasks assigned to the *vilica*,[43] and incense and wine, both ritually important items, could be included in the familial *penus*.[44] In addition, Roman women were charged with grinding grain, including the *far* (a type of grain) needed for ritual purposes.[45]

The importance of this aspect of women's role within household religion is indicated by the fact that these obligations were paralleled in the public realm by the duties fulfilled by priestesses, especially the Vestal Virgins, who stood at the heart of Roman public religion.[46] The Vestals

were responsible for producing and maintaining the items contained in the *penus Vestae*, the inner sanctum of the temple to which only they and the *pontifices* had access.⁴⁷ Much of what was stored in the *penus* comprised materials necessary for ritual observances: *muries*, the salt mixture later blended with *far* that had been ground by the Vestals to produce *mola salsa*, an ingredient necessary for sacrifice,⁴⁸ and several items necessary for the lustral rites of the Parilia on April 21: empty bean stalks, the blood of the October Horse, and the ashes of calves burned by the chief Vestal at the Fordicidia on April 15.⁴⁹ It is not certain that the Vestals themselves collected the congealed blood of the dismembered October Horse.⁵⁰

Within Roman domestic ritual there were clearly defined responsibilities for the *paterfamilias* and his wife, but not all rituals were observed by single individuals. On many occasions the whole family, including children and slaves, celebrated rites together. Ovid describes the domestic observance of the Terminalia (February 23):

> ara fit: huc ignem curto fert rustica testo
> sumptum de tepidis ipsa colona focis.
> ligna senex minuit concisaque construit arte
> et solida ramos figere pugnat humo:
> tum sicco primas inritat cortice flammas,
> stat puer et manibus lata canistra tenet.
> inde ubi ter fruges medios immisit in ignes,
> porrigit incisos filia parva favos.
> vina tenent alii; libantur singula flammis;
> spectant, et linguis candida turba favet.
> (*Fasti* 2.645–54)

[An altar is set up. To it a rustic pioneer woman herself carries on a broken potsherd a flame taken from the warm home hearth. The old man splits the firewood and he arranges the broken pieces skillfully. Then he struggles to affix the branches to the solid ground. He stirs up the first flames with dry bark. The boy stands and holds the

wide basket in his hands. Then, when he has tossed grain into the
fire three times, the little daughter offers cut honeycombs. Others
hold the wine; individual libations are poured for the flames; the
white-clad company watches and speaks words of good omen.]

This brief glimpse of a household rite shows family members sharing
in ritual obligations.[51] No one is excluded from the action. Here it is the
children who set the offerings to burn on the altar.[52] Horace similarly
describes old-fashioned rustic family observances in honor of Silvanus,
Tellus, and Genius (*Epist.* 2.1.139–44).

Family celebrations such as these also appear outside the idealized
realm of ancient country virtue. For example, the familial nature of the
winter festival of the Compitalia is made clear in a letter from Cicero to
Atticus that included an invitation to Atticus, his wife, and his mother
to join Cicero and Terentia for the holiday.[53] That women were more ex-
tensively involved in this festival is suggested by the display in the com-
pital shrines of a woolen doll for each free member of the household
and a woolen ball for each slave.[54] Because woolworking and weaving
were traditionally feminine tasks, the women of the household were
probably responsible for supplying the woolen figures.[55]

Although it is difficult to determine the religious duties dispensed by
individual family members, the evidence is sufficient to demonstrate
the importance of Roman women in the religious lives of their families
through their participation in certain rituals and through their respon-
sibility for the procurement of ritual supplies. A matron was respon-
sible for decorating the hearth on certain holidays, and she sought the
goodwill of the familial *Lares, Penates,* and *genius* who watched over
the very areas of the house and of life that were also her responsibili-
ties. In addition, she was responsible for the production, collection,
and preservation of items necessary for her family's survival, includ-
ing those items necessary for maintenance of good relations with the
gods: wine, grain, incense. One last point that cannot be conclusively
demonstrated but which is dictated by common sense is that, by virtue
of her responsibility for young children in the household, a Roman

woman would have been responsible for their religious, as well as practical, education.[56]

Authority in Domestic Ritual

The importance of the *paterfamilias* in household rites and the supremacy of his authority to instruct others to perform religious observances are not in question. It is less clear how much authority Roman matrons had, and whether they held that authority in their own right or only as their husbands' designated substitutes. A woman was certainly mistress of her own home, but she was also subordinate to her husband's authority.[57] A husband had the right to curb religious activity undertaken by his wife, as is implied in Cato's instructions to the *vilicus* on how he should supervise the *vilica*'s religious efforts. In addition to ensuring that the *vilica* performed all the proper rituals on the proper days, the *vilicus* should see to it that she did not observe any rite, or get others to do so for her, without the express permission of the master or mistress. Furthermore, the *vilicus* should not permit the *vilica* to engage the services of less-than-respectable seers and fortune-tellers. It should be noted that Cato's instructions about the *vilica*'s religious activities are parallel to his instructions to the master about the *vilicus*. Both the *vilicus* and the *vilica* are assigned responsibility for specific rites and are restricted from performing others. Furthermore, each is prohibited from trafficking with unsavory religious folk. The major difference between the two sets of instructions is Cato's concern that the *vilica* may try to get others to perform rites on her behalf, a concern that he does not express about the *vilicus*. This issue may arise with regard to the *vilica* because of ancient notions of women's excessive religiosity.[58]

To what extent could a freeborn Roman woman interact with the gods on her own behalf? We have seen that women could take part in sacrifices offered by men, as at the Terminalia. It also appears that women themselves sometimes offered sacrifice after the task was disregarded by the man whose proper responsibility it was, as in the case of

Plautus's *Aulularia* where a daughter is an acceptable substitute for her father.[59] There is less certainty as to whether Roman women could offer sacrifice of their own accord. In light of the vast amount of evidence for self-initiated female interaction with the gods (e.g., any dedication set up by a woman on her own), it has generally been assumed that women could indeed offer sacrifices in their own right. Recently, however, this assumption has been called into question. Because a woman's ability to participate in sacrifice stands at the very heart of the question of how important women were to the religious life of their families and of their communities, the remainder of this chapter considers the arguments on both sides of this issue.

Women and Sacrifice

Those who argue that women were interdicted from sacrifice, and by extension from the very line of communication between mortals and gods, point to several literary passages that suggest women were forbidden to attend sacrifices or were prohibited from handling grain and meat and from consuming wine proper for ritual use—three important food items regularly offered to the gods.[60] Upon closer examination, however, none of the passages in question necessitates such an interpretation, and in some cases the language of the source appears to contradict the idea that the women were kept away from sacrifice. For example, Paulus's redaction of an entry in Festus's lexicon under the word *exesto* ("Be away!") reports that on some ritual occasions (*quibusdam sacris*), an official chased away foreigners, prisoners, women, and girls lest they witness the rites. This is usually interpreted as a blanket interdiction on female participation in sacrifice, but the inclusion of the qualification that this only happens on certain (*quibusdam*) occasions suggests that women were permitted to attend the rest of the time.[61]

Another important passage for this idea that Roman women were not able to offer sacrifice comes from Plutarch's *Roman Questions*, where he explains the exemption of Roman women in olden days (τό παλαιόν) from grinding grain and cooking as a stipulation of the treaty

concluded between the Romans and the Sabines shortly after the founding of Rome: it was agreed that no Sabine woman would grind grain or cook meat for a Roman (*Mor.* 284F = *RQ* 85). This stipulation has been interpreted as an attempt to keep women from handling those materials with which the city ensured its relationship with the gods: the inferior social status of women is reflected in their exclusion from the very act that is the basis for the relationship between mortals and gods.[62] This passage is more reasonably read, however, as testimony to the elevated social status granted to the new Roman brides.[63] By freeing the Sabine women from kitchen duty, the Romans promised not to treat their new wives as chattel. This interpretation draws additional support from a statement in Plutarch's life of Romulus, referring to the same episode, that the Romans agreed that their Sabine wives should perform no work for their husbands other than spinning.[64] Taken together, these concessions on the part of the Romans seem to ensure the respectful treatment of their new wives: they were exempt from servile activities and were explicitly enjoined to spin, the epitome of proper matronal activity.

The passage from Plutarch's *Roman Questions* is the extent of evidence for a restriction on women handling grain and meat. The prohibition on female consumption of wine is much better attested, but its significance is far from certain.[65] Sources range from Fabius Pictor and the elder Cato in the late third and early second centuries B.C.E. to Athenaeus and Tertullian in the late second and early third centuries C.E. Although the details vary from one author to another, it is clear that Romans believed that in the earliest decades of the city, a law was established that prevented women from drinking a kind of unwatered wine called *temetum*.[66]

Ancient and modern interpretations of the stricture vary widely, and not all are tied to the religious sphere. Closely associated with charges of drunkenness in the ancient sources are concerns about the safety of household property (including the keys to the family's supply of wine), over which a Roman matron was supposed to keep watch,[67] and fears of adultery.[68] In addition to the idea that the restriction on female con-

sumption of wine was intended to keep women from materials of sacrifice, modern scholars have proposed that the ban was intended to keep women from a substance with abortifacient or prophetic properties.[69] Another suggestion is that the dating of the law to the mythical past was in part a response to Greek criticism of the Roman practice of allowing women to be present at dinner parties (*convivia*).[70] Some have seen the prominence of the theme of female consumption of wine in ancient sources as an indication that the stricture had come to be symbolic of outrageous female behavior of all sorts.[71]

Whatever its purpose, the prohibition was certainly not universal. Servius reports that in earlier generations (*apud maiores nostros*) women refrained from wine unless it was for ritual purposes on certain days,[72] two of the more famous of which are the matronal celebration of the December rite of the Bona Dea and the March festival of Anna Perenna.[73] Servius's statement implies both that the restriction had relaxed by his own day and that the consumption of wine for religious purposes had always been acceptable female behavior. Further evidence of women handling wine for ritual purposes comes from Paulus's redaction of Festus's definition of a *simpulum* (455L): "Simpulum vas parvulum non dissimile cyatho, quo vinum in sacrificiis libabatur; unde et mulieres rebus divinis deditae simpulatrices" (A *simpulum* is a small container, not unlike a *cyathus*, from which wine is poured out during sacrifices, and from which women devoted to divine affairs are called *simpulatrices*). The very existence of a category of female religious participants, indeed experts devoted to divine affairs (*rebus divinis deditae*) seriously undermines the argument that Roman women were interdicted from handling wine, especially within a religious context.[74] Outside of a religious context, women drank wine, albeit only those types proper to ladylike conduct: Aulus Gellius tells us that women were accustomed to drink certain sweet wines,[75] and the elder Pliny implies that by the mid-Republic it was acceptable for women to drink wine for medicinal purposes.[76] Archaeological evidence further indicates that women were accustomed to drink wine even in the earliest period: wealthy female tombs from the archaic

period containing ceramics used for storing wine have been found at Castel di Decima and Osteria dell'Osa.[77]

Even if women in the regal period were kept away from the materials of sacrifice (grain, wine, and meat) so that they might not interfere in the affairs of men and gods, such restrictions did not apply to women of the historical period. The language of the literary sources suggests that our authors knew Roman women who drank some kinds of wine on some occasions, including religious celebrations. Furthermore, the sources speak of all the various alimentary interdictions as curiosities of the distant past.[78] If anything, the ancient sources identify women with the production of staple food items, including those important for ritual purposes, rather than suggest they were excluded from handling them. The close association of a Roman matron with the familial *penus* has already been established. Plutarch, our only source for the prohibition on grain and meat, discusses the issue as an archaic oddity.[79] Furthermore, Pliny says that until the first professional bakers arrived in the early part of the second century, bread production had been primarily a task for the women of Roman households (*Nat.* 18.107). Agricultural writers frequently reserve culinary tasks for female slaves. Cato requires the *vilica* to provide food for the *vilicus* and other servants, as well as to grind grain.[80] Varro recommends that the gentleman farmer send women along with the herdsmen to provide their meals — and certain other services as well.[81] Columella includes the production of wine among the *vilica*'s responsibilities.[82]

In the end, there is little reason to believe that Roman women were kept away from the materials of sacrifice in any meaningful or widespread way in the historical period. But could they participate in the act of sacrifice, and in blood sacrifice in particular? Before answering that question it is important to recall that when our sources record a sacrifice (*rem divinam facere*), they do not always tell us what was offered to the gods. To the modern mind animal victims may come most readily, but the Romans offered a wide range of gifts (including incense and horticultural products) to their gods. Another aspect of Roman sacrifice that should be kept in mind is that at a public blood

sacrifice, the officiating magistrate or priest did not usually take part in the slaughtering of the animal: a specially trained professional (*popa*) stunned the animal and another killed it (*victimarius*).[83] Private sacrifices may have involved these same professionals, though economic considerations would likely have prevented their widespread employment: a cursory survey of the inscriptions in *CIL* 6 (inscriptions from Rome) does not suggest that *victimarii* were regularly employed by particular temples for the use of individual worshipers, but were organized as a professional *collegium* akin to the guild of ritual flute players (*tibicines*).[84] In sum, the person "performing" a grand public sacrifice was responsible for leading the procession to the altar, offering prayers, consecrating the victim, and burning the entrails (*exta*) after the animal had been slaughtered. Even a consul or a pontifex who offered a sacrifice *pro populo* was one step removed from the act of killing the victim, the act that may seem to us to be the critical moment of sacrifice.

On a public level, there is no question that the Vestals and other public priestesses could offer sacrifices on behalf of the people, even blood sacrifice as at the matronal celebration in honor of the Bona Dea (where, in fact, we assume the Vestals themselves slaughtered the pig).[85] On other occasions, priestesses took a supporting role in rites officiated by other priests, such as the sacrifice of a pregnant cow by the pontiffs at the Fordicidia in April.[86] Women who were not priestesses could also take part in public sacrifices, as we saw in such collective efforts as the sacrifice to Juno Regina offered in 207 by the matrons of Rome and outlying areas, apparently without any requirement that a man officiate at the ceremony.[87]

Although few literary accounts of women sacrificing in their own right as private individuals exist, the number of references is sufficient to suggest that female-initiated sacrifice — including blood sacrifice — was something familiar to the Romans. For example, Cicero implies that women could sacrifice by day (publicly or privately) without rousing suspicion when he says that he would ban all nocturnal sacrifices by women except those offered on behalf of the Roman people (*Leg.* 2.21.11).[88] Horace instructs the rustic Phidyle to offer incense,

grain, and a pig to the *Lares* (*Carm.* 3.23.1–4). Tibullus wishes that Delia would make offerings to the gods on behalf of his vines, grain crops, and herds (1.5.27–29), although it is admittedly not clear whether she would do so as the mistress of the house or as the narrator's chosen replacement. Juvenal's scorn for a woman who offered wine, cakes, and a lamb to Janus and Vesta is provoked not by the sacrifice itself but because it was grander than the woman's trivial purpose merited: such extravagant gifts would have been proper offerings for a request that her husband or son recover from an illness,[89] but they were too expensive for so ridiculous a question as whether or not her candidate was going to win an artistic competition (6.385–92). Perhaps most important for our purposes is Varro's description of a *rica*, a head covering women wore for the express purpose of offering sacrifice: "quod Romano ritu sacrificium feminae cum faciunt" (*L.* 5.130).[90]

All this suggests that in private circumstances as well as more public occasions, Roman women could offer sacrifices to the gods in their own right, not just as substitutes for the men whose responsibilities such sacrifices properly were. Furthermore, women were not limited to offering horticultural products. They could offer wine and could make blood sacrifices. The argument that women were interdicted from handling the materials of sacrifice rests on slender evidence and is contradicted by numerous literary references that link women with the procurement of wine, grain, and meat. This does not mean, of course, that within the realm of private, domestic ritual, women were equal to men. A wife's authority in religious matters was subordinate to that of her husband. It was his responsibility to ensure that she properly fulfilled her sacred obligations to the household gods. In those few instances where our ancient authors describe sacrifices in which the whole family takes part, the *paterfamilias* is the central figure: his wife and children participate, but it is he who officiates.

Roman women were well integrated into the religious lives of their families, but they did not enjoy the same full range of opportunities for participation as did men. Women had specific ritual obligations within the home, and they participated in observances alongside other family

members. In addition, women were chiefly responsible for ensuring that ritual supplies (incense, *far*, wine) were available when needed. The responsibilites women had within their own homes were paralleled in the public realm by the duties fulfilled by priestesses, especially those of Vesta. As the Vestals were charged with ensuring the divine preservation of Rome, the women of Roman households were charged with the continued prosperity and good fortune of their families.

FIVE

SOCIAL STATUS AND
RELIGIOUS PARTICIPATION

At the beginning of this book, it was pointed out that not all aspects of
Roman religious praxis were open to all Romans: gender, social, and
marital status often dictated what opportunities were available to an
individual. As we have explored the extent of female religious activity
in the republican period, it has become clear that in many cases ritu-
als open to women were not open to *all* women, or at least not to all
women equally. For example, the complex of expiatory rites observed
in 207 in response to the birth of a hermaphrodite comprised different
activities for *matronae* and for *virgines*. Another type of social distinc-
tion was made at the shrine of Patrician Chastity (Pudicitia Patricia)
which was not open to plebeian matrons or to patrician women who
had married into plebeian families, no matter how wealthy and politi-
cally prominent.[1] This chapter examines the role that a woman's social

standing and her marital or sexual status played in determining what avenues for religious participation were open to her.

Priesthoods

As we saw in chapter 2, the female religious officials best documented in literary and epigraphic sources are priestesses. Thus we know more about the role played in social factors in the selection for priestly duty than we do for other, less prominent offices such as those of *magistra* and *ministra*. Interestingly, the main criteria by which individuals were selected for both male and female priesthoods were distinguished lineage and model behavior, although the degree to which the latter was applied differed greatly between men and women. The close link between the prominent political families of Rome and male public priesthoods is well established. Early in the Republic, public priesthoods and political offices were open only to patricians, thus ensuring the traditional oligarchic leaning of religious and civic officials. Even after plebeians were allowed into the major priestly colleges by the end of the fourth century, the colleges retained their elite character. The new plebeian priests were aristocrats with everything but patrician lineage: "non infimam plebem . . . sed ipsa capita plebis" (not the lowest of the plebs . . . but its leaders [Livy 10.6.4]). A prosopographical survey of male priests in the Roman Republic reveals that not only did most of them come from the families of Rome's political elite but that they were themselves men of consular rank, the elite of the elite.[2]

Prosopography is less helpful for female priesthoods because we know the names of very few priestesses. We are best informed about the Vestals, about whom our sources report that they were selected from among the daughters of leading families in the republican period.[3] This appears to have been the case. For example, the three Vestals accused of unchastity in 114 and 113 all bear the names of prominent political *gentes*: Aemilia, Licinia, and Marcia. No family connection is attested for the first of these, but Licinia was probably the daughter of C. Licinius Crassus, tribune of the plebs in 145. Marcia was most likely

the daughter of the praetor of 144, Q. Marcius Rex, and the sister of his son of the same name, the consul of 118.[4] The requirement that the *flamen Dialis* and his wife and the *rex* and *regina sacrorum* be married by *confarreatio*[5] ensured the aristocratic status of those priestesses. This formal ancient rite was probably available only to patricians and, since it required the participation of the *pontifex maximus* and the *flamen Dialis*,[6] was most likely performed for only the most elite Roman families. It is doubtful that such powerful religious officials attended the weddings of nonaristocratic Romans.

Exemplary behavior and pristine reputation were the other major requirements applied to both male and female priests, though with very different standards. For male priests, the standard was set at a fairly low level. Augurs and the Arval Brethren retained their priesthoods no matter how they behaved, although other priests forfeited their religious offices if convicted in court.[7] Incompetence does not appear to have been much of an issue over the course of the Republic. Stories like that of a *flamen Dialis* who relinquished his position after he erred during a sacrifice are rare.[8] Lastly, sexual and marital status do not appear to have been important to male priesthoods: our sources are silent on the subject with regard to most. The exception, of course, is the *flamen Dialis*, who was permitted to be married only once and who was required to resign his office if his wife should die.[9] In his catalog of chaste pagan priests, Tertullian claims that the *pontifex maximus* was also permitted to be married only once.[10] This requirement, however, if it ever existed, was relaxed by the late Republic. Julius Caesar held the office despite his divorce from Pompeia after her (alledgedly) unwitting involvement in the Bona Dea scandal of 62 and his subsequent marriage to Calpurnia.[11]

For women, the standards of priestly behavior were much more stringent and personal. The Vestals were famously chaste: their aristocratic lineage and their age at induction, between six and ten years, essentially ensured their virginal status, which they were required to maintain for the duration of their tenure.[12] Failure to do so resulted in capital punishment.[13] Less severe was the punishment meted out for

failure to fulfill priestly obligations: a Vestal who allowed the goddess's fire to go out could be beaten by the *pontifex maximus*.[14] The *flaminica Dialis* was required to maintain the highest form of marital virtue (she must be a *univira*, a woman married only once), and her activities were circumscribed by the ritual tasks and taboos she shared with her husband.[15]

Aside from these most prominent priesthoods, ancient literary sources provide little information about officials of other cults. One can only speculate about the requirements for such positions, though it might reasonably be conjectured that moral rectitude and distinguished familial links played a part in the selection process for other female cult officials as well. Although we are not certain of the social or marital status of the priestesses of Ceres,[16] Cicero (*Ver.* 4.99) tells us that the *antistitae* who aided those priestesses in daily cult functions at the goddess's sanctuary in Catena, Sicily, were older aristocratic women ("maiores natu probatae ac nobiles mulieres").[17] We do not know if such assistants were employed in Rome as well. With regard to other cults outside the state religion, inscriptions demonstrate that while the social standing of women who held various positions presents a cross section of Roman society, freeborn women generally held more prestigious positions (*sacerdotia*) than women of freed or slave status. Those of lesser rank were more likely to serve as *magistrae* and *ministrae*.

Other Religious Honors

Priestesses of Vesta were chosen in part by the *pontifex maximus*, who selected twenty candidates who then drew lots for the honor.[18] The *flaminica* and the *regina sacrorum* came to their positions as a function of their marriages, again with the *pontifex maximus* selecting both priestly pairs.[19] Other women who were not priestesses but who were given other religious honors, such as the prominent Roman matron who hosted the annual ritual of the Bona Dea, also came by those honors because of their spouses' positions as leading politicians of the day. The same criteria applied to these women as applied to priestesses — lineage

(assured by the prominence of their social position) and exemplary behavior. Again, the aftermath of Clodius's successful infiltration of the Bona Dea's celebration at the home of Julius Caesar in 62 is pertinent. Although Caesar's wife, Pompeia, had been cleared of any impropriety, the taint of suspicion remained, making her an unfit spouse for an important political figure (praetor) in the city.[20] Divorce quickly ensued.

In some instances, the selection of a woman to perform an extraordinary public religious duty did not depend on her husband's position as a member of Rome's political or priestly elite. From a survey of several accounts from the Republic, it appears that the Romans had a somewhat regular practice in such situations. First, the Senate chose a number of women, always *matronae* and numbering as few as ten or as many as all the married women in Rome. Then these women selected from among themselves the woman who would receive the honor. This selection mechanism functions on the same principle, albeit on a much smaller and far more restricted scale, as the regular process whereby men were elected to political office: an individual could only be elected by others in the same general social group. Matrons were selected by matrons to respond, on behalf of the Roman people, to religious crises affecting the feminine sphere. In contrast the Vestal Virgins, public priestesses whose actions *pro populo* were not restricted to responding to prodigies and prophecies pertaining to feminine matters, were selected by the gods themselves through the drawing of lots by candidates selected by the *pontifex maximus*.[21]

The story of the squabble over the establishment of a temple to Fortuna Muliebris is a good example of this process at work.[22] After rejecting the matrons' proposal to found the temple themselves, the Senate made a conciliatory offer to allow the *matronae* to select one of their own to perform the inaugural sacrifice in the new temple. The women settled on Valeria, who had organized the all-female embassy to Coriolanus, which had resulted in the cessation of hostility with the Volscians. Valeria was a woman of action, fine reputation, and renowned family. Plutarch identifies her as one of the most notable women in the city and as enjoying a good reputation (*Cor.* 33.1); Dionysios of Hali-

carnassus says Valeria was distinguished in both her lineage and reputation (8.39.2). Valeria's own service to Rome had been preceded by that of her brother, Publicola, who had been instrumental in freeing Rome from the Etruscan monarchy.

Whether or not the story of the temple of Fortuna Muliebris is historical fact, the details of Valeria's selection match those of other accounts from the historical period. The same process and the same criteria of impeccable reputation and noble descent were used in the selection of Sulpicia to dedicate a statue of Venus Verticordia. Sometime prior to 204, the Senate, on advice from the *decemviri* who had consulted the Sibylline books, determined that a statue of the goddess must be dedicated so that the minds of women and young girls might be turned more easily from lust to chastity: "quo facilius virginum mulierumque mens a libidine ad pudicitiam converteretur."[23] A group of one hundred *matronae* was selected from all the married women in Rome. These were then narrowed by lot to ten. This smaller group nominated Sulpicia, daughter of C. Sulpicius Paterculus (cos. 258) and wife of Q. Fulvius Flaccus (cos. IV 209) for the honor.[24] What distinguished Sulpicia from her colleagues was not only her venerable lineage and the status of her husband but also the outstanding propriety of her behavior: Sulpicia was judged by her peers to be the most chaste.

The same basic mechanism of selection was used twice during the Hannibalic War. The first instance was part of the action taken in response to the lightning strike at the temple of Juno Regina in 207 that resulted in the matronal offering to the goddess. After the *haruspices* interpreted the omen as pertaining to matrons, the curule aediles instructed the married women of Rome and the outlying areas to select twenty-five of their number to collect funds for a donation to Juno Regina.[25]

Three years after the donation to Juno Regina, Claudia Quinta was chosen as the female counterpart to P. Cornelius Scipio Nasica in welcoming the Magna Mater to Rome. The version of the tale most familiar to modern audiences is actually a pastiche of accounts in Livy and

Ovid:[26] after consulting the Sibylline books, the Roman Senate decided to bring the Magna Mater, or rather a black stone that represented her, to Rome from Asia Minor. When the goddess's ship arrived at the mouth of the Tiber, she was to be met by Nasica, who had been selected by the Senate as the *vir optimus* of Rome, and the most respectable women of the city. Claudia had been excluded from this group because her reputation was not beyond suspicion. Along the goddess's journey up the Tiber, the barge carrying her image ran aground. Claudia came forward, proclaimed that if she were chaste the goddess would follow her to Rome, and then hauled the ship all the way to the city. Claudia's reputation for virtue was assured forever after.

There is reason to suspect that this version of the story was not the only, nor the earliest, one. Republican sources, Cicero and Diodorus, speak of Claudia as a well-known model of feminine virtue and suggest that she was the Senate's choice for a counterpart to Nasica.[27] Only imperial authors claim that Claudia's *castitas* was suspect.[28] Ovid tells us that the popular, revised account was performed on stage, presumably at the annual festival in honor of the Magna Mater, suggesting that the story had been altered for dramatic effect.[29] An altar from Rome, tentatively dated to the reign of Tiberius, depicts the theatrical version of the tale with Claudia pulling the goddess's boat behind her, underlining the popularity of this story in the early imperial period.[30] It is possible that this ribald version was even actively promoted in the imperial period. It certainly makes good theater and heightens the role of the Claudian family in the goddess's arrival.[31] In all likelihood, Cicero's and Diodorus's presentation of Claudia is closer to the truth. Claudia and Scipio Nasica were selected to welcome the Magna Mater to Rome on the basis of their unblemished reputations and their ties to opposing political families.[32]

Religious and Social Division

The official organization of exclusively female rituals has been interpreted as special efforts by Roman leaders to manipulate and control

the female population. The idea is not a new one. In 1911 Fowler wrote of the matronal offering to Juno Regina in 207, "Doubtless it was all part of a deliberate policy to keep the women of the city in good humor, and in touch with the religion of the State, instead of going after other gods, as they already had gone and were again to go with amazing and perilous fervor."[33] More than sixty years later, Pomeroy interpreted the same matronal offering as a forced confiscation, rather than as eager participation under the direction of religious officials.[34] Sounding the same theme on a grander scale, Kraemer argues, "The methods chosen to limit and regulate women's autonomy combined the passage of legislation with the establishment of religious shrines and rites that expressed and reinforced the expectations of elite Roman men for elite Roman women."[35]

There is little question that exclusively female rites functioned in this way, as did nearly every other rite observed by the Romans. The importance of ritual in simultaneously strengthening social distinctions and integrating different groups into society as a whole was not limited to women but applied to all Romans. Across the spectrum, the division of religious responsibility generally reflected the stratification of Roman society along the lines of social status (citizen or noncitizen; patrician or plebeian; free, freed, or slave) and sexual (or marital) status, this last division with particular significance for women. Articulation of these categories was so important to the Romans that they were reinforced on a daily basis by distinct clothing and even by the seating arrangements at public entertainment, where the audience was seated according to gender, class, and occupation.[36]

To the Roman mind, the relationship between social and religious divisions was so close that membership in a particular social group frequently entailed obligatory participation in special rites. For example, Roman *curiae*, one of the basic political divisions of citizens at Rome, had their own gods and their own festivals.[37] The close relationship between social and religious groupings is demonstrated especially well by those instances in which several distinct groups participated in concert. A particularly good example comes from Macrobius who, citing

the augur Marcus Laelius,[38] records a combined *obsecratio* and *lectisternium*, which, under priestly direction, was funded by freedwomen of good standing ("libertinae . . . quae longa veste uterentur, in eam rem pecuniam subministrarent") and celebrated by boys of freeborn and freed status, while young, unwed girls whose parents were still alive offered a special hymn.

Without a doubt, religious ritual was an effective tool for channeling female energy and for reinforcing the categorization of women within Roman society. The division of women into groups for collective worship was often structured on the basis of sexual status, as we have already seen in the groups who took part in the rites of 207 (*virgines* and *matronae*). A range of annual observances, such as the Matronalia and the December ritual of the Bona Dea, were restricted to *matronae*, women who exemplified the Roman feminine ideal of fertility properly employed in legitimate childbearing. In the cults of Pudicitia, Fortuna Muliebris, and Mater Matuta, only women who had been married once (*univirae*) were permitted to approach the goddesses' statues.[39] Concubines (*paelices*) were forbidden to touch the temple of a Juno, which one we are not told.[40] Prostitutes figured prominently in the April celebration of the Floralia and worshiped Venus Erycina only at her temple outside the Colline Gate on the Vinalia.[41]

Social status was also a factor, albeit less frequently, in determining eligibility for inclusion in certain rites. In 217, after the *matronae* of Rome made a dedication to Juno Regina, they and the freedwomen of the city made a joint dedication to Feronia.[42] Slave women were generally excluded from the Matralia, the June festival of Mater Matuta, though a single female slave was brought into the temple for the express purpose of being beaten and then driven out.[43] Such a ritual pointed up the distinction between freeborn women and slaves even more so than a simple interdiction on servile participation. In contrast to their exclusion from the Matralia, slave women were especially honored at the July rites of the Capratine Nones at which they wore festive clothing, offered sacrifice, feasted outdoors, and participated (alongside men) in mock battles and other holiday activities.[44]

The combination of marital and broader social divisions among Roman women is sometimes manifested on a larger scale by paired cults. In Livy's account of the shrines of Patrician and Plebeian Chastity (10.23.1–10), social distinction sparks religious division. In the course of a *supplicatio* ordered by the Senate, a squabble erupted in the shrine of Pudicitia Patricia over whether a patrician woman who had married a plebeian might still participate in rites restricted to patrician matrons. In response, the patrician woman at the center of the controversy established a shrine to Pudicitia Plebeia in her home, where rituals nearly identical to those in the patrician shrine ("eodem ferme ritu") were observed by plebeian *matronae*.[45]

Another example of paired cults reinforcing marital and social divisions is the celebrations held on the first of April in honor of Venus Verticordia and Fortuna Virilis. On the same day that *matronae* washed and dressed the statue of Venus Verticordia, the goddess whose responsibility was to ensure that women remained chaste, lower-class women went to the baths to expose themselves to Fortuna Virilis, who was charged with removing physical blemishes so that women might be more attractive to men.[46]

Female religious activity could also reflect social and financial status in an informal way. From Polybius, writing in the middle of the second century, we get a rare glimpse of how a high-ranking aristocratic lady could advertise her position in society through her participation in religious rituals observed outside the domestic context. Aemilia, the wife of the great Scipio Africanus and the adoptive grandmother of Polybius's close associate P. Cornelius Scipio Aemilianus, was famous for the extravagance she displayed when she attended the public ceremonies that were open to women.[47] Not only were her clothes and her carriage remarkable for their luxury, but she was also known for the large number of attendants (male and female) that made up her entourage and the gold and silver religious items they carried with them (baskets, cups, and other implements). No terracotta libation cups for the widow of the most powerful man of his day. Upon Aemilia's death, Aemilianus received a large inheritance from her, including all her

ritual paraphernalia, which he in turn bestowed on his mother, Papiria. Papiria, Polybius tells us, had long been without the means to live according to her rank, and so had not been an active participant in public life. Once she came into possession of Aemilia's carriage, horses, attendants, and all the rest of the ritual accoutrements, Papiria again attended public rites.

Each of the individuals in this story was aware of the power and social importance of displays of conspicuous consumption within a religious context. The distinguished Aemilia was so closely identified with her religious extravagance that when Papiria finally appeared in public, the other women in attendance immediately recognized the carriage and the other trappings as having been Aemilia's. It was sufficiently important for an aristocratic woman to "look the part" at sacrifices and other rites that Papiria preferred to stay home rather than attend in a style unbecoming to her elevated social position. Furthermore, Aemilianus saw the benefit to himself from such a magnanimous gesture. Polybius says that his generosity was noted by the women of Rome, who began to pray for his continued success, and that this was the beginning of his reputation for nobility and virtue.

In the Roman world, women were vital participants in the religious lives of their families and of their communities. This is true in both senses of "vital": their role was both active and essential in a range of rites and cults that addressed both conventional feminine concerns and matters outside the traditionally feminine realm. Yet even within this broader range of religious experience and participation, all rites and offices were not open to all women. Her status — whether a woman was married or not, whether she was or had been a slave or was a freeborn person — determined what religious offices were open to her, what parts she might play in particular observances, and, in some cases, even which rites or cults she might attend. Additional avenues for participation could be opened or closed based on her private behavior, reputation, and family background. In every instance, a woman's religious activity outside her home advertised to those around her the

position she held in her community. Conversely, the source of advertisement could be a woman herself, as in the case of Aemilia's golden *pocula*, the inscriptions recording female-sponsored refurbishment of religious spaces, or, in an earlier age, the richly adorned statues from ancient Lavinium.

CONCLUSION

In the past thirty years, scholars have turned their attention to recovering what can be known about the lives of Roman women. The result of these efforts indicates that Roman women no longer appear to have existed only on the fringes of Roman society. A long series of studies has fleshed out the details of Roman domestic life, traced the role of women in the Roman work force, examined the effects of Roman law on feminine affairs, and demonstrated the importance of aristocratic women as community benefactors and as actors, albeit in an unofficial capacity, in the political maneuvering of local and imperial government.

The present study has argued that religion is another area of daily life in which Roman women took an active role in both the private and public spheres. The Vestal Virgins did not stand alone, but were instead the most prominent members of a group of women who held

high-profile positions in the religious life of Rome: priestesses of Ceres, Liber, and Venus; the *flaminica Dialis* and the *regina sacrorum*; *magistrae* and *ministrae* of other cults; and aristocratic matrons who hosted rites, dedicated statues, and organized large-scale donations of gifts to the gods. Women worshipers in general were not restricted to exclusively female rites that addressed only traditionally feminine concerns. Rather, they were essential participants in a wide range of rituals that had civic and political import in addition to observances that addressed matters of marriage, childbirth, and the continued well-being of loved ones. Women and men worshiped the gods together, perhaps as often as they worshiped them separately, and they addressed to the gods many of the same concerns. As with other areas of Roman social history where studies of the specific roles of women have been integrated into the wider field, so, too, it is hoped, will the conclusions drawn here expand and refine our understanding of Roman religion itself. In the end, the picture that emerges is of a religion of greater flexibility and inclusiveness.

NOTES

Abbreviations

Some works cited in this study are noted with the following abbreviations. All journal citations in the bibliography follow the abbreviations in *L'Année Philologique*.

AE	*L'Année Épigraphique*. Paris: Presses Universitaires de France, 1888–.
CB, CE	Inscriptions from Cosa, as noted in F. Brown's excavation notes from 1948–54. Inscriptions are cited according to the excavation reference number and year of discovery. Excavation notes are at the American Academy in Rome.
CCCA	M. J. Vermaseren, *Corpus Cultus Cybelae Attidisque*. 7 vols. Études Préliminaires aux Religions Orientales dans l'Empire Romain, 50. Leiden: Brill, 1977–89.
CIL	*Corpus Inscriptionum Latinarum*. Berlin: de Gruyter, 1863–.

Civiltà	*Civiltà del Lazio primitivo.* Rome: Multigrafica, 1976.
Enea	*Enea nel Lazio: Archeologia e Mito.* Rome: Fratelli Palombi, 1981.
Forcellini	A. Forcellini, *Lexicon Totius Latinitatis.* 6 vols. Prati: Aldina Edente, 1867–87.
ILLRP	A. Degrassi, *Inscriptiones Latinae Liberae Rei Publicae.* 2 vols. Florence: La Nuova Italia Editrice, 1957–63.
ILLRP Imagines	A. Degrassi, *Inscriptiones Latinae Liberae Rei Publicae Imagines.* Berlin: de Gruyter, 1965.
ILS	H. Dessau, *Inscriptiones Latinae Selectae.* 3 vols. Berlin: Weidmann, 1892–1916.
LIMC	*Lexicon Iconographicum Mythologiae Classicae.* 8 vols. Zurich: Artemis, 1981–99.
LSAM	F. Sokolowski, *Lois sacrées de l'Asie Mineure.* École Française d'Athènes, Travaux et Mémoires des Anciens Membres Étrangers de l'École et de divers savants, 9. Paris: De Boccard, 1955.
LSJ	H. G. Liddell, R. Scott, H. S. Jones, and R. McKenzie, eds. *A Greek-English Lexicon.* 9th ed. Oxford: Clarendon Press, 1968.
LTUR	E. M. Steinby, ed. *Lexicon Topographicum Urbis Romae.* 6 vols. Rome: Quasar, 1993–2000.
LTUR-S	A. La Regina, ed. *Lexicon Topographicum Urbis Romae: Suburbium.* 2 vols. Rome: Quasar, 2001–.
MRR	T. R. S. Broughton, *The Magistrates of the Roman Republic.* 3 vols. New York: American Philological Association, 1951–52.
OGIS	W. Dittenberger, *Orientis Graeci Inscriptiones Selectae.* 2 vols. Leipzig: S. Hirzel, 1903–5.
OLD	P. G. W. Glare, ed. *Oxford Latin Dictionary.* Oxford: Clarendon, 1968–82.
RE	*Paulys Real-encyclopädie der classischen Altertumswissenschaft.* Stuttgart: Metzlerscher, 1894–1972.
RMR	*Roma Medio Repubblicana: Aspetti Culturali di Roma e del Lazio nei secoli IV e III A.C.* Rome: Assessorato Antichità, Belle Arti e Problemi dell Cultura, 1973.
TLL	*Thesaurus Linguae Latinae.* Leipzig: Teubner, 1900–.

Introduction

1. Several good introductory discussions of the nature of Roman religion are available, including Scheid 2003a; Turcan 2000; Beard, North, and Price 1998; and Scullard 1981.

2. Wissowa 1912; Altheim 1938; Rose 1959 (esp. on domestic cult); Latte 1960; Beard, North, and Price 1998. Roman women also appear in comparisons of female religious participation across several ancient religions (including ancient Greek worship, as well as Judaism and early Christianity), such as Kraemer 1992 and, less satisfactorily, Sawyer 1996. Religious matters are also treated in more general works on ancient women: Balsdon 1962; Pomeroy 1975; Fantham et al. 1994; and Fraschetti 2001.

3. E.g., Brouwer 1989 and Spaeth 1996.

4. Bendlin 2000 persuasively proposes a marketplace model for Roman religious pluralism in the Republic.

5. *Res Gestae* 13 and 19; Dio 52.36.1–2. Nock 1972; Syme 1939, 256 and 411–12; Zanker 1988, 101–35; Beard, North, and Price 1998, 1.167–210.

6. Caesar's efforts were directed at, and limited to, promoting his own divine lineage: Nock 1972, 19, n. 17; Meyer 1919, 508–30; Weinstock 1971, 80–132.

7. See, e.g., Boëls-Janssen 1993, 1–2, and Scheid 1992 and 2003b.

8. The difficulty in applying these terms to Roman religious practice can be seen in, to take just a single example, Richlin's (1997) wide-ranging and useful survey of evidence for the women's religious activity. Despite her efforts to limit the discussion to "women's religion," Richlin acknowledges the participation of men in "women's cults" and of women in cults not restricted to female participants.

9. Also the demands of genre. See Dixon 2001, 16–25, for an extended discussion of the hazards of failing to identify the importance of genre in shaping the nature of the information available to us. Her comments may be extended to the interpretation of other categories of evidence as well, especially epigraphic material.

10. Scheid 1992, 377. He refers here to *The Tongue Set Free*, the first volume of the autobiography of Elias Canetti, winner of the 1981 Nobel Prize for literature. All three volumes of Canetti's account of his youth in early twentieth-century Europe are now available in a single English-language volume, *The Memoirs of Elias Canetti* (New York: Farrar, Straus and Giroux, 1999).

11. Indeed, it is not difficult to find opposite interpretations of this same circumstance. One recent example is Tamar Frankiel, whose own involvement

in orthodox Judaism came late in life: "I found utterly incomprehensible [the Orthodox women's] rationale for accepting this ancient way of life, but I saw that they were sincere. Moreover, I saw that they were, indisputably, powerful and influential in their families and communities. As I grew to know them, my first feelings of condescending pity toward these victims of patriarchy changed to admiration and wonderment" (Frankiel 1990, xi).

12. Canetti 1999, 22-26.

13. The debate over the nature and reliability of ancient historiography is rather extensive and ever-growing. A selection of some of the most important, recent treatments includes: the contributions by Raaflaub ("The Conflict of the Orders in Archaic Rome: A Comprehensive and Comparative Approach") and Cornell in Raaflaub and Cornell 1986; Woodman 1988; Wiseman in Gill and Wiseman 1993; Cornell 1995, 1-30; Oakley 1997-98, 1.3-108 (esp. 100-104). For a concise summary of the major schools of thought on the issue, see Kraus and Woodman 1997, 1-9.

14. E.g., Sallust, *BC* 5.9, and Livy, *praef.* 9-10.

15. E.g., Beard, North, and Price 1998, 1.1-18.

16. See Cornell 1991 for a more extensive treatment of this issue. Beard's (1991) discussion of the importance of writing, including "bureaucratic" record keeping, in Roman religion focuses on the late republican and imperial periods, though the main thrust of her argument may be applied to earlier periods of the Republic as well.

17. Lowe 1978, 141; Castagnoli 1980, 165. See Kampen 1981, Forbis 1990, and Dixon 2001 for reflections on the differences between value structures represented in epigraphic and literary sources.

18. The main area over which the terracotta-filled deposits are scattered extends northward into Etruria as far as Volsinii and Vulci, eastward from Rome throughout Latium, as well as into parts of Umbria and the territory of the Sabines and Aequi, and as far south as Capua (Comella 1981, 768-69, esp. figure 3). Deposits of this type have also been found outside the general area of distribution. Such occurrences have long been thought to follow the pattern of Roman colonization of the Italian peninsula, although this view has recently been called into question (Glinister, forthcoming).

19. Comella 1981, 758.

20. Spaeth 1996, 11-13.

21. North 1976.

22. For a day-by-day account of public ceremonies observed during the re-

publican period, see Scullard 1981. This work offers a basic summary and extensive ancient references for the festivals mentioned below.

23. The distinction is an ancient one. See, e.g., Livy 1.20.6; Cic., *de Har. Resp.* 14; and Festus 284L, s.v. "publica sacra."

24. Again, see Scullard 1981, 58–60 for the basic references. The most famous evidence for the familial nature of this observance comes from Cicero's letters to Atticus (*Att.* 2.3 and 7.7 = Shackleton Bailey 1965–71, 23(II.3)4 and 130(VII.7)3).

25. Goldsmiths: *ILLRP* 110 = *ILS* 3683d. Cattle or sheep dealers: *ILLRP* 106 = *ILS* 3683c = *CIL* 1².1450 = *CIL* 14.2878. Money changers: *ILLRP* 106a. Childbirth: *ILLRP* 101 = *ILS* 3684 = *CIL* 1².60 = *CIL* 14.2863; see below, chapter 2.

26. E.g., Walsh 1997, 165; Boëls-Janssen 1993, 271 and 472–73; Gagé 1963, 131–37.

27. Such as Champeaux 1982, 341–60, and Mustakallio 1990, 130–31.

28. Livy 39.8.6, 39.13.10–14, 39.15.9 and 12–14.

29. Flower 2002.

30. The landmark studies in this field are Fenelli 1975 and Comella 1981, now supplemented by Turfa 2004 and F. Glinister's forthcoming article on religious Romanization in the early Republic.

31. The last general study was De Marchi 1896–1903, although aspects of domestic ritual have been studied, e.g., Harmon 1978b and Boëls-Janssen 1993, 229–71.

32. *Contra* Minieri 1982 and de Cazanove 1987.

33. Brunt 1988, 92.

Chapter 1

1. Fowler 1911, 324–25. Livy (25.1.6–8) reports that there was a rise in supersitious practices among the populace, unnerved by the war with Hannibal that seemed to drag on without any progress toward resolution.

2. Balsdon 1962, 246.

3. Pomeroy 1975, 209. For a more extensive consideration of Livy's treatment of attitudes toward marriage and Augustus's marriage legislation through the episode of the rape of the Sabine women, see Miles 1995, 179–219, esp. 213–19.

4. Kraemer 1992, 52.

5. Koep (1962) traces the shift in meaning of *religio* and *ritus* as the terms move from a pagan to Christian context. For a more extended treatment on the interpretation of ritual ("Ritual is what there was"), see Price 1984, 7–11.

Price's introductory chapter also includes an excellent discussion of the influence of Christian concepts in the study of Roman history (11–16). The use of the terms *cultus*, *ritus*, *religio*, and *sacrum* among classical authors deserves separate study, some of which is now available in Bremmer 1998.

6. *OLD*, s.v. "ritus" and "cultus."

7. A *matrona* was a freeborn married woman who was easily identifiable by her dress: "matronas appellabant eas fere, quibus stolas habendi ius erat" (as a rule they call those women "matrons" who have the right to wear the stola [Fest. 112L, s.v. "matronas"]). The category of *matrona* is frequently juxtaposed against other categories of women within Roman society, for example, *virgines* (Livy 27.37.7–15) and *meretrices* (prostitutes; Pl., *Mil.* 790–93, *Mos.* 190, *Cas.* 585, and *Cist.* 78–80; Hor., *Ep.* 1.18.3). Freedwomen are not *matronae*, at least for religious purposes (cf. Macr., *Sat.* 1.6.13–14 and Livy 22.1.18). That women from different, free strata of Roman society could be called *matronae* may be implied by such phrases "matronae primores civitatis" (leading matrons of the city [Livy 29.14.12]). It seems clear that *matrona* does not always refer exclusively to upper-class married women. That said, the reader should bear in mind that our authors were most familiar with women of their own (i.e., wealthy) class, and therefore the depiction of *matronae* in the ancient sources is skewed toward the activities of affluent women. For further discussion and references, see Forcellini 3.39, s.v. "matrona." A more extensive examination of the meaning of *matrona* can be found in Treggiari 1991, esp. 7. Cf. Staples 1998, 56 and 72–80. Given that the ritual observed in honor of the Bona Dea took place in the home of a senior public official, the evening could not possibly have included all, or even most, of the married women in the city: it must have been restricted to the most prominent ladies of Rome.

8. Staples 1998, 51.

9. E.g., *CIL* 1².972 = 6.59 = 6.30688 = *ILS* 3491 = *ILLRP* 56 = Brouwer 1989, 29–30, no. 15 and *CIL* 1².1793 = 9.3138 = *ILLRP* 57. For further discussion, see chapter 2.

10. A more extensive discussion found in Schultz, forthcoming.

11. Livy 8.14.2. Cf. Cic., *Mur.* 90. For a summary of relevant bibliography prior to 1953, see De Sanctis 1907–64, 4.2.2.139–43. A republican inscription from Lanuvium (*CIL* 1².1430 = 14.2090 = *ILS* 3097 = *ILLRP* 170) reveals the goddess's full name. Elsewhere, she is referred to by the abbreviation I.S.M.R. (*ILS* 316, 5683, 6196), suggesting that her name, complete with all four elements, was commonly recognized. The cognomen *sispes* is attested epigraphi-

cally; the variant Sospita is the result of later efforts to derive Juno's epithet from the Greek σωτήρ (R. Palmer 1974a, 30. Ernout and Meillet 1959, 638, s.v. "*sospes*"; cf. Paul., *Fest.* 389L, s.v. "*sospes*," and 462L, s.v. "*sispitem*.") On citizenship awarded to Lanuvium, see Heurgon 1973, 200.

12. Shrine: Ov., *Fast.* 2.55–59. Temple: Livy 32.30.10 and 34.53.3. At 34.53.3 Livy identifies the temple as belonging to Juno Matuta. This is doubtless an error as Juno Matuta is otherwise unknown, and Livy also mentions that this was the temple vowed four years earlier by the consul Gaius Cornelius, meaning that he must be referring to the temple of Juno Sospita founded in 194. Cf. Briscoe 1973, 227; Scullard 1981, 70–71; Orlin 1997, 63–64; F. Coarelli, *LTUR* 3.128–29, s.v., "Iuno Sospita (in Foro Holitorio)." Livy's statement may arise from the confusion of two neighboring temples: Juno Sospita and Mater Matuta both had temples at the foot of the *vicus Iugarius* where it entered the Forum Holitorium after descending the Capitoline. See Coarelli 1992, 205–53; Richardson 1992, 217–18 and figs. 37 and 38, s.v. "Juno Sospita, Aedes." Further cult sites may be implied by Julius Obsequens 55 (*templa foedarentur*). Ovid's statement that Juno Sospita had a temple next to that of the Magna Mater on the Palatine (*Fast.* 2.55–56) may be further confusion of the Great Mother with Mater Matuta (De Sanctis 1907–64, 4.2.2.140, n. 51). Recently, however, scholars have identified either of two *sacella* uncovered near the temple of the Magna Mater as Ovid's Palatine temple of Juno Sospita (F. Coarelli, *LTUR* 3.129–30, s.v. "Iuno Sospita [Palatium]" and addendum 5.269; see also Rüpke 1995, *contra* Ziolkowski 1992, 77–79).

13. Many of the groups involved in the Latin War also took part in the Social War, although not necessarily in the same relationship to Rome. For example, the Marsi, who had been loyal to Rome during the Latin and Hannibalic wars, were among Rome's leading opponents in the Social War. For Marsian alignment during the Latin War, see Livy 8.6.8; Diod. 20.44.8 and 20.101.5. Hannibalic War: Livy 28.45.19. Social War: Vell. 2.15.1, 2.21.1.

14. Coarelli 1996, 382–417; Chiarucci 1983, 166–87.

15. One further inscription, purporting to be an epitaph of a priestess of Juno Sospita on a cinerary urn now in the National Gallery of Scotland in Edinburgh, has sometimes been cited in discussions of the cult despite suspicions of counterfeit that arose soon after the urn came to light in the nineteenth century. The urn has now been decisively labeled a late forgery on the basis of a paleographic examination. For further discussion, see Schultz forthcoming.

16. Hänninen 1999a, 35–36; Walsh 1997, 165; Boëls-Janssen 1993, 271 and 472–

73 (not to the exclusion of political and defensive functions); Gordon 1938, 28 (though he does not see this aspect of the goddess as relevant to the ritual in the cave at Lanuvium [p.38]). Dumézil 1970, 298, implies close parallels between the cult of Juno Sospita and Juno Lucina. See next note.

17. R. Palmer 1974a, 37. Vesta Mater: Cic., *Font.* 47, *Dom.* 144, *Har.* 12; Verg., *G.* 1.498; Sen., *Con.* 4.2. Mars Pater: Cato, *Agr.* 141; Liv. 3.61.5, 8.9.6; Prop. 3.4.11; Ov., *Ars* 1.203 and 2.563, *Fast.* 5.465; Serv., *A.* 3.35. Vesta Mater and Mars Pater (among others): *ILS* 5035 = *CIL* 6.2074 = *CIL* 6.32371. See also Lucil. 1.19–22 (Marx 1904–5, 1.4) *apud* Lact., *Div. Inst.* 4.3.12 and Ov., *Fast.* 4.828.

Dumézil (1970, 298) asserts that "placed as it is in the second position, the word *Mater* cannot simply be the lofty honorary title which it or its masculine equivalent is in such expressions as Mars Pater or Vesta Mater; it has to have its full meaning, and it reminds us that the feasts of the Roman Lucina are called *Matronalia*: fertility feasts for the participation of women who are both wives and mothers." Although Marouzeau does not speak directly to this particular issue in his extensive survey of Latin word order, he concludes that the motivation for changing the order of a common phrase—here Juno Sospita Mater instead of the expected Juno Mater Sospita—was the desire to emphasize the word that fell in an unexpected place (Marouzeau, 1922–38, 1.219–22). Throughout Marouzeau's survey, the position of a word within a phrase is linked to its importance within that phrase; nowhere does Marouzeau suggest that a shift in position necessitates a shift in meaning. In the case of the Lanuvine Juno, her worshipers felt that her aspect as *Sospita*, whatever its meaning, was the most important of her epithets.

18. See also Aelian, *NA* 11.16. The account of Juno's rite in Propertius 4.8 is in keeping with the theme of rites, days, and the ancient names of places ("sacra diesque . . . et cognomina prisca locorum" [4.1.69]) that the poet claims for his fourth book. Despite his claim to the contrary, Propertius is unable to break cleanly away from the proper stuff of elegy, hence 4.8 develops into a tale of lovers.

19. Crawford 1974, 439–40 [412/1]. For consideration of Juno Sospita's appearance on the coins of Q. Cornificius in her capacity as a military deity, see Fears 1975, 595–97. Rawson (1991a, 281–83) rightly disagrees with Fears's assertion that the goddess was a patron of Carthage. Richardson (1977, 462) identifies military imagery and the theme of "purity and elegance versus dirt and impurity" in his introductory note to Propertius 4.8, but does not draw a connection to the cult of Juno Sospita.

20. Obs. 55. See Frazer 1929, 2.300; Balsdon 1962, 249; Dumézil 1970, 430–31. Scullard clearly relies on Obsequens's account, though he does not cite it (1981, 71 and n. 72: N.B., the citation here should read *Div.* 1.99, not 4.99).

21. Prostitution: Pailler 1997, 518; Dumézil 1970, 430–31. Latrine: Balsdon 1962, 249.

22. Many scholars have attempted to emend the text, with no success. Looking at the text as it stands, *obscenus*, "boding ill, unpropitious," is most often used in a religious context in republican and early imperial sources, particularly with reference to negative omens (*OLD*, s.v. "obscenus"). Livy himself uses *obscenus* sparingly: only four times in the extant books, most often referring to prodigies (31.12.6) or to Bacchic ritual (39.11.7, 39.15.13) in contexts that imply some sort of sexual transgression, though not necessarily prostitution. The fourth occurrence of *obscenus* refers to a group of *mollibus viris* (effeminate men) who are suspected of murdering the Boeotarch Brachyllas (33.28.5), and thus conforms to the secondary meaning of the adjective as "immodest or offensive to a sense of propriety." This secondary meaning is increasingly common in the imperial period and would both have been familiar to Obsequens and appealed to his delight in the unsavory. *Sordidus*, "filthy," most commonly refers to unclean clothing (indeed this is the standard Livian usage) though the word can be used to mean "foul" or "scandalous" or even "ignoble" (*OLD*, s.v. "sordidus"). If the text accurately records Livy's own words, then it is possible (but not certain) that the passage refers to a failure on the part of matrons to cleanse themselves properly before or after performing a ritual, or to the performance by matrons of a rite that they should not have undertaken. At the very least, the text does not require the sensational interpretation it is sometimes given.

23. Pease 1920–23, 52–53 and 275. Caecilia's father, Balearicus, was consul of 123 (*MRR* 1.512–13, s.a. 123). Her husband was Appius Claudius Pulcher (*MRR* 2.82, s.a. 79) and her son, the infamous P. Clodius, tribune of the plebs in 58 (*MRR* 2.195–96, s.a. 58). On Sisenna and his treatment of dreams, see Rawson, 1991b, 380–82.

24. Religious matters are generally outside the scope of studies by Salmon 1967, 335–79 (down through Sulla's dictatorship); Gabba 1976, 70–130 and 214–50; Gabba 1994; Brunt 1988, 93–143; Mouritsen 1998; Wulff Alonso 2002. The catalog of portents in Heurgon's (1959) treatment of the prophecy of Vegoia does not include Caecilia's vision.

25. Beard 1990, 30–34.

26. Cic., *Har.* 18, *Div.* 1.99; Plin., *Nat.* 2.199, 7.34–35, and 8.221; Julius Obsequens 54; Orosius 5.18.3–9. See also Augustine, *Civ. Dei* 3.23. The prophecy of Vegoia is generally thought to date to this period: Heurgon 1959, 43–44; Pfiffig 1975, 157–59; Valvo 1988, 103–4; Haynes 2000, 384. Scholarly opinion on the matter, however, is not unanimous: Harris 1971, 31–40; Turcan 1976; North 2000, 99.

27. Cic., *Div.* 1.99; Plin., *Nat.* 8.221. Pliny's assertion that the shields were silver indicates their ritual function.

28. See Flemming, forthcoming, for further discussion.

29. Halkin 1953, 9–13. From Livy alone we know of more than sixty separate public *supplicationes*. See Lake 1937, 250–51, for a partial catalog of references.

30. Wissowa 1912, 424–25; Latte 1960, 245; Scullard 1981, 21.

31. The all-inclusive *supplicationes* can be found at Livy 10.23.1–2, 22.10.8, and 27.51.8 respectively. *Virgines* and *ingenui*: Livy 37.3.6 and Obs. 1. For male and female participation in the *Ludi Saeculares*, see Phlegon, *Macr.* 5.2(99) second oracle, lines 18–32.

32. On the importance of communal participation in *supplicationes*, see Bendlin 2000, 125–26.

33. That is, with heads uncovered. Latte 1960, 214; Haug, *RE* 8.565–66, s.v. "Hercules"; Scheid 1995.

34. No other republican *supplicatio* is explicitly identified as exclusively female. It is possible that a *lectisternium* — a ritual at which images of the gods or objects representing them were laid out on couches so that the gods might enjoy a communal meal — held in 217 may also have been restricted to female participants but Livy's Latin is ambiguous, suggesting that either the historian or his sources were uncertain:

> Decemvirorum monitu decretum est Iovi primum donum fulmen aureum pondo quinquaginta fieret, Iunoni Minervaeque ex argento dona darentur et Iunoni reginae in Aventino Iunonique Sospitae Lanuvi maioribus hostiis sacrificaretur, matronaeque pecunia conlata quantum conferre cuique commodum esset donum Iunoni reginae in Aventinum ferrent lectisterniumque fieret, et ut libertinae et ipsae unde Feroniae donum daretur pecuniam pro facultatibus suis conferrent. (22.1.17–18)
> [On a warning from the Board of Ten Men, it was decreed that, first, a golden thunderbolt weighing fifty pounds should be given as a gift to Jupiter. Then gifts of silver should be given to Juno and Minerva, and large victims should

be offered to Juno Regina on the Aventine and Juno Sospita at Lanuvium. After a collection had been taken up (each donating as much as was appropriate), the matrons should give a gift to Juno Regina on the Aventine and a lectisternium should be held, and that they (the matrons) and the freedwomen should take up a collection (each giving as much as she was able) and give a gift to Feronia.]

In Livy's prose, the *lectisternium* is closely linked to the preceding mandate by the *-que* and is bracketed by two orders directed specifically at women, implying that these actions were all subsections of a general portion of the decree. The impersonal nature of *fieret*, however, makes it impossible to decide conclusively. R. Palmer (1974a, 25) accepts the *lectisternium* as exclusively female.

35. Wissowa 1912, 423–26; Latte 1960, 245–46. Lake (1937, 250–51) does not claim that her catalog is comprehensive, so such an omission may simply be an oversight and should not be understood as an indication of her opinion on the status of this particular celebration.

36. Halkin 1953, 11.

37. Halkin 1953, 115–29.

38. The panic of 211 is described in Livy 26.9.7–8 and Silius Italicus 12.545–51. The poet mentions only the hysteria of women, but does not describe them as flooding the temples and shrines of the city. Female panic in the crisis of 49 appears in Lucan 2.28–42.

39. Livy, 5.18.11. Halkin 1953, 9; Dumézil 1970, 570; Wissowa 1912, 425, nn. 8 and 9. This notion is based on a passage from Festus (206L, s.v. "ob vos sacro") that records an unusual word order found in certain prayers: "Ob vos sacro, in quibusdam precationibus est, pro vos obsecro, ut sub vos placo, pro supplico" (In certain prayers, [the phrase] "entreat you I do" is used in place of "I entreat you," just as [elsewhere is used] "beg of you I do" instead of "I beg you"). While this passage from Festus demonstrates a peculiar parallel use of *obsecro* and *supplico* in prayer formulae, it does not indicate that the terms *obsecratio* and *supplicatio* refer to the same ritual. The identity of the *supplicatio* with an *obsecratio* is further disproved by three passages in Livy where an *obsecratio* and a *supplicatio* are listed side-by-side in other catalogs of official expiatory actions, thus indicating that the two terms are distinct elements of a technical religious vocabulary now largely lost to us (Livy 27.11.6, 31.9.6, 42.20.3). The subtle distinction between the two rituals cannot be recovered. The entry for "obsecratio" in *TLL* (9.174–75) does not suggest that the two terms are interchangeable.

40. For example, in 216, the Romans sent Q. Fabius Pictor to Delphi to learn "quibus precibus suppliciisque deos possent placare" (by what prayers and entreaties they might appease the gods [Livy 22.57.5]). Furthermore, not only the gods were approached *cum suppliciis*. In Sallust, Jugurtha sent envoys to Metellus *cum suppliciis* for mercy should the king surrender (*Jug.* 46.2). Later, the Vagenses persuaded *suppliciis* of the king to enter into a conspiracy against the Romans, with whom they had ostensibly aligned themselves (*Jug.* 66.2). None of Halkin's examples of unofficial, exclusively female *supplicationes* stands up under close examination.

41. On the *graecus ritus*, see Latte 1960, 214, and below, note 42. For Roman sacrifice as a ritual meal for both gods and men, see Wissowa 1912, 416–20, and Latte 1960, 375–78.

42. As at the rites of Hercules at the Ara Maxima (Schultz 2000). See Latte 1960, 214; Ogilvie 1970, 57. Also Haug, *RE* 8.565–66, s.v. "Hercules." Scheid (1995, 22) is not convinced. To my knowledge, the only possible evidence for women observing a ceremony *ritu graeco* comes from Phlegon's record of the Sibylline instructions for the expiation of 125 (*Mir.* 10.16), where the recipient of the oracle is instructed to ensure that the young women involved in the celebration perform the rites Ἀχαιστί, which is often rendered in English as "in the Greek rite" or "in the Greek style" (e.g., Hansen 1996, 40, and North 2000, 103). Indeed, *LSJ* offers only *ritu graeco* as a translation for this term and cites only this passage. It is also possible that the Greek should be rendered *sacrum Graecum*, meaning that women were instructed to perform a ritual that is identical to one performed in Greece, rather than to perform a rite in the Greek style (with head uncovered, etc.). Indeed, Cicero identifies the rite performed by the (Greek) priestesses of Ceres in Rome as "Graecum illud sacrum" (*Balb.* 55). Phlegon's text of the Sibylline prophecy should refer to a Greek ritual, rather than a Greek manner of observing an otherwise Roman ritual. It is unlikely that it is coincidence that the deities to whom the expiation of 125 was directed are Demeter (Ceres' counterpart) and Persephone.

43. Livy 5.21–23; Plu., *Cam.* 6.1–2; V. Max. 1.8.3 (identifies the goddess as Juno Moneta), D.H. 13.3. Richardson 1992, 215–16, s.v. "Juno Regina, Aedes (2)"; M. Andreussi, *LTUR* 3.125–26, s.v. "Iuno Regina" and addendum 5.269.

44. Eager to avoid being detained by the Senate and to engage the Carthaginians, Flaminius took control of his troops in the field before his formal investiture as consul. In so doing, Flaminius failed to perform several religious obligations in Rome, including the taking of the annual auspices, declaring the

Latin Festival, and offering a sacrifice to Jupiter Latiaris on the Alban Mount (Livy, 21.63.5–11).

45. Wissowa 1912, 49.

46. Livy 27.37.5–15.

47. Gagé 1963, 131–37; Boëls-Janssen 1993, 279. Hänninen, who points out that Juno Regina is not associated with feminine fertility, also elides the lightning strike and thus appears to link the matronal dedication directly with the androgyne prodigy: "It is noteworthy that Juno Regina of the Aventine was propitiated during the Hannibalic War although no prodigy was necessarily associated with her" (Hänninen 1999b, 44). It seems to me that there is no way to disassociate the lightning strike at the goddess's temple with the goddess herself. For Juno's general procreative concerns: Fowler 1911, 135–36; Rose 1959, 216–19; Latte 1960, 168; Fabian 1978, 90. In this line of interpretation, Juno in all her manifestations is primarily a fertility deity who becomes a political divinity by the extension of her interest in individual fertility to concern for the fertility, and therefore the continued preservation, of Rome as a whole.

48. Boyce 1937, 170–71. This argument rests largely on the fact that *matronae* are not explicitly listed in sources for the expiation of other hermaphrodites. There are, however, hints of matronal attention to Juno Regina in later expiations of androgyne prodigies. Phlegon's record of the Sibylline oracle for the expiation of 125 includes sacrifices to Hera Basileis (= Juno Regina) made by unknown parties and a hymn sung by γένει προφερέστεραι (women of very distinguished lineage [*Mir.* 10.50 and 55]). Phlegon's text also includes matronal offerings to Demeter and virginal offerings to Proserpina (lines 18–28). Obsequens's brief notice for 99 (Obs. 46) records donations by the *populus*, *matronae*, and *virgines*, and the perambulation of a virginal chorus. See Mac-Bain 1982, 129–32.

49. R. Palmer 1974a, 22. In all her manifestations, Juno had ties to the political realm. Even the interests of Juno Lucina, in whose honor the festival of the Matronalia was observed, were not restricted to the traditionally feminine sphere: her sanctuary was preserved by Roman magistrates (*CIL* 6.358 = *ILS* 3102 = *ILLRP* 160) and was a stop on the circuit of the Argei (R. Palmer 1974a, 20).

50. MacBain (1982, 71) reached the same conclusion. Hänninen (1999b, 45) points out that Juno was also associated with Carthaginian Tanit, which may have further contributed to her popularity during the Hannibalic War.

51. Livy 31.12.9. The text says that the same rites were observed ("res divinas

easdem") and in addition a virginal chorus and matronal sacrifice were organized. Livy has probably confused his source (MacBain 1982, 128), as he makes clear in book 27 that the virginal chorus was the initial expiation prescribed for the hermaphroditic prodigy.

52. MacBain 1982, 134. Appendix E of MacBain's work (pp. 127–35) includes a catalog of androgyne prodigies and a full consideration of the development of this particular set of expiatory rites.

53. D.H. 8.39.1–56.4; Livy 2.40.1–13; Plu., *Cor.* 33.1–37.3.

54. D.H. 8.56.2–3: ὁσίῳ πόλεως νόμῳ γυναῖκες γαμεταί δεδώκατέ με (Matrons, you have dedicated me in accordance with the sacred law of the city). Plu., *Cor.* 37.3: θεοφιλεῖ με θεσμῷ γυναῖκες δεδώκατε (Women, you have given me in accordance with divinely favored law). V. Max., 1.8.4: "rite me, matronae, dedistis riteque dedicastis" (Matrons, you have given me in accordance with religious law, and you have dedicated me in accordance with religious law).

55. Mommsen 1874, 24.

56. Gagé 1963, 48–63.

57. Champeaux 1982, 341–60. This interpretation is closely followed by Boëls-Janssen 1993, 376–77.

58. Mustakallio 1990, 130–31.

59. Aside from this one episode, Fortuna Muliebris is not known from other literary sources and there is no certain epigraphic evidence of her cult. See R. Egidi, *LTUR-S* 2.272–73, s.v. "Fortuna Muliebris Aedes, Templum." The only certain indication that the cult survived the early republican period is a denarius of Faustina the Younger (Mattingly 1923–62, 4.399 no. 96–97, pl. 55 no. 7). Cf. Champeaux 1982, 343, n. 45, and 349–50, pl. ix, no. 5.

60. Cornell 1995, 304–9.

61. For the most recent analysis, see Lucchesi and Magni 2002, 13–16. See also *CIL* 1².2832a.

62. Versnel in Stibbe et al. 1980, 128–40. See also Bremmer 1982 and Lucchesi and Magni 2002, 17–19. The identification is accepted by Torelli 1999, 16.

63. Ov., *Fast.* 1.619–28; Plu., *Mor.* 278B (= *RQ* 56); G. Pisani Sartorio, *LTUR* 1.240–41, s.v. "Carmentis, Carmenta." According to Livy, the right to ride in carriages was granted to the women of Rome after they voluntarily contributed to a donation to Apollo in 395 (5.25.8–9).

64. Degrassi 1963, 121, 418–19. For more discussion, see G. Giannelli, *LTUR* 3.122–23, s.v. "Iuno Lucina, Aedes." Also Ov., *Fast.* 3.245–48. Coarelli 1996, 455–69. Plu., *Rom.* 21.1–2, says that the festivals of the Matronalia and the Carmen-

talia were established by the Romans and Sabines after the two communities were united.

65. Richardson 1992, 214-15, s.v. "Juno Lucina, Aedes," also passes over the issue of matronal involvement.

66. The power to authorize the dedication of a new temple resided with the Senate or the tribunes of the plebs in the early Republic but later was reserved for the plebs themselves. For full consideration of the legal issues surrounding the right of dedication, see Orlin 1997, 162-72.

67. Var. *L.* 5.74, D.H. 4.15.5. Several inscriptions from the Republic attest refurbishment or expansion of sacred places by women, for example, *CIL* 1².981 = 6.30899 = *ILS* 3423 = *ILLRP* 126 (from Rome); *CIL* 1².1688 = 10.292 = *ILS* 5430 = *ILLRP* 574 (from Padula); *CIL* 1².3025 = *AE* 1973.127 (from Ostia). Orlin's catalog of public temples (1997, 199-202) does not list any women as either vowers, financiers, or dedicators.

68. Fest. 284L, s.v. "publica sacra." There is no indication that Fortuna Muliebris's sanctuary on the Via Latina was a sacred site prior to the temple built after 488.

69. *MRR* 1.176, s.a. 296. The rancor in the temple of Pudicitia Patricia was an extension of the patrician-plebeian strife that had colored elections for that year (Livy, 10.15.7-12). Despite Appius Claudius's desire that he be elected consul along with another patrician, the people gave him the plebeian Volumnius as a colleague. The relationship between the two men, who had been consul together already in 307, was hostile for the rest of the year (10.18.10-19.22).

70. Livy (5.25.8-9) notes that special precautions were taken to record who gave how much, so that the matrons might be properly reimbursed.

71. Livy, 5.50.7. The matrons were repaid after the Romans, under Camillus's command, defeated the Gauls (Livy, 5.48.7-49.3 and 6.4.2).

72. Livy 34.1.1-34.8.3; Tac., *Ann.* 3.34; V. Max. 9.1.3.

73. App., *BC* 4.135-46; V. Max. 8.3.3.

74. D.H. 8.43.3-7. This element of the tradition was known to Livy, who withholds judgment on its verity: "id publicum consilium an muliebris timor fuerit parum invenio" (whether this was due to a public resolution or to feminine timidity I am hardly able to determine [2.40.1]).

Chapter 2

1. At present, the first volume of the *Corpus Inscriptionum Latinarum* exists in two editions. T. Mommsen's 1863 collection of Latin inscriptions dated down through the death of Caesar (commonly cited as *CIL* 1) was superseded by

E. Lommatzsch's three-fascicle 1918 edition (*CIL* 1²), which corrected and expanded Mommsen's work. Fortunately, work on the collection has continued, and in 1986, A. Degrassi and I. Krummrey released a fourth fascicle of the second edition. This latest release includes updated bibliography and textual revisions for some texts in *CIL* 1 and 1², as well as some new items. Degrassi and Krummrey's work is sometimes cited as *CIL* 1³, although it is identified as another installment of *CIL* 1² by both its title page and the fact that its pagination is continuous with the earlier fascicles of the second edition. In this study, references to the 1986 publication are given as *CIL* 1² with the appropriate page number.

2. Epigraphic corpus: Saller and Shaw 1984, 124, n. 1. Sacred inscriptions: Panciera 1989–90, 906. Note that Panciera's statistics include neither gravestones nor other types of inscriptions such as laws that may pertain to ritual matters.

3. Methodological hazards of working with epigraphic material on a large scale are discussed in MacMullen 1982. See also Friggeri and Pelli 1980, 95–97, on the lack of standardized criteria for epigraphic surveys. On inadequate publication of provincial inscriptions, see Curchin 1982, 179–80. For a specific critique of the approach in Saller and Shaw 1984, see Mann 1985. Bodel 2001, 46–56, offers a general survey of the "pitfalls" an ancient historian must avoid when working with epigraphic material.

4. As, for example, on silver bowl from an early seventh-century tomb at Praeneste. See Cornell 1991, 16–17 (with bibliography), which makes a strong case for a more literate archaic Latium than has generally been posited by scholars.

5. Panciera 1989–90, 911–12.

6. The increasing visibility of women in the public sphere over the last two centuries of the Republic eventually led to the prominence that women of the imperial household enjoyed from the earliest period of the Principate. For a proposed link specifically between the status of priestesses in the late Republic and that of the great ladies of the early Empire, see Scheid 2003b.

7. Häussler 2002 and the papers in Cébeillac-Gervasoni 1996.

8. It is possible that women worshipers appeared in the epigraphic record contemporaneously with men but that their lower financial status meant their dedications were inscribed on less expensive, perishable materials. On perishable writing materials within a religious context, see Beard 1991, 42–43.

9. Much of the evidence from earlier centuries comes from inscriptions on domestic items found in aristocratic tombs. See Cornell 1991.

10. Panciera 1989–90, 911–13.

11. *CIL* 1².1773 = *ILLRP* 44a, *CIL* 1².3212–15. All dedications to this goddess were found inside tombs. Spaeth (1996, 3) links the goddess of Sulmo with Ceres, but Le Bonniec (1958, 44) rightly hesitates over a close identification between the two deities.

12. *ILLRP* offers a representative selection of female-authored religious inscriptions, especially in section IV: *numina et sacerdotes* (pp. 45–173). Brouwer 1989 includes an extensive catalog of dated inscriptions for the cult of the Bona Dea.

13. Jupiter: *CIL* 1².2171b = 5.2799 = *ILS* 2992 = *ILLRP* 195 (from Aquileia); possibly also *CIL* 1².1816 (from the area near Alba Fucens). Apollo: *CIL* 1².1928 = 9.5803 = *ILS* 3213 = *ILLRP* 49 (from Morrovalle). Hercules: *CIL* 1².981 = 6.30899 = *ILS* 3423 = *ILLRP* 126 (commemoration of temple refurbishment; from Rome). A sample of other inscriptions of uncertain or imperial date: Jupiter: 6.424 (from Rome), 10.928 (from Pompeii). Mars: 10.5046 (man and woman together; from Atina). Mercury: 6.84 (offered by a man and woman together; from Rome). Hercules: *AE* 1989.239 (from Sulmo). Liber Pater: *CIL* 10.6510 = *ILS* 3367 (from Cora).

14. Admittedly, the absence of Carmenta from the epigraphic record may be due to ritual practice particular to her cult (e.g., dedications may have been recorded only on perishable materials).

15. The following are examples of male-authored dedications to these deities. Bona Dea: *CIL* 6.75 = *ILS* 3508 = Brouwer 1989, 27–28, no. 13 (who identifies it as "Pre-Augustan"; from Rome), *CIL* 1².972 = 6.59 = 6.30688 = *ILS* 3491 = *ILLRP* 56 = Brouwer 1989, 29–30, no. 15 (from Rome). Juno Lucina: *CIL* 1².359 and 360 = *ILS* 9230 and 9230a = *ILLRP* 162 and 163 (from Norba). Diana: *CIL* 1².610 = 14.4268 = *ILLRP* 75 and *CIL* 1².1436 = *ILLRP* 78 (both from Nemi), *CIL* 1².1696 = *ILS* 3237 = *ILLRP* 86 (from Tarentum), *CIL* 1².2288 = 3.1772 = *ILLRP* 87 (from Narona).

16. Dorcey 1989, 144.

17. For Turpilius's *nomen* (family name), see commentary on *ILLRP* 82.

18. Dessau 1884, 455 (following Mommsen).

19. Wissowa 1912, 259; commentary in *CIL* 1², p. 868. Petit (1980, 182) and Degrassi (commentary on *ILLRP* 101) equivocate.

20. Gatti and Onorati 1992, 202–6. For further discussion of Praenestine local aristocracy, see Harvey 1975. Petit 1980, 182, and *CIL* 14.2863 have clear representations of Orcevia's bronze plaque.

21. This has been the most popular interpretation of these items. There is, of

course, no way to know if these two items were dedicated together. For a review of the scholarship on the topic and argument against associating the written dedication and the breast, see L. L. Holland, forthcoming. Photographs and drawings of the inscription (but not the breast) can be seen in *CIL* 1² and *ILLRP Imagines* no. 33. The inscription is dated to the late fourth or early third century (*RMR*, 327–28). For the significance of anatomical votives, see chapter 3.

22. Two other republican dedications from Pisaurum, one definitely and the other possibly to Mater Matuta, have sometimes been interpreted as dedications by wet nurses:

Matre / Matuta / dono dedro / matrona / M(ania) Curia / Pola Livia / deda. (*CIL* 1².379 = 11.6301 = *ILS* 2981 = *ILLRP* 24)
[To Mater Matuta, the matrons gave this gift. Mania Curia and Pola Livia gave this.]

[– – –] / Nomelia / dede. (*CIL* 1².380 = 11.6302 = *ILS* 2982 = *ILLRP* 25)
[(– – –) Nomelia the wet nurse (?).]

The first of these inscriptions has been thought to be two different inscriptions, breaking between the fourth and fifth lines. A recent consideration of the stone (with photograph) argues against such a reading, pointing out that the letter forms and even the traces of guidelines still visible indicate the text is all part of a single unit (Cresci Marrone and Mennella 1984, 138–39). See also Harvey, forthcoming.

Uncertainty about the meaning of these inscriptions arises from the identification of the women as *dedae* and not as *nutrices*. *Deda* had long been thought to be the Illyrian equivalent of *nutrix* (Degrassi, commentary on *ILLRP* 24 and L. Palmer 1988, 40), and its continued usage at Pisaurum, on the east coast of Italy, evidence of an Illyrian slave population in that region. This has come under significant criticism, most notably from Ernout 1965, 192, n. 1, and *CIL* 1², p. 879, commentary on 1².379, who argue that the word is an abbreviated form of *deda[t]*. This reading requires that the stone contain two different inscriptions, each with its own verb (*dedro[nt]*, *deda[t]*). Cresci Marrone and Mennella, drawing on literary descriptions of Mater Matuta's June festival at which women prayed for the continued well-being of their sister's children, propose that *deda* means not "wet nurse" but something equivalent to "godmother" (1984, 141–42). This proposal could accommodate the fact that it is highly improbably that Mania Curia and Pola Livia earned their livings as wet nurses.

These two women were, in all likelihood, members of two families prominent in republican Pisaurum. Ollendorff, *RE* 13.854–55, s.v. "Livius (12)" and "Livius (13)"; Cresci Marrone and Mennella 1984, 142–43. Ultimately, *deda* and its variants must be forms of *dare*: it also appears in another republican dedication from Pisaurum, this time to Feronia by a male worshiper who cannot possibly have been a wet nurse (*CIL* 1².377 = 11.6299 = *ILS* 2979 = *ILLRP* 22; Cresci Marrone and Mennella 1984, 125–31 and 145–47).

23. On the prevalence of *nutrices* in Roman society, see Bradley 1986. For a sample of inscriptions relevant to female employment, see Lefkowitz and Fant 1992, 208–24.

24. That collective female actions were not uncommon in Roman society is also suggested by Var., *L.* 7.66.

25. Although the phrase *matrona Pisaurese* may appear to be singular, it is generally taken to be plural. See commentary offered by *CIL* 1², p. 879; Panciera 1989–90, 911, n. 76.

26. See note 22, above, on the interpretation of this stone.

27. On the identification of Eretum and dating of the inscription, see Degrassi 1969 (with photograph of the inscription).

28. This stone bears another, later inscription *CIL* 10.6511 = *ILS* 3488: "Cervaria Sp. f. Fortunata / magistra / Matri Matutae / d(onum) d(edit)" (Cervaria Fortunata, daughter of Spurius Cervarius and *magistra*, gave this gift to Mater Matuta).

29. The *consuplicatrices* may have a parallel in the imperial *consacerdotes* (male and female!) of the Magna Mater attested in *CIL* 9.1540 = *ILS* 4186 = *CCCA* 4.40, no. 100 (from Beneventum).

30. Although this inscription was thought to come from Rome, a recent consideration argues for a Norban origin for this as well as *CIL* 1².360. See Quilici Gigli 1993–94, 292–94 (with photographs of both plaques).

31. Latte, *RE* 13.1650, s.v. "Lucina," and 1960, 50; Degrassi, commentary on *ILLRP* 161 and 163.

32. R. Palmer 1974a, 20. See also Le Bonniec 1958, 404–12.

33. As suggested by Latte 1960, 50, n. 2.

34. One might reasonably assume that the other dedication made to Juno Lucina *Diovis castu* (*CIL* 1².361 = 6.357 = *ILS* 3101 = *ILLRP* 161, mentioned above) was also offered by a male worshiper, but this cannot be established with any certainty.

35. For photographs, discussion, and interpretation, see *Enea* 187–264 and Torelli 1984, 19–50 and 216–26.

36. Among the gifts are eggs, animals, and small boxes containing tablets (?): *Enea* 217–18, figs. D170–86, and 224–29, figs. D201–4, 206.

37. *Enea* 239–41, fig. D224.

38. Torelli 1984, 219–25 and figs. 42–45 = *Enea* 243–48, figs. D227–29.

39. *Enea* 225–27, fig. D202.

40. E.g., *Enea* 260–61, fig. D254 (late third or early second century).

41. Maintenance of cult facilities appears to have been one of the tasks assigned to *magistrae* and *ministrae* (see below).

42. Bodel 1994; R. Palmer 1974a, 79–171 (esp. 79–89).

43. L. Octavius Ligus was consul in 75 (*MRR* 2.96, s.a. 75). His brother, Marcus, was a senator (*MRR* 2.493; Cic., *Ver.* 2.1.125–27 and 2.2.21). For an extensive discussion of the dating of *CIL* 1².3025 and of Octavia's and her husband's families, see Cébeillac 1973 and Cébeillac-Gervasoni 2004.

44. It is possible that we can identify one of Publicia's cousins: a Publicius served as moneyer in the early first century. See below.

45. *ILLRP* offers a large selection of this type of inscription in section V: *Magistratus Romani* (176–248).

46. On the organization of towns outside of Rome and the titulature of local magistrates, see Laffi 1973.

47. *CIL* 1².1721 = 9.1138 = *ILLRP* 522 (from Aeclanum).

48. *CIL* 1².1533 = 10.5074 = *ILS* 5367 = *ILLRP* 551 (from Atina).

49. *CIL* 1².1537 = 10.5679 = *ILS* 5738 = *ILLRP* 546 (from Arpinum).

50. Mineia's restoration has been dated to approximately 15 B.C.E. (Torelli 1999, 84; cf. Torelli 1996, with bibliography). Torelli also identifies as roughly contemporary with the euergetism of Minea and her fellow townswomen another inscription from Paestum recording a woman's refurbishment of an Isaeum, though others date it much later, to the late second or early third century C.E. (Mello and Voza 1968–69, 2.235 [n. 160]).

51. Fest. 188L, s.v. "Octaviae porticus." Livy, *Per.* 140. Suetonius (*Aug.* 29.4) and Dio (49.43.8) state that Augustus built the structure in Octavia's name. Regardless of who funded the structure, a monumental building attached to the name of a prominent woman would not have been unique in Roman experience. Richardson 1992, 317–18, s.v. "Porticus Octaviae"; A. Viscogliosi, *LTUR* 4.141–45, s.v. "Porticus Octaviae." Comparanda may be found in a fragmentary inscription from an architrave found in Verona that may record Sulla's dedication (refurbishment?) of a building in his sister's name (*CIL* 1².2646).

52. *CIL* 10.810. The precise purpose of Eumachia's structure is not known. Castrén 1975, 95 and 101; De Vos and De Vos 1982, 39–41; Zanker 1998, 93–102.

53. *CIL* 9.3677 = *ILS* 5684.

54. *Contra* Purcell 1986, 89. The role of women of Augustus's household as models for aristocratic women elsewhere in Italy is highlighted also in Kleiner 1996.

55. Much of what follows in this section appeared in Schultz 2000.

56. Mommsen, commentary on *CIL* 6.337; Wissowa 1912, 279; Latte 1960, 382; R. Palmer 1996, 93. Opinion is not unanimous, however. Some reject the idea of universal exclusion, maintaining that female worshipers were only restricted from participating in rites held at the Ara Maxima: Fowler 1899, 142 and 194, also Fowler 1911, 29; Haug, *RE* 8.566–67, s.v. "Hercules"; Balsdon 1962, 243; Staples 1998, 24–30.

57. Haug, *RE* 8.552–60, s.v. "Hercules"; Richardson 1992, 185–89; *LTUR*, 3.11–26.

58. *ILS* 3446, identified as *CIL* 6.327, corresponds not to this inscription, but to *CIL* 6.327 *bis*, p. 61. *CIL* 6.327 does not appear in Dessau's collection.

59. *CIL* 6.33936; F. Coarelli, *LTUR*, 3.19–20, s.v. "Hercules Olivarius."

60. Coarelli 1992, 201–4.

61. Zappata 1996, 90–96.

62. Verg., *A.* 5.410–14. Cf. *FGrH* 690.2 and 76.93. Also J. Boardman, *LIMC* 4.796, s.v. "Herakles."

63. Macrobius himself tells us elsewhere in the *Saturnalia* that anything thought to belong to the gods is called *sacrum* (3.3.2). Forcellini 5.287, s.v. "sacer." *OLD*, s.v. "sacrum." See also Fest. 422–24L, s.v. "sacer mons."

64. Verg., *A.* 8.268–72; Livy 1.7.12; Macr., *Sat.* 3.6.12–13; Fest. 270L, s.v. "Potitum et Pinarium"; Aurelius Victor, *De Vir. Ill.* 34.2; *Origo* 8.1.

65. Cf. any play of Plautus; Lodge 1925–26, s.v. "castor," "hercle," "ecastor," "mecastor," "mehercle."

66. The exclusion of women from a ritual feast of Hercules is not unique to Rome. Tertullian (*ad Nat.* 2.7.17 [ed. Borleffs]) tells us the women of Lanuvium were subject to the same restriction.

67. Macr., *Sat.* 3.6.17. Serv., *ad Aen.* 8.276 = Thilo and Hagen 1881–87, 2.236; Livy 1.7.3; Strabo 5.3.3; D.H. 1.40.3. On exclusion of women as a possible element of the *ritus graecus*, see chapter 1, n. 42. The exact location of the Ara Maxima is uncertain: no conclusive remains of it have been found. See Coarelli 1992, 61–77 and Coarelli, *LTUR* 3.15–17, s.v. "Hercules Invictus, Ara Maxima," with addendum 5.263; Richardson 1992, 186–87, s.v. "Herculis Invicti Ara Maxima."

68. *Origo* 8.5. Macrobius (*Sat.* 3.6.13) and Aurelius Victor (*De Vir. Ill.* 34.2)

also record the tradition that Claudius used bribery to achieve his aims, but only the *Origo Gentis Romanae* includes the admission of women to the cult as part of Claudius's program.

69. *CIL* 1².61 and 62 = 14.2891 and 2892 = *ILS* 3420 and 3419 = *ILLRP* 131 and 132. Both stones appear to have been statue bases. Some items from this deposit that are now housed in the Museo Nazionale Romano have recently been published in Pensabene 2001. The types of anatomical votives published in Pensabene's volume are amply duplicated by unpublished items from the same deposit now kept in the Museo Archeologico di Palestrina, which I was able to examine briefly during the spring of 1998 thanks to the generosity of A. M. Reggiani and S. Gatti of the Soprintendenza Archeologica per il Lazio. On the possibility that men dedicated female anatomical votives to the gods and the possibility of joint male-female dedications, see chapter 3.

70. R. Palmer 1996, 93, n. 87.

71. Crawford 1974, 82 and 396 [380/1]. While Hercules commonly appears on Roman coins in the republican period, Publicius's coin is unique in its portrayal of the hero and the Nemean lion. Crawford implies a connection between the family of the *monetalis* and Hercules by citing as comparanda for the coin only Publicia's inscription. Grueber (1910, 1.365–66 [no. 2896–915]) is either unaware of the inscription or dismisses any possible link between it and the coin and thus does not include it. In fact, he writes "since it is not possible to associate the design in any way with the personal history of the moneyer's family, it may refer to the recent victory of Sulla over the Marian party" (p. 365, n. 3). Grueber goes on, however, to say that references to recent events on coinage in this period are rare. Sydenham (1952, 125 [no. 3768]) offers nothing further.

72. Silvanus: Dorcey 1989 and 1992, 124–34. Mithras: David 2000. Women may even have been initiates into the Mithraic mysteries and may have served as cult officials.

73. Brouwer 1989, 254–96; Bouma 1996, 1.284–90.

74. Rome: *CIL* 1².974 = 6.2182 = *ILS* 3342 = *ILLRP* 61. Atina: *CIL* 1².1532 = 10.5073 = *ILS* 3344 = *ILLRP* 62. Sulmo: *CIL* 1².3216. Torre dei Passeri: *CIL* 1².3257. Formiae: *CIL* 1².3110 = 10.6103. Imperial and undated inscriptions include: *CIL* 10.129 = *ILS* 3337 (*sacerdos XVviral*; from Lucania), *CIL* 6.2181 = 6.32443 = *ILS* 3343 (*sacerdos publica Populi Romani Sicula*; from Rome), *CIL* 9.1084 = *ILS* 3345 (from Aeclanum).

75. Bovianum: *CIL* 1².1751 = 9.2569 = *ILLRP* 273. Teate Marrucinorum: *CIL*

1².3260 (= revised text of *CIL* 9.3032) and *AE* 1980.374 (undated; from Pescara). Cf. *CIL* 9.3166 = *ILS* 3187 (from Pratola).

76. *CIL* 1².1541 = 10.5191 = *ILLRP* 63; *CIL* 1².1774 = 9.3087 = *ILLRP* 65; *CIL* 1².1775 = 9.3090 = *ILS* 3351 = *ILLRP* 66. To these add *CIL* 1².1777 = 9.6323 from Pentima: *Titia L. f. sacerdos* (cult affiliation unknown). Colonna (1956, 216) reasonably assumes that Titia was also a priestess of Ceres and Venus: no other priesthood is attested for the region in this period. The priesthood is attested through the imperial period (*CIL* 9.3089). Scholars debate the significance of the "Herentas inscription," a first-century B.C.E. sepulchral inscription, written in Paelignian, of a priestess of Ceres (and Venus?) from Corfinium. Cf. Colonna 1956 and Peruzzi 1995 (including a text of the inscription).

77. *CIL* 1².1550 = 10.5422 = *ILS* 3353 = *ILLRP* 205.

78. Juno Populona: *CIL* 10.4789 = *ILS* 3112 and *CIL* 10.4790 (from Teanum). Isis: *CIL* 9.3091 (from Sulmo). Magna Mater: *CIL* 9.1540 = *ILS* 4186 = *CCCA* 4.40, no. 100 (from Beneventum). For a more extensive list of inscriptions naming priestesses and other cult officials from Italy, see Richlin 1997, 368–72.

79. *CIL* 9.307 = *AE* 1990.202. The bestowal of such an honor on a child is not unique; cf. *CIL* 10.846 = *ILS* 6367 (from Pompeii).

80. Vestals: Plu., *Num.* 10.1. Priestesses of Liber: Var., *L.* 6.14.

81. E.g., *CIL* 10.4793 and 4794 = *ILS* 3346 and 3347 (from Teanum), *CIL* 9.1541 = *ILS* 4184 (from Beneventum).

82. Ceres: *CIL* 10.129 = *ILS* 3337 (from Potentia). Unidentified deities: *CIL* 5.4400 (from Brixia); also *CIL* 9.1538 and 9.1541 = *ILS* 4185 and 4184 (from Beneventum) probably, though not explicitly, record priestesses of the Magna Mater.

83. Minturnae: *CIL* 1².2685 = *ILLRP* 737 = Johnson 1933–35, 2.25, no. 8. Aquinum: *AE* 1978.99 (undated); cf. *AE* 1978.97 (undated).

84. Servile *ministra*: *CIL* 11.4635 = *ILS* 3494 = Brouwer 1989, 97–98, no. 93 (Augustan period; from Tuder). Brouwer's text of the inscription, from Praeneste, reads: "Quieta Aties / Pieridis / ministra Bon(a)e di(a)e / proma(gistra?) pos[u]it d. d." Both *CIL* and *ILS* prefer to read *proma* in line 4 as the feminine equivalent of *promus* (steward). Another inscription from Rome (*CIL* 6.68 = *ILS* 3513 = Brouwer 1989, 53–54, no. 44) also records a *ministra* of the goddess, but the dating of the stone is uncertain—anywhere from first century B.C.E. to second century C.E. or later (see Brouwer for further discussion).

Paired *ministrae* from Aquileia: *CIL* 5.762 = *ILS* 3498 = Brouwer 1989, 116–18, no. 113B (dated to the imperial period). On this same stone is an earlier

inscription recording an unspecified donation "de sua pecunia" by two *magistrae*, again one free and one freedwoman.

85. *Ministra Magnae Matris*: *CIL* 9.3146 = *ILS* 4107. *Ministra Salutis*: *CIL* 9.4460 = *ILS* 3828.

86. *CIL* 10.4789 and 4791 = *ILS* 3112 and 3113.

87. Cosa: *CIL* 1².1994 and p. 1068 = *CIL* 11.2630. The latest editors of *CIL* 1².1994, P. B. Harvey Jr. and E. J. Bace, now think the inscription is, in fact, two separate entities. Orthography suggests that the first two lines are indeed a late republican text, and the second two a later inscription on the same theme. F. Castagnoli, in an unpublished note, suggested that the transcription in *CIL* 1².1994 = 11.2630 is, in fact, two separate inscriptions. This information courtesy of the American Academy in Rome, E. J. Bace and P. B. Harvey Jr. The forthcoming publication of inscriptions from Cosa will offer more detailed information.

Two similar inscriptions unearthed by the American Academy excavations at Cosa also document *magistri and magistrae*, though separately.

[m]atronae dederun[t- - -]
[C]osano(rum) magistra[e- - -]
M(ania) Muucia C(ai) f(ilia) cu(raverunt- - -). (Three fragments;
CB [1949] 580, 963, 1739)
[The matrons gave (this) . . . mistresses of the Cosan . . . and Mania Mucia,
daughter of Gaius Mucius, saw that it was done.]

[- - -]tes cont(ulerunt), m[agistri curaverunt] *or*
[- - -]tes cont(ulere), m[agistri coiraverunt]
[-Cal]purnius T(iti) f(ilius) [- - -]. (Perhaps same individuals as in
CIL 1².1994; CE [1952] 108)
[. . . collected [the funds] and the masters saw that it was done. . . .
Calpurnius, son of Titus.]

An examination of the *magistri* inscriptions from Minturnae and Capua yields no examples of mixed-gender colleges. Those from Capua are certainly all male (for text and bibliographic references, see Frederiksen 1984, 281–84, and ILLRP 705–23b). The Minturnae inscriptions include all-male and all-female groups (Johnson 1933–35, 2.17–48 = *CIL* 1².2678–708; some are also included in *ILLRP* 724–46).

88. *CIL* 1². 581= *ILS* 18 = *ILLRP* 511 (from Tirolo).

89. Cf. Livy 39.14.7.

90. *Magistri Cereris* are known from Capua (*CIL* 1².677 = 10.3779 = *ILS* 3340 = *ILLRP* 714 = Frederiksen 1984, 281, no. 8) and Minturnae (*CIL* 1².2699 = *ILLRP* 729 = Johnson 1933-35, 2.41, no. 22).

91. The distinction between priests tied to a specific cult (such as the priestesses of Ceres) and those priests who served the Roman people in a much more general capacity, such as the *pontifices*, is extremely important. Beard 1990 has drawn attention to the problems of defining a typical Roman priesthood, in particular the fallacious assumption that every office labeled *sacerdos* entailed the same responsibilities. The focus of Beard's work, however, is the major priestly colleges of *pontifices* and *augures*, both religious organizations that served in large part as advisers to the Senate in its capacity as the ultimate religious authority in Rome. Neither college was responsible for the daily activities of any particular cult.

92. Bona Dea: Cic., *Att.* 1.13 = Shackleton Bailey 1965-71, 13(I.13)3 and *Har.* 37; Plu., *Cic.* 19.4 and 20.1; Dio 37.35.3-4 and 37.45.1-2. Argei: Ov., *Fast.* 5.621; D.H. 1.38.3. On the role of the Vestals in numerous annual public rites, see Wildfang 2001.

93. Boak 1916, esp. p. 34; Johnson 1933-35, 2.122; Frederiksen 1959, 83-94, and 1984, 265-66.

94. On the difficulties of dating this inscription (anywhere from the late first century B.C.E. to the late empire), see Brouwer's commentary (1989, 53).

95. Saller and Shaw 1984, 127.

96. *CIL* 1².2685 = *ILLRP* 737 = Johnson 1933-35, 2.25, no. 8: "[- - -] / duovir(eis) / hasc(e) mag(istras) V(eneri?) / d(onum) d(ant): / [T]ertia D[o]matia S(puri) f(ilia) / Alfia (Gaiae) l(iberta) Flora / Cahia (Gaiae) l(iberta) Astapium / Dositea Calidi N. s. / Stolia Minidi L. s" (When . . . and . . . served on the board of two men, these *magistrae* gave a gift to Venus [?]: Tertia Domatia, daughter of Spurius Domatius, Alfia Flora, freedwoman of a woman, Cahia Astapium, freedwoman of a woman, Dositea, slave of Numerius Calidius, and Stolia, slave of Lucius Minidius). *Magistras* is nominative plural (see note in *ILLRP* and *CIL* 1², p. 818).

97. Cosa: *CIL* 1².1994 = 11.2630. Praeneste: *CIL* 14.2997 and 3006 (of almost certain Praenestine origin).

98. Livy, 39.13.8.

99. Champeaux 1982, 348-49; Boëls-Janssen 1993, 376-77; Gagé 1963, 48-63.

100. F. Graf, *Der Neue Pauly* 2.1070-73, s.v. "Ceres"; Wissowa 1912, 301; Le Bonniec 1958, 411-12; Peruzzi 1995, 10; Spaeth 1996, 115.

101. *Met.* 10.431–35, *Am.* 3.10. Although the episode in *Met.* 10 takes place in Cyprus, Ovid's description of the rite is thought to be patterned after celebrations in Rome (Frazer 1929, 3.306; Le Bonniec 1958, 410–11; Bömer 1969–86, 5.147–50. *Contra* Wissowa 1912, 301, n. 8).

102. Serv. *ad Aen.* 4.58 = Thilo and Hagen 1881–87, 1.473.

103. For consideration of African Ceres, see Pugliese Carratelli 1981. See Rives 1995, 45–50 and 157–61, for discussion of the grafting of African and Italic traditions in the cult of Ceres in Carthage.

104. *CIL* 1².1532 = 10.5073 = *ILS* 3344 = *ILLRP* 62 (from Casinum); *CIL* 1².974 = 6.2182 = *ILS* 3342 = *ILLRP* 61 (from Rome); *CIL* 1².3110 = 10.6103 (from Formiae); *CIL* 1².3257 (from Torre dei Passeri); *CIL* 1².3260 = 9.3032 (from Teate Marrucinorum = modern Chieti).

105. Zambelli 1968, 360.

106. Forcellini 3.155, s.v. "nepos."

107. The stone is now lost and its most recent editor doubts its provenance (Segenni 1992, 34).

108. Again, Laffi 1973 on Italian municipal officials. Alleia, her husband, and son appear in Castrén 1975, nos. 23.8, 12, and 13 respectively (p. 133). In his treatment of priestesses in Pompeii (pp. 70–72), Castrén concludes that they were recruited from among the upper echelons of local society.

109. Cic., *Cael.* 34; V. Max. 5.4.6; Suet., *Tib.* 2.4 (incorrectly identifies Claudia as the consul's sister); *MRR* 1.471, s.a. 143.

110. Crassus; Plu., *Crass.* 1.2; *MRR* 2.114, s.a. 73. Murena: Cic., *Mur.*, 73; *MRR* 2.172, s.a. 63.

111. It is assumed, but not known, that the priestesses of Liber were public religious officials, meaning they could perform rites *pro populo* in the city of Rome. Evidence for public priestesses of Liber elsewhere in Italy comes from a tombstone from Aquinum (*CIL* 1².1550 = 10.5422 = *ILS* 3353 = *ILLRP* 205).

112. See, e.g., Beard 1990 and Szemler 1972.

113. As in Scheid 1993, 57–58. In the epigraphic record, both priestesses of Ceres known from Rome are identified as *sacerdos Cereris publica* (*CIL* 1².974 = 6.2182 = *ILS* 3342 = *ILLRP* 61 and *CIL* 6.2181 = 6.32443 = *ILS* 3343), as are the two from Teanum Sidicum (*CIL* 10.4793 and 4794). All other known members of the priesthood are not given this designation, raising the possibility that Rome and Teanum Sidicum may have organized their cults of Ceres differently from other towns in Italy. Chirassi-Colombo (1981, 422) identifies Calliphana's arrival at Rome in 95 as the beginning of public administration of the cult in that city. Cf. V. Max. 1.1.1.

114. Paul., *Fest.* 79L, s.v. "flammeo"; Serv., *ad Aen.* IV.29 = Thilo and Hagen 1881–87, 1.465; Tertullian, *Cast.* 13.1 and *Monog.* 17.4.

115. The only literary evidence for the *regina sacrorum* comes from Macrobius, who tells us that she offered a sacrifice to Juno on the first of each month (*Sat.* 1.15.19). R. Palmer (1974a, 23–24 and 34), eager to identify her as an official for a cult of Juno, takes Macrobius's statement to mean that the *regina sacrorum* was in fact a priestess of the goddess. A stronger interpretation, however, is offered by Scheid (1992, 384) and Boëls-Janssen (1993, 393), who view the *regina*'s sacrifice as an integral part of ritual tasks required of the couple who served as *rex* and *regina sacrorum*. Two imperial inscriptions from Rome name a *regina sacrorum* (*CIL* 6.2123 and 2124 = *ILS* 4941 and 4941a). Cf. Wissowa 1912, 506.

116. Gel. 10.15.26–27.

117. The same may be said of the *regina sacrorum*. This matter is not addressed in the discussions of the pontifical college by Wissowa 1912, 501–23, and Latte 1960, 394–403.

118. As she is presented by Scheid 1993, 57. Vanggaard (1988) is less dismissive of the *flaminica*'s role but does not give the office full treatment. His primary interest is in determining which *flamines* were accompanied by *flaminicae* (Vanggaard 1988, 30–31). With reason, he concludes (*contra* Wissowa 1912, 506, n. 5) that wives of both the *flamen Dialis* and the *flamen Martialis* certainly bore the title, and that the wife of the *flamen Quirinalis* probably did as well. There is no evidence for *flaminicae* among the other, lesser flaminates, although it might reasonably be concluded that all these priesthoods were structured in the same fashion.

119. The *flaminica* is barely mentioned in discussions of the flaminate by Wissowa (1912, 503–8 [pontifical college]) and Latte (1960, 402–4). Dumézil (1970, 151–52, 172–73) mentions certain requirements put upon her, but leaves her out of his overall consideration of the nature and significance of the priesthood. The pendulum swings the other way in Boëls-Janssen's (1993) treatment of the *flaminica*, where the *flamen* receives little mention.

120. The parallel nature of both paired priesthoods is further suggested by the requirement that both the *flamen* and *flaminica Dialis* and the *rex* and *regina sacrorum* were required to be married by the traditional rite of *confarreatio*. Gaius, *Inst.* 112; Tac., *Ann.* 4.16.

121. The bibliography on the crisis of 186 is enormous and ever growing. Among the more important recent treatments are Pairault-Massa 1987; Pailler 1988 (with extensive bibliography); Rousselle 1989; Scafuro 1989; Gruen

1990; Walsh 1996; Cancik-Lindemaier 1996; Nippel 1997; Mouritsen 1998, 49–58; Beard, North, and Price 1998, 1.91–98; Courtney 1999, 93–101; de Cazanove 2000a; Flower 2002.

122. For a discussion of bias and internal contradictions in Livy's account, see North 1979, 86–90.

123. Plautus, who died in 184, makes several references to the Bacchanalia, suggesting that his audience was familiar with the rites. Cf. Bruhl 1953, 111–14. There is some hint that even Livy is not convinced that the rites were unknown in Rome; he reports that some senators, after hearing Postumius's revelation, feared that some of their own number might be involved (39.14.4). For discussion of the physical evidence for Dionysiac cult in Italy as early as the sixth century, see Bruhl 1953, 58–81. Since the publication of Bruhl's work, an underground Bacchic shrine, dating to the third century and destroyed about the time of the Bacchic scandal, has been discovered at Volsinii, modern Bolsena (Pailler 1971, 384–401; 1976, 739–42; 1983, 29). For the identification of the underground complex as a Bacchic cult site, see Pailler 1976, 739–40 and Pairault-Massa 1987, 573–74. A photograph of a terracotta throne from the sanctuary can be seen in Beard, North, and Price 1998, 1.94, fig. 2.4.

124. *CIL* 1².581 = *ILS* 18 = *ILLRP* 511. The most thorough analysis of this text is offered by Tierney 1947; see also Courtney 1999, 93–101.

125. It is important to note the that inscription is not an exact copy of the Senate's decrees but is a composite of several decisions taken by the Senate that has been recast for an audience outside the city of Rome (Flower 2002, 83). That said, I follow the standard practice of referring to the inscription as the *Senatus Consultum de Bacchanalibus*.

126. The events of 213, including inappropriate rites performed by women in the Forum and on the Capitol, are mentioned in Livy 25.1.6–12. It is somewhat misleading to refer to the Senate's action as a crackdown on female religious activity (so Beard, North, and Price 1998, 1.91). The women's behavior was part of a larger problem in Rome at that time, but it was not the whole story. The Livian passage sets the errant female behavior in the context of a city flooded by "sacrifculi ac vates" (shady sacrificers and charlatan prophets) who prey on the minds of men, especially the rustic plebs who had flooded into the city. The praetor's actions are clearly directed at the ersatz prophets and others who gained financially from the religious panic in the city, as well as at those individuals (both male and female) who panicked and behaved improperly.

The expulsions of 139 are recorded in V. Max. 1.3.3 and Livy, *Per.* 54. For commentary on this passage in Valerius Maximus and a discussion of the con-

fusion over the identity of the Jews, see Wardle 1998, 148–51. A third instance of governmental restriction of a religious practice is the banning of human sacrifice in 97 (Plin., *Nat.* 30.12). See also Gruen 1990, 39–46.

127. Several scholars accept at least in part Livy's assertion that the cult's particular attraction for female worshipers contributed to, if not actually sparked, the Senate's interest in controlling it. For example, Balsdon 1962, 37–43 (cf. Livy 39.13.12–14) embraces Livy's account so completely that his discussion of the Bacchic repression, including the motivation behind it, consists of little more than a lengthy paraphrase of the ancient historian. Spaeth (1996, 12) identifies the cult's strong appeal to upper-class women in particular as the basis for Roman suspicion. The idea that women were especially devout participants in Dionysiac ritual is often closely tied to a belief that traditional Roman religion could not accommodate feminine emotional requirements and that, therefore, female energies were especially attracted to foreign religions.

128. So Hänninen 1998, 121–22, following Kraemer 1992, 59. Pomeroy (1975, 223) offers a similar argument in less stark terms.

129. Kraemer 1992, 45–46.

130. Livy, 39.13.9–10, 14. Hispala Faecenia claims that Annia Paculla admitted men to the rites, increased the frequency of initiations, and changed the meeting time from day to night. In addition, initiation was limited to those under the age of twenty. For acceptance of these claims, see North 1979, 89 (acknowledging evidence of male initiates in the Hellenistic period and nocturnal celebrations, but arguing that these were absent from the Italic cult and were instituted by Annia Paculla). Gruen (1990, 52–54) argues against alleged innovation.

131. Pomeroy 1975, 217. Flower (2002, 88) suggests that men had always been involved in some cult activities, and that Annia Paculla's innovation was the admission of men to the initiation cult specifically.

132. Colonna 1991, 121–26.

133. *Ba.* 170–209 and 466. Burkert (1985, 291) also points out that Dionysus, in mortal guise, leads the *thiasos* onto the mountain, claiming to have received to *orgia* himself and to be charged with imparting them to others (*Ba.* 461–70). Nilsson, however, discounts this example of male involvement in the *orgia* precisely because the man involved is really Dionysus (Nilsson 1957, 8, n. 12; cf. Nilsson 1953, 176–77). Of course, the members of the *thiasos* in the *Bacchae* do not know their leader's true identity: the god has only revealed himself to the audience (*Ba.* 4, 43–54). For a recent treatment of this issue, see des Bouvrie 1997.

134. Nilsson 1957, 7–12. It is possible that single-sex *thiasoi* of either male or female worshipers were the norm, although mixed-gender *thiasoi* are known in the Hellenistic Greek world (e.g., *OGIS* 735 [Thera]; *LSAM* 48 [Miletus]). A Hellenistic mixed-gender *thiasos*, the primary purpose of which was to provide proper burial for its members, is known from Piraeus (Sokolowski 1962, 210–12, no. 126; cf. 202–3, no. 120). On *thiasoi* generally, see Burkert 1985, 173 and 290–93.

135. Nilsson 1953, 176; Gruen 1990, 53.

136. This is corroborated by Livy 39.14.7.

137. To my knowledge, the imperial evidence for mixed-gender priesthoods in Italy (other than the flaminates and the *rex* and *regina sacrorum*) is limited to an inscription naming a heterogeneous pair of *consacerdotes* of the Magna Mater at Beneventum, and even in this case it is possible that the two individuals were married to one another. See note 29.

138. *Magistri Cereris* are known from Capua (*CIL* 1².677 = 10.3779 = *ILS* 3340 = *ILLRP* 714 = Frederiksen 1984, 281, no. 8) and Minturnae (*CIL* 1².2699 = *ILLRP* 729 = Johnson 1933–35, 2.41, no. 22). See note 86.

139. As has been argued by Flower 2002, 89.

140. Also *Am.* 703–4, *Bac.* 53–56 and 371–72, *Cas.* 979–82, and *Cist.* 156–59.

141. On the structural similarity between Livy's account and common elements in New Comedy, see Scafuro 1989. Walsh (1996) and Wiseman (1998) suggest that an actual drama about the events of 186 was performed at Rome, though Flower (2000) has made a persuasive argument against this notion.

142. Nippel (1997, 71–73) sees the frequency with which this issue arises as evidence of a deeply ingrained fear of conspiracies in Roman society, especially in its political culture, and argues that this was the underlying cause of the Senate's reaction.

143. Suggested by Balsdon 1962, 42. See Cic., *Catil.* 1.8, 13, and 25–26 ("quanta in voluptate bacchabere"), among others. Also Sallust, *Cat.* 14.1–7 and 24.3–25.5. The link between secrecy and criminal behavior is also evident in Livy 1.33.8.

144. *Ep.* 10.96.8; cf. Livy 39.15.3, 16.6. The defense the Christians offered Pliny on their own behalf echoes in the inverse the accusations made against the Bacchants:

Adfirmabant autem hanc fuisse summam vel culpae suae vel erroris, quod essent soliti stato die ante lucem convenire carmenque Christo quasi deo

dicere secum invicem seque sacramento non in scelus aliquod obstringere, sed ne furta ne latrocinia ne adulteria committerent, ne fidem fallerent, ne depositum adpellati abnegarent; quibus peractis morem sibi discedendi fuisse rursusque coeundi ad capiendum cibum, promiscuum tamen et innoxium; quod ipsum facere desisse post edictum meum, quo secundum mandata tua hetaerias esse vetueram. (Pliny, *Ep.* 10.96.7)

[They (the Christians) assert, moreover, that this was the sum of their guilt or error: that they were accustomed to meet on a particular day at dawn and to offer a responsive prayer to Christ as if he were a god, and to bind themselves by an oath — not for any criminal purpose, but so that they should not commit theft, robbery, or adultery, nor swear a false oath, nor deny a deposit when they had been called upon to return it. (They also claimed that) after these rites had been observed, it was their custom to disperse and then gather again for a regular, innocent meal, but that they had given this up following my edict, in which I had banned secret societies, in accordance with your instructions.]

Pliny is also concerned that rites have spread among individuals of every age and class, both men and women alike, in the cities as well as the countryside (10.96.9). The influence of Livy's description of the Bacchic conspirators can also be seen in the description of Christian rites in Min. Felix, *Oct.* 9.1–10.5. For an excellent discussion of pagan and Christian attitudes toward one another, see Dodds 1965, 102–38 (esp. 110–16).

145. On the discourse of gender relations between these texts, see Cancik-Lindemaier 1996.

146. This particular restriction is not unique: a similar stricture was applied to the male priesthood of the Magna Mater, who came to Rome in 204 (D.H. 2.19.3–5). Citizens were not permitted to hold this office until the reign of the emperor Claudius (Lydus, *Mens.* 4.59). See Roller 1999, 292–96 and 315–16.

147. From Livy's account it appears that slaves could be initiated into the rites; Hispala Faecenia participated before her manumission (39.10.5). Hispala's assertion that there were *nobiles* among the Bacchants (39.13.14) implies the involvement of other freeborn aristocratic elements, perhaps hinted at by the identification of *ingenui* at 39.8.7. For a recent review of the evidence for the range of groups to whom the *Senatus Consultum* applied, see Mouritsen 1998, 49–58.

148. Flower (2002) also sees the Senate's primary interest as the curbing

of male activity. Where our interpretations differ is that Flower believes the underlying issue was male encroachment into traditionally female roles and the importation of organizational structures from groups traditionally overseen by men into a sphere traditionally supervised by women. I argue that the form of Bacchic ritual and the organization of the cult in 186 was substantially the same (if not completely identical) to what had preceded. What had changed was the tenor of group meetings: in addition to their usual religious activities, worshipers had begun to organize themselves politically against Roman hegemony.

149. Rousselle 1989, 60.

150. Pairault-Massa 1987, 590–93.

151. This same description could be applied to many, though not all, of the named Catilinarian conspirators as well (Sallust, *BC* 17.1–7). For the ringleaders in 186 (M. and C. Atinius, L. Opicernius, and Minius Cerrinius), see Livy 39.17.6–7; Gruen 1990, 59; and Bauman 1990, 341–342. Members of the *gens Atinia* had succeeded as far as the praetorship in the decade preceding the crisis. The Cerrinii were a prominent family at Pompeii. Nothing is known about Opicernius. North 1979, 94: "[T]he leadership came from well-off, though not top-ranking families."

152. De Sanctis 1907–64, 4.2.2.367.

153. Bruhl 1953, 115; Bayet 1969, 152; Gruen 1990, 72–73 (though not as a reaction against the Scipionic group specifically).

154. Bruhl 1953, 115–16; Bayet 1969, 152; Dumézil 1970, 521.

155. North 1979; Gruen 1990, 72–73; Beard, North, and Price 1998, 1.95–96.

156. Rousselle 1982, 96–116.

157. See *MRR* 1.352–67, s.a. 191–188, with citations of ancient sources.

158. It is possible that growing political opposition was one of the factors determining the Senate's decision to send troops into Bruttium and Etruria, though it is equally possible that Roman presence in the region stirred up an opposition that had not existed previously. Another possibility is that the Romans came into contact with Bacchic cells through their military involvement in these areas.

159. Gruen 1990, 72; Walsh 1996, 199.

160. Pairault-Massa 1987.

161. Pairault-Massa 1987, 575. For the assimilation of Fufluns and Dionysus, see Bruhl 1953, 73–75; M. Cristofani, *LIMC* 3.1.531–40, s.v. "Fufluns"; and Bonfante 1993.

162. Pairault-Massa 1987, 591.

163. Asconius 7.10 on *Pis.* 8. For commentary, see Marshall 1985, 94 and 262–63.

164. That the *Senatus Consultum* refers to participation in Dionysiac rites as "Bacas . . . adiese" (going to the Bacchae [line 7]) may indicate that the Senate perceived the cult as primarily appealing to women. Even if this is in fact the case, however, such an understanding would not preclude a further perception of the cult as a cover for the organization of political opposition.

Chapter 3

1. Wissowa 1912 and Latte 1960.

2. For example, Beard, North, and Price 1998, 1.12–13. Specialist studies abound, including Maule and Smith 1959, Pensabene et al. 1980, Bouma 1996, and the volumes in the series *Corpus delle Stipi Votivi*. The study of votive material has advanced a great deal now that it is considered as a broader cultural phenomenon rather than only as an element of individual archaeological sites. The first of two fundamental articles for this line of inquiry is Fenelli's 1975 article on the votive deposit from Lavinium. Fenelli lays out many of the most important controversies surrounding the interpretation of anatomical votives and offers a map illustrating the geographical distribution of finds similar to the Lavinium deposit, a basic catalog indicating the types of items found in each deposit, and a bibliography of the most important sources to date for each site. The second, Comella 1981, builds on Fenelli's quantitative work. Comella expands and occasionally corrects Fenelli's site catalog and updates her bibliography in an effort to identify the typological characteristics of the votive practice that defines the religious koine of west central Italy. Comella also offers an explanation for the diffusion of these votive deposits beyond Etruria, Latium, and Campania into much of the Italian peninsula.

3. Augustine, *CD* 6.9 (probably drawing on Varro); Festus 93L, s.v. "ipsilles," and 398L, s.v. "subsilles."

4. 2.10.3; cf. Non. 161–62L, s.v. "flavisas."

5. On *stips*, see Var., *L.* 5.182. Cf. Livy 5.25.5, 25.12.14, 27.37.9, 38.45.9 (not in a religious context). Also *CIL* 1².680 = 10.3781 = *ILS* 5561 = *ILLRP* 717 = Fredericksen 1984, 282, no. 12 (from the area around ancient Capua) and *CIL* 1².800 = 6.7 = *ILS* 3836 = *ILLRP* 39 (from Rome), among others. See also Wissowa 1912, 428–29; Latte 1960, 252 and 294; Hackens 1963, 84; Forcellini 4.492, s.v. "stips." For more detailed examination of terminological difficulties, see Hackens 1963 and Bouma 1996, 1.43–51.

6. See, e.g., the discussions by Brilliant 1974, 224–32, and Felletti Maj 1977, 43–65.

7. Comella 1981, 768–69, esp. fig. 3. The geographical limits of this practice, defined by Comella and generally accepted by scholars, have now come under significant criticism, on which see below.

8. Comella 1981, 758.

9. The issue of Romanization and the spread of anatomical votive practice will be discussed below.

10. Torelli in *RMR* 138–39. Lesk 2002, 194 (following Turfa 1994, 224–25) cites "Etruscan social change and Roman expansion" as reasons for an increased nonaristocratic presence at sanctuaries.

11. For further consideration, see Beloch 1926, 352–66, and Scullard 1980, 76–84. Cornell (1995, 318–22) does not dispute Rome's growth during the course of the fourth century, but is more skeptical than Beloch and Scullard about the extent to which the Gallic sack of the city disrupted Roman military success and territorial expansion.

12. Livy 6.42.1–2 (*decemviri*) and 10.6.4–10.9.2 (*lex Ogulnia*).

13. Torelli in *RMR* 341–43; Comella 1981, 775. See also Turfa 1986, 206; Edlund 1987, 56; de Cazanove 1991 and 2000b. The explanation of the phenomenon as a by-product of Romanization is sometimes combined with others, e.g., Bouma 1996, 1.209 (a combination of Roman propaganda, personal belief, and economic factors) and Lesk 2002, 194 (adds increased popular attendance of religious sites). Söderlind (2000–2001) examines another facet of west central Italic votive practice, terracotta heads, and links its development to Roman conquest as well.

14. On the putative Corinthian origin of Italic anatomical votives, see Lesk 2002.

15. De Cazanove 1991 and 2000b.

16. Turfa 2004, 359.

17. Turfa 2004, 360.

18. Glinister, forthcoming. Cf. Turfa 2004, 360.

19. Glinister, forthcoming.

20. MacCormick and Blagg 1983, 46; Potter 1985, 40; Girardon 1993, 31; Söderlind 2002, 346–58 (attributing the decline in quality of votive terracotta heads over time and the contemporary appearance of anatomical votives to increasing popularity of doctors among those who could afford their services, thus leaving healing cults to the less affluent).

21. Rizzello 1980, 202; Arthur 1991, 46–47; Lesk 2002, 195.

22. Glinister (forthcoming) proposes, but does not pursue, this idea.

23. A photograph of one such example, dated to the third or second century and coming from the Minerva Medica deposit from Rome, can be seen in Baggieri 1999, 37, fig. 2.

24. Discussed above, chapter 2.

25. So Turfa 2004, 360–61.

26. Fenelli in Castagnoli et al. 1975, 253; Fenelli 1975, 212; Comella 1981, 762.

27. Gatti Lo Guzo 1978, 139, no. S8 and pl. LII; Martini 1990, 19, fig. 10b. Also in Baggieri 1999, 49, fig. 27.

28. Fenelli in Castagnoli et al. 1975, 261–62, fig. D68–70; Fenelli 1975, 216–18; Pensabene et al. 1980, 262–65 and pls. 105–6; Girardon 1993, 34. See also Decouflé 1964, pl. 3. Ferrea and Pinna (in Coarelli 1986, 135), disagree with Fenelli about the Lavinian phalluses. See also Turfa 2004, 361.

29. Panciera 1989–90, 914.

30. For Turpilius as the *nomen* of Publilia's husband, see the note for *ILLRP* 82.

31. Allegrezza and Baggieri in Baggieri 1999, 34–35. The possibility is raised, though not necessarily endorsed by Girardon 1993 and Turfa 2004, 361.

32. Pazzini 1935; Pugliese Carratelli 1968, 325–26; Fenelli 1975, 210. Also Ferrea and Pinna in Coarelli 1986, 132–33. Pensabene et al. (1980, 25–26) does not think that Pazzini's explanation applies to Roman votive practice from the classical period, but is willing to entertain the possibility that such an explanation is valid for religious practice of an earlier age.

33. Pazzini 1935, 52.

34. Pazzini 1935, 50–51.

35. Pazzini 1935, 47.

36. Pazzini (1935, 55) also cites Matthew 18.8–9 as evidence for a Christian belief that the loss of a part of the human body could absolve an individual of his sin and purify his whole person. As evidence for the prevalence among ancient cultures of the belief that illness was identified with a sin to be expiated, Pazzini (1935, 54, n. 1) cites the *Susruta Ayurveda*, the *Iliad* and the *Odyssey*, and the Bible.

37. There is some question about the exact nature of the Philistines' affliction. The Hebrew text of Samuel has the word *ofolim*, meaning tumors. Masoretic commentary on the passage, written perhaps as early as the eighth century C.E. and designed to promote stability of the Hebrew text, indicates that

ofolim ought to be replaced with *tchorim*, "hemorrhoids." In fact, Masoretic notes indicate such a change at every occurrence of the word in the Bible (elsewhere in this passage and at Deuteronomy 28:27), which lends authority to the substitution. In general, Masoretic notes indicate changes in pronunciation or scribal error, but the two Hebrew words with which we are concerned here are too different in appearance and pronunciation for either concern to have prompted the note. It is possible that there were two traditions of the tale, and it appears that this variation existed far earlier than the codification of the Masoretic text. The Masoretic correction was favored by the Septuagint translation, which says that the Philistines offered πέντε ἕδραι χρυσᾶι (LXX 1 Reigns 6.4; *Septuaguinta*, Alfred Rahlfs, ed.). Jerome, the translator of the Vulgate Samuel, also anticipates the Masoretic tradition, translating the Hebrew as *ani aurei* (*Biblia sacra: iuxta vulgatam versionem*, 1983 ed.). Both *ofolim* and *tchorim* come into modern Hebrew as "hemorrhoids."

38. I Sam. 6.4. Translation from *The New Jerusalem Bible* (1966). The priests' response demonstrates the potential political implications of what otherwise appears to be a very personal and intimate matter. The number five is significant for the Philistines, whose land was populated by five major cities (the Philistine Pentapolis): Gaza, Ashkelon, Ashdod, Gath, and Ekron (Dothan 1982, 17). The expiatory offering of five golden hemorrhoids together with the golden rats indicates that the punishment visited upon the Philistines was a punishment upon their whole people, for an action committed on behalf of the whole people. The inclusion of the golden rats probably indicates that the afflictions were thought to have been brought into the land by vermin.

39. Dothan (1982, 21) accepts the incident as typical of Philistine religious practice, identifying the golden representations as one of "the few specifically Philistine beliefs that appear in the Bible." All that can be said with certainty, however, is that the practice of offering anatomical votives is foreign to Jewish tradition.

40. For a partial list of the locations of the Argei, see Var. *L.* 5.45–54. Etiologies and descriptions of the rite celebrated on the Pons Sublicius are found in Var., *L.* 7.44, and in the second book of the *De Vita Populi Romani*, quoted by Non., 842L; Ov., *Fast.* 5.621–62; D.H., 1.38; Plu., *Mor.* 272B = *RQ* 32 and 285A = *RQ* 86; Gel. 10.15.30; Paul., *Fest.* 14L, s.v. "Argeos," 18L, s.v. "Argea," and *Fest.* 452L; Macr., *Sat* 1.11.47; Lact., *Inst.* 1.21. The observance in May is the second of two involving the topographical Argei. Ovid mentions an earlier rite in mid-March (*Fast.* 3.791–92), but other sources offer no details. Gellius and Plutarch

include in the procession the *flaminica Dialis*, who is omitted by the other authors. Modern scholars disagree about whether the priestess was present at the March ceremony or the event in May.

41. Pazzini 1935, 46–47 and 56–59; Frazer 1929, 4.91–94. Also Var., *L.* 7.44; D.H. 1.38.3 (sacrifice demanded by Saturn); Ov., *Fast.* 5.623–32 (sacrifice demanded by Jupiter) and 5.650–62 (Argives); Plu., *Mor.* 272B = *RQ* 32. The Varronian etymology (Argei / 'Ἀργεῖοι) is accepted by Wissowa (1912, 60 and 420) and also Nagy (1985, 16–20). Fowler (1899, 112–13), Latte (1960, 143) and R. Palmer (1970, 84) rightly prefer uncertainty to the ancient derivation.

42. L. A. Holland 1961, 313–31.

43. R. Palmer 1970, 84–97.

44. Harmon 1978a, 1446–59; Torelli 1984, 99–104 and 121; Nagy 1985; Ziolkowski 1998–99, 215.

45. Pazzini 1935, 50–51.

46. E.g., see Orcevia's dedication to Fortuna (*CIL* 1².60 = 14.2863 = *ILS* 3684 = *ILLRP* 101, discussed above, chapter 2), also *CIL* 1².42 = 14.4270 = *ILS* 3234 = *ILLRP* 82 (from Nemi), and perhaps also *CIL* 1².2440 = *ILLRP* 204 (provenance uncertain, now in Vienna).

47. Pazzini 1935, 47–48.

48. Aesculapius: Coarelli 1986, 89–144. Minerva Medica: Gatti Lo Guzo 1978; Martini 1990, 13–20. Ceres: Thomasson 1961, 136–38. Gravisca: Comella 1978, 89–92. On this general issue, see Turfa 2004, 362–63.

49. E.g., Thomasson 1961, 137.

50. A possibility raised by Turfa (1986, 207 and 1994, 224), though more recently she has moved away from this idea (Turfa 2004, 360).

51. A similar situation regarding the multiple spheres of divine influence is found in the worship of Catholic saints, who are often thought to have exceptional competence in a particular area but who are also approached by worshipers with concerns outside the saint's sphere of expertise. Traces of this phenomenon can be seen in Delehaye's (1998, 119–69) discussion of pagan survivals in the cults of Catholic saints.

52. Potter (1989, 93–94) discusses the sanctuary at Ponte di Nona as a healing sanctuary, although there is no indication of the deity to whom the area belonged. Based on the number of anatomical votives yielded by the excavations at Ghiaccio Forte, Del Chiaro (1974a, 271) writes "Hence, though there has thus far appeared no conclusive evidence to determine the identity of the deity or deities whose favor was sought or recompensed by these votive objects,

there can be no question that an important healing cult existed at Ghiaccio Forte." Elsewhere (1974b, 389; 1976, 30) he leaves open the possibility that the cult might have focused on fertility.

53. Carbardiacum lies in the area south of Placentia along the Trebia River.

54. Comella 1981, 762.

55. These are largely unknown in other contexts (north and south Italian, as well as Greek). Turfa 2004, 360–61.

56. For further discussion, see Ferrea and Pinna in Coarelli 1986, 133–34. The most extensive discussion of the interpretation of votives of internal organs is Turfa 1994.

57. Turfa 2004, 361.

58. Two cow and calf pairs are known from Ghiaccio Forte (Del Chiaro 1976, 28 and pl. XII). Lavinium has yielded a veritable menagerie of cows, pigs, a wild boar, birds (including a swan), a ram, a sheep (?), and others (Castagnoli et al. 1975, 334–37). Among the offerings found at the Campetti site at Veii are two terracotta birds and a cow (Vagnetti 1971, 94 and pls. LII, SI–SIII).

59. Lavinium: Thomasson 1961, 123, and Castagnoli et al. 1975, 335–36, fig. 403, nos. E 230–33. The hoof from Tessenanno can be seen in Costantini 1995, 70 and pl. 29. The hoof from Caere is on display at the museum in Cerveteri.

60. Fenelli in Castagnoli et al. 1975, 253 and 303.

61. Turfa 1994, 227.

62. Del Chiaro 1976, 27–28; Comella 1978, 61 and pls. xxxi–xxxv; Turfa 1994, 228.

63. Wells 1964, 267, n. 34 and pl. 34; Decouflé 1964, pl. 1 (side-by-side comparison of abnormal uteri with a "healthy" organ); De Laet and Desittere 1969, 22 and pl. 6; Bartoloni 1970, 266 and pl. 22d; Torelli and Pohl 1973, 245–47, esp. figs. 121–23; Pensabene et al. 1980, pls. 102 and 103; Martini 1990, 18, fig. 9c; Castagnoli et al. 1975, 263–64, fig. 357, nos. D 73–75.

64. Sambon 1895, 149 (ovary and tube); Wells 1964, 267, n. 34 (fibroid tumor or vaginal cyst); Bartoloni 1970, 266 (blister or ovary); Comella 1978, 61 (small tumor); Costantini 1995, 75 (fibroma or cyst). For additional bibliography on each of these interpretations, see Fenelli 1975, 220, n. 60. Again, the most comprehensive treatment of the interpretive issues raised by these objects is found in Turfa 1994.

65. As tentatively proposed by Potter 1989, 48.

66. Fenelli 1975, 218–24. Other proponents of the theory are Rouquette 1911, 394; Holländer 1912, 192–93; Tabanelli 1962, 74; and De Laet and Desittere 1969,

22. For additional bibliography, see Turfa 1994, 228, n. 55. Turfa dismisses this interpretation as "fanciful."

67. See Dean-Jones 1994, 1–40, for a concise history of the study of gynecology in antiquity and a discussion of ancient theories of feminine anatomy (41–109). Also Gourevtich 1996.

68. As cited by Aristotle (*De Gen. An.* 4.1, 763b) and the third-century C.E. scholar Censorinus (*De Die Natali* 6.6–8). Censorinus also attributes the idea to the philosopher Empedocles, roughly contemporary with Anaxagoras, but Aristotle says that Empedocles thought the gender of a fetus was determined by the temperature of the uterus during gestation.

69. *De Usu Partium* 14.4–7 = 4.151–176K (quoting Hippocrates at 14.4 = 4.153K). Hanson (1992, 45) argues that the idea is largely absent from the Hippocratic Corpus and was given medical authority only by Galen's support of it. See also Dean-Jones 1994, 166–68, and O'Dowd and Philipp 1994, 46.

70. *De Gen. An.* 4.1, 765a.

71. Von Staden 1989, Fr. 61, T61, also pp. 165–69 and 296–99; Jackson 1988, 95.

72. *Gyn.* 1.11–12 = Temkin 1956, 11–12; Jackson 1988, 95.

73. *De Usu Partium* 14.11 = 4.189–190K, *De Semine* 2.1 = 4.593–610K; Blayney 1986, 234. Dean-Jones 1994, 68: "Both the Hippocratics and Aristotle therefore believed that a woman's reproductive apparatus was limited to the womb."

74. According to Pliny (*Nat.* 29.12–13), Archagathus of Sparta arrived in Rome 219 as the first Greek doctor to practice in the city. It is more likely, however, that Archagathus was not the first physician in Rome but rather was the first Greek doctor appointed to serve as a public physician among the Romans (Jackson 1988, 31, n. 33; Nutton 1993, 59). Passing references to medical specialists working in Rome prior to the advent of Archagathus can be found in D.H. 10.53.1 and V. Max. 2.4.5. On the dating of Asclepiades' career, see Rawson 1991c, 430–34. For consideration of Roman attitudes to medicine and the medical profession, see Scarborough 1993 and Nutton 1993.

75. Turfa (2004, 362) points out how the phenomenon of "visiting gods" might complicate research in this vein.

76. Potter 1985, 31–32.

77. Above, chapter 2.

78. Fenelli 1975, 232–45; Comella 1981, 720–59. A more recent catalog in Bouma 1996, vol. 3, does not include a typological breakdown of the deposits.

79. The deposits found at Lavinium (more than 1,000 terracottas) and at

Fregellae (more than 4,000) fall into this category. Conveniently, the recent publication of a massive concentration of votives (more than 8,000 terracotta pieces) from Ponte di Nona outside of Rome includes an examination of the relative proportions of different types of votives from the site and a comparison of those statistics with other large deposits (Potter 1989, 91–96).

80. In fact, at the present time, the sanctuary at Gravisca remains the only well-published site to yield a large group of votives that contains anatomical votives of only a single gender. Of the 660 items from the site, 330 are anatomical votives. The vast majority of these, 301 out of 330, are obviously female: breasts (5), uteri (294), and external female genitalia (2). The remainder of the Gravisca anatomical votives comprises ears, feet, and hands. There are no phalluses in the deposit.

81. Satricum: Bouma 1996. Tessenanno: Costantini 1995. Vulci: Pautasso 1994. Ghiaccio Forte: Del Chiaro 1976.

82. It is not clear how accurate is Glinister's assertion that "deposits usually contain many more female than male votive heads and statuettes" (Glinister, forthcoming).

Chapter 4

1. Harmon 1978b, 1592.

2. E.g., Harmon 1978b and Orr 1978.

3. See, e.g., the brief treatments in Scheid 2003a, 165–70, and Latte 1960, 103–11. The subject does not figure prominently in Beard, North, and Price 1998.

4. Most recently Turcan 2000, 14–50. Boëls-Janssen 1993, esp. 253–71, is an excellent resource.

5. Rose 1959, 178–81; Orr 1978, 1561–62. Each part of the house was consecrated to the gods: Serv., *A.* 2.469 = Thilo and Hagen 1881–87, 1.291.

6. Varro, *L.* 5.69; Ov., *Fast.* 2.435–52; Boëls-Janssen 1993, 259–66.

7. See, e.g., the instructions in Cato's *De Agricultura* for prayers and offerings to Jupiter Dapalis and Vesta for the oxen (132); to Ceres, Janus, Jupiter, and Juno for the harvest (134); and to Janus, Jupiter, and Mars for the lustration of fields (141).

8. Cic., *Dom.* 143.

9. These questions have been long debated without any definitive answers being reached. See, e.g., the various interpretations offered by De Marchi 1896–1903, 1.37–78; Wissowa 1912, 156–81; Dumézil 1970, 1.340–44; Orr 1978; and Harmon 1978b.

10. Numerous examples are listed in De Marchi 1896–1903, 1.28, n. 1.

11. Ov., *Fast.* 6.291–310.

12. Cato, *Ag.* 143.2; Ov., *Fast.* 6.310.

13. Some argue that Vesta was, in fact, one of the *Penates* (Orr 1978, 1560; Rose 1959, 178).

14. *Dig.* 33.9.3.

15. E.g., Cic., *Cat.* 4.18; Tac., *Ann.* 15.41. The exact nature of the contents of the *penus Vestae* was the subject of much speculation. Dionysios of Halicarnassus (2.66.3–6) and Plutarch (*Cam.* 20.5–6) both record a variety of proposals, ranging from the Palladium and other items brought from Troy (Cic., *Scaur.* 48 and *Phil.* 11.24; D.H. 1.69.2–4; Ov., *Fast.* 6.421–36 and *Tr.* 3.1.29) to a phallus-shaped object (Plin., *Nat.* 28.39). Most commonly, the ancients believed the temple of Vesta contained the Palladium and other items that ensured the continuation of Roman *imperium*. Additional references can be found in Wissowa 1912, 159, n. 5.

16. Ov., *Fast.* 5.129–36; Orr 1978, 1567, n. 54. The numismatic evidence comprises a denarius of L. Caesius, otherwise unknown. The coin is dated to the late second century (Crawford 1974, 1.312, no. 298).

17. Pl., *Aul.* 1–5.

18. Pl., *Aul.* 23–25 (*cottidie*); Cato, *Ag.* 143.2.

19. Cato, *Ag.* 2.1.

20. The method for determining the date of the celebration is not certain (Fowler 1899, 279–80). See the introduction, above.

21. Cic., *Att.* 2.3 = Shackleton Bailey 1965–71, 23(II.3)4. Paul., *Fest.* 273L, s.v. "pilae et effigies."

22. Festus 84L, s.v. "genium." Orr 1978, 1569–75.

23. Tib. 2.2; Arn., *Nat.* 2.67.

24. E.g., *CIL* 10.772 (from Stabiae; imperial); Verg., *Aen.* 5.84–85, and Servius's commentary on the passage (Thilo and Hagen 1881–87, 1.602–3).

25. E.g., *ILS* 2289–92 (all imperial).

26. E.g., *ILS* 7066 (from Voorburg) and 7067 (from Colonia Agrippina), both of imperial date.

27. The *Genius populi Romani* can be seen on two denarii of the 70s (Crawford 1974, 1.407, no. 393 and 409, no. 397).

28. Fishwick 1987–2002, 2.375–87; Beard, North, and Price 1998, 1.184–85; Gradel 2002, 116–28. Ov., *Fast.* 5.137–46.

29. Lygdamus [Tib.] 3.6.48 and [Tib.] 3.19.15–16. See Rives 1992, 34–35. On the poems in the *corpus* and their authorship, see Conte 1994, 330–31.

30. Cf. Plin., *Nat.* 2.16.

31. E.g., *CIL* 8.22770 (from Tatahouine, Tunisia). See also Orr 1978, 1570–71.

32. This is the view taken by Rives 1992 (which includes a helpful survey of earlier arguments and a careful consideration of the dating of the available evidence) and Boëls-Janssen 1993, 268–71.

33. Rives 1992, 38.

34. See note 32, above.The dedications are *CIL* 11.3076 = *ILS* 116 (from Borghetto along the via Flaminia) and *ILS* 120 (from El-Lehs in Africa). On the specific dating of these inscriptions, see Rives 1992, 37, n. 15.

35. Rives's (1992, 43–44) association of the *iuno* with the spread of marriage *sine manu* may be correct, but the state of the available evidence requires that this remain hypothetical.

36. Lemuria: Ov., *Fast.* 5.431–44. Ambarvalia: Tib. 2.1.21–24.

37. Cato, *Ag.* 5.1.

38. The relationship between the two couples is laid out explicitly in Col. 12.praef.8–10.

39. Gel. 4.1.1–23; Col. 12.praef.2–6. De Marchi's (1896–1903, 1.109–10) discussion of the role of the *matrona* in domestic religion is greatly supplemented by Boëls-Janssen's (1993, 253–58) treatment/reconstruction.

40. *Agr.* 143. On the *vilica*'s performance of matronal duties, see Col. 12.

41. Nonius 852L, s.v. "nubentes"; Boëls-Janssen 1993, 254. Prayer: Arn., *Nat.* 2.67. A Roman marriage bed was called the *genialis lectus*: Paul., *Fest.* 83L, s.v. "genialis lectus"; for additional ancient testimony and extended discussion, see Boëls-Janssen 1993, 209–16.

42. Boëls-Janssen 1993, 254.

43. Col. 12.19.1–41.1.

44. Gel. 4.1.7 (wine) and 4.1.20 (incense). For the ancient legal debate of what was properly stored in the *penus*, see Digest 33.9.3. The Digest makes it clear that debate lasted for centuries, from Q. Mucius Scaevola in the early first century B.C.E. (*MRR* 2.11, s.a. 95) to Ulpian in the third century C.E. The definition of *penus* expanded over time to include all household items, including livestock.

45. Cato, *Agr.* 143.3. Plin., *Nat.* 18.107. It is unlikely that home-ground *far* was intended exclusively for ritual purposes: another traditionally feminine task was baking bread. *Far* may also have been turned into a porridge (*puls*), an easier task as it required less refinement of the tough grain (Plin., *Nat.* 18.83–84; this passage also notes the ritual use of *puls* for *sacra prisca et natalium* [ancient rites and birthday celebrations]).

46. Wildfang 1999 argues that the importance of the Vestals resides mainly in their role as producers and keepers of ritually necessary items.

47. D.H. 2.66.3. Cf. Fest. 296L, s.v. "<penus>," and H.A., *Heliog.* 6.6.

48. The Vestals produced *mola salsa* three times a year: at the Lupercalia, the Vestalia, and the Ides of September. Fest. 152L, s.v. "muries." Cf. Servius, *ad Ecl.* 8.82 = Thilo and Hagen 1881–87, 3.106. On alternate days between the Nones and the Ides of May, the three senior Vestals harvested, roasted, and ground *far*. It is likely that, after they completed grinding the *far* in May, the Vestals bound the leftover stalks together for disposal at the Pons Sublicius the next day, at the annual procession of the Argei (L. A. Holland 1961, 313–31).

49. Ov., *Fast.* 4.731–34. For ancient speculation about other items stored in the *penus Vestae*, see note 15 above.

50. Ov., *Fast.* 4.629–40; Fest. 190L, s.v. "October equus," and 246L, s.v. "panibus"; Plu., *Mor.* 287A–B = *RQ* 97, where the sacrifice is incorrectly dated to Ides of December.

51. For public ritual obligations shared among members of a priest's family, see D.H. 2.22.1.

52. Cf. Tib. 1.10.23–24 and Verg., *A.* 7.71–72.

53. *Att.* 2.3 = Shackleton Bailey 1965–71, 23(II.3)4.

54. Paul. ex Fest. 273L, s.v. "pilae et effigies," and 108L, s.v. "laneae."

55. Cf. *CIL* 1².1211 = 6.15346 = *ILLRP* 973 = *ILS* 8403 = Courtney 1995, 46–47, n. 17, and 234–236. Although spinning and weaving are closely associated with proper matronal activity throughout Roman history (as evidenced by numerous literary references and funerary monuments), it is unlikely that aristocratic ladies of the late Republic were responsible for clothing their families. For the coexistence of commercial and domestic textile production in the middle republican period, see Morel 1983, 31–32. This article explores the difficulty of establishing the nature of the commercial or industrial situation of Italy in that period. Moeller (1976, 4–8) offers a strong argument for the nearly complete industrialization of wool production by the late republican or early imperial period, although he acknowledges that the long-lived association between feminine virtue and woolworking harkens back to a "former and more simple age." For a discussion of weaving imagery and the promotion of feminine virtue in the imperial period, see D'Ambra 1993, 78–108.

56. Boëls-Janssen 1993, 258.

57. On the close relationship between a woman's position as *domina* and her obedience to her husband, see Pearce 1974.

58. The overall similarity of the two passages illustrates Cato's primary concern to direct the slaves' religious activities toward the benefit of the household as a whole and away from the benefit of the slaves themselves.

59. Pl., *Aul.* 23–25.

60. Gras 1983; de Cazanove 1987; Scheid 1992, 379–80; Versnel 1996, 194–95; Beard, North, and Price 1998, 1.297. On women and wine generally, see Durry 1955; Piccaluga 1964; Minieri 1982; Bettini 1995a and 1995b; Russell 2003. Pailler (2000) offers a very useful review of the ancient evidence and of the development of the modern debate on the interdiction of wine.

61. Festus, 72L. This issue is addressed further in Flemming, forthcoming.

62. De Cazanove 1987; Scheid 1992, 380; Versnel 1996, 195.

63. Flemming, forthcoming, comes to the same conclusion.

64. Plu., *Rom.* 15.4. On the close connection between spinning and proper matronal virtue, see note 55 above.

65. For more extensive treatment, see Flemming, forthcoming.

66. The locus classicus is Gel. 10.23.1–5.

67. E.g., Fabius Pictor ap. Plin., *Nat.* 14.89.

68. E.g., Cato ap. Gel. 10.23.4–5; D.H. 2.25.6–7. For variations on this theme, see, e.g., Noailles 1948, 15–17; Bettini 1995a and 1995b.

69. Durry 1955 (abortifacient); Piccaluga 1964, 202–23 (enhances female tendency toward prophetic or mad speech).

70. Murray 1985, 48–49. On women at Roman and Latin *convivia*, see Rathje 1990, 283. Several of the contributions, including another by Rathje, in Murray and Tecusan 1995, take up aspects of the *convivium* in Roman society.

71. MacCormack 1975, 173–74.

72. Serv., *ad Aen.* 1.737 = Thilo and Hagen 1881–87, 1.205. Columella includes the production and preservation of wine among the tasks of the *vilica* (12.18.1–41.1).

73. Bona Dea: Plu., *Mor.* 268D–E = *RQ* 20, and also Macr., *Sat.* 1.12.25 (cf. Brouwer 1989, 327–36). Anna Perenna: Ov., *Fast.* 3.523–42.

74. Flemming, forthcoming.

75. Gel. 10.23.2. Cf. Bettini 1995b.

76. Plin., *Nat.* 14.89; for commentary see Pailler 2000, 74–75.

77. Russell 2003, 80; Bietti Sestieri 1992, 102–18 and 230–31; Gras 1983, 1069; *Civiltà* 166–86; Bartoloni 1974. Another category of archaeological evidence, small votive cups (*pocula*), may also indicate the ritual use of wine by women. Many of these miniature cups, sometimes bearing the name of the Roman deity to whom they were given, have been found in Rome and outlying regions. Their

shape implies the pouring of libations, and their prevalence among votive material suggests that they, like anatomical votives and statuary, were regularly offered to the gods by all worshipers. For further discussion and bibliography, see Gianfrotta's treatment of the ceramics from the round temple of Hercules in the Forum Boarium in Rakob and Heilmeyer 1973, 4–6. For a different interpretation (*pocula* as pilgrimage souvenirs), see *RMR* 57–72 and Beazley 1947, 209–16.

78. E.g., D.H. 2.25.6–7; Plu., *Mor.* 284F = *RQ* 85 and *Lyc.-Num.* 3.5; Serv., *ad Aen.* 1.737 = Thilo and Hagen 1881–87, 1.205. The interdiction on wine was certainly a topic of antiquarian interest: "qui de victu atque cultu populi Romani scripserunt mulieres Romae atque in Latio aetatem abstemias egisse hoc est vino semper" (Those who have written on the civilization and culture of the Roman people say that women at Rome and in Latium lived an abstemious life, that is, they abstained from wine [Gel. 10.23.1]).

79. *Mor.* 284F = *RQ* 85.

80. Cato, *Agr.* 143.2–3.

81. Var., *R.* 2.10.6–8.

82. Col. 12.18.1–41.1.

83. An extended description of Roman sacrificial procedure is offered by Scheid 2003a, 79–93. See also Wissowa 1912, 409–32 (esp. 416–20) and 498; Latte 1960, 375–93: Dumézil 1970, 2.557–59; Beard, North, and Price 1998, 1.36–37. Images of Roman sacrifice are found in Ryberg 1955 (e.g., pls. XXI and XXI bis) and Torelli 1982, pl. III.20–21.

84. *Collegium victimariorum*: CIL 6.971 = *ILS* 4963 (from Rome; imperial). *Collegia tibicinum*: CIL 1².988 = 6.3696 = 6.30932 = 6.36756 = *ILLRP* 185 (from Rome) and CIL 1².989 = 6.3877 = 6.32448 = *ILLRP* 775 (from Rome).

85. For the various sacrifices (blood and horticultural) offered by the Vestals throughout the year, see Wildfang 2001. The *regina sacrorum* sacrificed a pig or a lamb to the Capitoline Juno on the Kalends of each month (Macr. *Sat.* 1.15.19; see the discussion in R. Palmer 1974a, 23–35, but disregard his assertion that this sacrifice "confirms" that the *regina sacrorum* was a priestess of Juno). Public priests (e.g., the pontiffs) regularly made sacrifices to a host of gods but were not tied to any one deity in particular. Priestesses of Liber sacrificed special cakes for paying customers at the Liberalia (Var., *L.* 6.14).

86. Ov., *Fast.* 4.629–40.

87. Juno Regina: Livy 27.37.8–10 and above, chapter 1.

88. Commentary in Dyck 2004, 312.

89. Contrast the properly respectful tone of Horace's *Carm.* 3.14.5–6, where

Livia is encouraged to make offerings to the gods for Augustus's safe return from Spain.

90. Flemming, forthcoming, offers more extensive consideration of this and other references to female sacrificial headgear, which she has collected. It is clear from her discussion that it cannot be determined if we are to understand from Festus that any woman could wear a *rica* and offer sacrifice or, if a more restricted reading is in order, that only those women who could offer sacrifice (the Vestals and other public priestesses) wore the *rica* when they did so.

Chapter 5

1. On the dispute over Pudicitia Patricia and the establishment of a shrine to Pudicitia Plebeia, see above, chapter 1.

2. Szemler 1972, 30–31.

3. Gel. 1.12.5 and 12; Dio 55.22.5 (unsuccessful first attempt to select a Vestal from among candidates of equestrian and freed status in 5 C.E.).

4. *MRR* 1.534 and 537, s.a. 114–113. On the family connections of the Vestals involved, see E. Klebs, *RE* 1.590–91, s.v. "Aemilia (153)"; F. Münzer, *RE* 13.498, s.v. "Licinia (181)"; and F. Münzer, *RE* 14.1601–2, s.v. "Marcia (114)." For the father of Licinia, see *MRR* 1.470, s.a. 145; the father and brother of Marcia, *MRR* 1.471, s.a. 144 and 1.527, s.a. 118, respectively. See note 13 below.

5. Gaius, *Inst.* 1.112; Tac., *Ann.* 4.16. On the status and ritual requirements for a confarreate marriage, see Treggiari 1991, 21–24, and Linderski 1986.

6. Serv., *ad G.* 1.31 = Thilo and Hagen 1881–87, 3.139.

7. Plu., *Mor.* 287D–E = *RQ* 99; Plin., *Nat.* 18.2.6. Cf. Beard 1990, 24.

8. Liv. 26.23.8.

9. Tertullian, *Cast.* 13.1; Gel. 10.15.

10. Tertullian, *Cast.* 13.1 and *Monog.* 17.4. On the appearance of priestesses of Ceres in this catalog, see chapter 2.

11. Julius Caesar held the pontificate from 73. He became *pontifex maximus*, beating out more senior candidates, following the death of Q. Caecilius Metellus Pius in 63. See *MRR* 2.113, s.a. 73 and 2.171, s.a. 63.

12. Virginal chastity was not the only aspect of the Vestals' existence that set them apart from other Romans. Beard (1980, followed by the "affectionate critique" in Beard 1995) considers the combination of virginal, matronal, and even masculine elements in the requirements and duties observed by the Vestals. See also Wildfang 1999.

13. The best-documented instance from the republican period is the trial in 114–113 of three Vestals, of whom only one was convicted. See discussion earlier in this chapter. After public outcry, the Vestals were tried again; this time all three were convicted. In the aftermath of this incident, a temple was built for Venus Verticordia: Dio 26.87.1–5; Livy, *Per.* 63; Obs. 37. See also Plu., *Mor.* 283F–284C = *RQ* 83, who does not mention Venus Verticordia. Mustakallio 1992 traces a link between the type of omen that revealed a Vestal's transgression and the time of year the transgression occurred. We do not know of any provision for the punishment of a promiscuous *flaminica* or *regina sacrorum.*

14. Plu., *Numa* 10.4–7.

15. Gel. 10.15.26–30; Plu., *Mor.* 276D–F = *RQ* 50; Tac., *Ann.* 4.16; Ov., *Fast.* 6.226–32; Serv., *ad Aen.* 4.29 = Thilo and Hagen 1881–87, 1.465. Noble status and, presumably, sexual purity were also required of the *camilli* and *camillae*, youths of excellent character who attended the *flamen Dialis* and his wife in their duties: Macr., *Sat.* 3.8.7. Serv., *ad Aen.* 11.543 = Thilo and Hagen 1881–87, 2.543–44; Paul., *Fest.* 82L, s.v. "flaminius camillus" and "flaminia." A further requirement of these young people, that both their parents be living, is a common thread in accounts of *pueri* and *puellae* (*virgines*) selected to assist religious officials in a variety of sacral acts: Cic., *Har.* 23; Livy 37.3.6; Obs. 40; Tac., *Hist.* 4.53; Macr., *Sat.* 1.6.14; Phlegon, *Macr.* 5.2(99), second oracle, lines 18–22. Young men who met these same ritual requirements participated in the rites of the Arval Brethren: Henzen 1874, 12–13; Scheid 1990, 535–36 and 547–49. The requirement that both parents be alive is a function of the Roman need to insure that those performing religious ritual existed in a perfect state—that no aspect of their existence was contrary to natural law.

16. The issue of their marital status is taken up at some length in chapter 2.

17. Spaeth (1996, 105) implies that Cicero's statement is evidence for the age and social class of the priestesses at Catena as well. Although this cannot be proved, everything we have seen thus far suggests that any woman selected for a religious honor must have met certain requirements of family and reputation. See above, chapter 2.

18. Gel. 1.12.11.

19. Although in essence selecting a married couple for the priesthood, the ancient sources indicate that the *pontifex maximus* was concerned primarily with the husband's qualifications. Wissowa 1912, 487–89; Gaius, *Inst.* 1.112.

20. Cic., *Att.* 13(1.13)3. Suet., *Jul.* 6.2. *MRR* 2.173, s.a. 62.

21. There is debate among scholars whether sortition in a public context was

viewed by the ancients as a randomizing process or as a way to allow the gods
to make a selection. See, e.g., Rosenstein 1995, Bers 2000, and many of the con-
tributions in Cordano and Grottanelli 2001. It is possible that the drawing of
lots for political purposes, such as the selection of ambassadors from among
local town officials, may have been intended to select fairly, without concern
for divine will, an individual for an onerous task or exceptional honor (see
Maffi's contribution in Cordano and Grottanelli 2001). Even so, it is hard to
see the use of lots for the selection of a Vestal as a randomizing device (*contra*
Rosenstein 1995). There is nothing random about the process. As noted above,
Vestals always came from the most prestigious families, and the slate of can-
didates was handpicked by the *pontifex maximus* himself. It is clear that not
just any Roman girl could grow up to become a Vestal. The limits placed on
the early steps of the process ensured that the gods would make an acceptable
choice (acceptable to the Romans, that is), no matter which candidate they
chose.

22. This story is examined in detail in chapter 1.

23. V. Max. 8.15.12. Cf. Plin., *Nat.* 7.120, Solinus 1.126.

24. For Sulpicia's father and husband, see *MRR* 1.206, s.a. 258 and 1.285, s.a.
209 respectively. Wiseman (1979, 98, n. 147) believes this episode is a complete
fabrication due to what he perceives as confusion about the date of the dedica-
tion of the statue. The episode is generally dated to the end of the third century
based on the identity of Sulpicia's father and husband and on the elder Pliny's
statement (*Nat.* 7.120) that this was the first instance of a woman being selected
sententia matronarum for a religious distinction, the second being the selec-
tion of Claudia Quinta in 204. Julius Obsequens (37), however, reports that
a temple to Venus Verticordia was not dedicated until 114 in response to the
punishment of three Vestals for *incestum*. Wiseman's skepticism is unnecessary.
The ancient sources are relatively consistent in the identification of Sulpicia's
father and husband, both of whom can be identified as consuls in the mid- to
late third century. Furthermore, within Roman religious practice it was pos-
sible to dedicate a statue of one deity in the temple of another; see, e.g., Plin.,
Nat. 36.24 and *CIL* 10.8416 = *ILS* 3487 (from Cora): "Matri [Ma]tutae / Magia
Prisca / signum Iovis / d(onum) d(edit)" [To Mater Matuta, Magia Prisca gave
this statue of Juppiter as a gift). Schilling (1954, 226) rightly argues that the
statue of Venus Verticordia must have been dedicated in the third century and
that the goddess went without a temple of her own until 114. Sulpicia's dedi-
cation probably took place prior to the war with Hannibal: it is unlikely that

the dedication could have happened during that war and completely escaped the notice of Livy. Sulpicia may well have been married prior to her father's consulship in 258 and therefore would have qualified as a *matrona* for several decades prior to the Hannibalic War. See also Torelli (1984, 80–82), who dates Sulpicia's dedication after 204.

25. See above, chapter 1.

26. Livy 29.10.4–14.14 and Ov., *Fast.* 4.247–349.

27. Cic., *Cael.* 34 and *Har.* 27. Diod. Sic. 34/5.33.2 (identifies the woman as Valeria).

28. The story appears in the works of no fewer than thirty different authors, in addition to the accounts of Livy and Ovid. The sources have been tirelessly collected and the conflicts among them carefully laid out by Schmidt 1909, 1–18. See also Roller 1999, 264–71.

29. Ov., *Fast.* 4.326. On the importance of drama to the development of Roman historiography, see Wiseman 1994, 1–22.

30. *CIL* 6.492 = 6.30777. The dedication, made by Claudia Syntyche, contains a relief of Claudia Quinta pulling a ship carrying a statue of Cybele. Below is an inscription reading: "Matri deum et Navi Salviae / Salviae voto suscepto / Claudia Syntyche / d(ono) d(edit)" (To the Mother of the Gods and to the Ship [called?] Savior <Savior>, Claudia Syntyche, having taken a vow, gave this as a gift). On the sides of the altar are reliefs of cult objects. Clear photographs of the altar can be seen in Vermaseren 1977, pl. 30, and Beard, North, and Price 1998, 2.46. Dating of the altar: R. T. Scott, personal communication.

31. For discussion of Julio-Claudian attention to Cybele's cult, see Vermaseren 1977, 40–41 and 177–79; Wiseman 1979, 94–99.

32. Gruen 1990, 26; Wiseman 1979, 94–99; Köves 1963, 335–47.

33. Fowler 1911, 328–29. Presumably, Fowler here makes reference to the religious hysteria that swept through Rome in 213, driving the people—and especially women—to seek comfort in the performance of all sorts of questionable rituals (Livy 25.1.6–12).

34. Pomeroy 1975, 178.

35. Kraemer 1992, 56. Cf. Pomeroy 1975, 206, and Chirassi-Colombo 1981, 421.

36. "Dress for a Roman often, if not primarily, signified rank, status, office, or authority" (Bonfante in Sebesta and Bonfante 1994, 5). For the early imperial *lex Iulia Theatralis*, see Rawson 1991d. Even before Augustus's legislation, special seating at public entertainment was a long-standing privilege of Roman

senators and equestrians. The latter lost this right under Sulla, though it was restored by the *lex Roscia Theatralis* of 67 (Rotondi 1912, 374–75 and 507).

37. For an extended discussion of curial religion, see R. Palmer 1970, 80–179.

38. Macr., *Sat.* 1.6.13–14. It is possible that the text of Macrobius incorrectly records the *praenomen* of the augur. There is no other record of an augur named M. Laelius. The augur Gaius Laelius, famous for his wisdom and eloquence (Cic., *N. D.* 3.5), served as consul in 140 and was probably appointed to his priesthood prior to that time (*MRR* 1.478–79, s.a. 141 B.C.E.). In all likelihood, it is this Laelius to whom Macrobius refers. This identification draws further support from the fact that the *praenomen* Marcus is unknown among members of the *gens Laelia* in the republican period. For further discussion, see F. Münzer, *RE* 12.413, s.v. "Laelius (8)."

39. D.H. 8.56.4. Serv., *ad Aen.* 4.19 = Thilo and Hagen 1881–87, 1.464 (*bis nuptae* banned from the priesthood); Fest. 282L, s.v. "Pudicitiae signum" (and Paulus's somewhat misleading excerpt [283L]). Tert., *Monog.* 17.3.

40. Gel. 4.3.3.

41. The Floralia was famous for its licentious nature: Ov., *Fast.* 5.331–78; Mart. 1.praef; Aug., *Civ. Dei* 2.27. On the Vinalia, see Ov., *Fast.* 4.863–900; R. Palmer 1974b, 135–37; McGinn 1998, 24–26.

42. Livy 22.1.18. Above, chapter 1.

43. Plu., *Mor.* 267D = *RQ* 16. Ov., *Fast.* 6.473–568 (esp. 551–58, 481–82).

44. Plu., *Rom.* 29.3–6 and *Cam.* 33.2–6; Macr., *Sat.* 1.11.35–40. Cf. R. Palmer 1974a, 7–17.

45. See above, chapter 1.

46. Ovid's treatment of these rituals (*Fast.* 4.133–64) opens with an address to the two different groups of women — "matresque nurusque / et vos, quis vittae longaque vestis abest" (mothers and newlywed girls, and you who lack the headbands and the long dress) — but the poet then conflates the two rituals. The Fasti Praenestini do not mention Venus Verticordia, but rather suggest that all women worshiped Fortuna Virilis though only the *humiliores* went to the men's baths (Degrassi 1963, 127, 433–34; cf. Plu., *Num.* 19.2). Modern efforts to resolve the apparent confusion have not been successful. Staples (1998, 110) claims that "Fortuna Virilis . . . is nothing more than a cult title of Venus. It is not a name meant to denote a separate entity. Fortuna Virilis has the same force as Verticordia." Subtler are Torelli's statements (1984, 80–82) that the cult of Venus Verticordia was added to the cult of Fortuna Virilis and that Venus Verticordia was a euphemistic name for Fortuna. These arguments, however, are without

substantiation or precedent. No ancient author claims that the goddesses were one and the same, and to my knowledge, there is no evidence from Italic religious practice of one deity regularly addressed by the name of another. Despite confusion in the sources, Fortuna Virilis and Venus Verticordia were clearly two different deities who were worshiped on at least one particular day by two different groups of women. Fantham (1998, 120) implies that the worshipers of Fortuna Virilis were prostitutes, but Pomeroy (1975, 208) rightly points out that it is unclear whether the cult was popular among plebeian women generally, or courtesans and prostitutes specifically. See also McGinn 1998, 25. Other ancient sources indicate that worship of Venus Verticordia was restricted to *matronae* (Macr., *Sat.* 1.12.15; Lydus, *De mens.* 4.65). On the significance of Venus Verticordia, see V. Max. 8.15.12, Plin., *Nat.* 7.120, and Solinus 1.126.

47. Polyb. 31.26.1–10. For commentary on this passage, see Walbank 1979, 3.503–5, which includes a very helpful family stemma. For Polybius's presentation of Aemilianus's public persona as a conscious construction, see Walbank 1979, 3.499.

WORKS CITED

Altheim, F. 1938. *A History of Roman Religion*. Translated by Harold Mattingly. London: Methuen.

Arthur, P. 1991. *Romans in Northern Campania: Settlement and Land-Use around the Massico and the Garigliano Basin*. Archaeological Monographs of the British School at Rome, 1. London: British School at Rome.

Baggieri, G. 1999. *L'antica anatomia nell'arte dei Donaria*. Rome: Ministero per i Beni e le Attività Culturali.

Balsdon, J. P. V. D. 1962. *Roman Women: Their History and Habits*. London: Bodley Head.

Bartoloni, G. 1970. "Alcune terrecotte votive delle collezioni medicee ora al Museo Archeologico di Firenze." *SE* 38: 257–70.

———. 1974. *Le Tombe NN. 23 e 68 bis della necropoli arcaica di Castel di Decima*. Documenti Ostiensi 2. Rome: Soprintendenza alle Antichità di Ostia.

Bauman, R. A. 1990. "The Suppression of the Bacchanals: Five Questions." *Historia* 39: 334–48.

Bayet, J. 1969. *Histoire politique et psychologique de la religion romaine.* 2nd ed. Paris: Payot.

Beard, M. 1980. "The Sexual Status of Vestal Virgins." *JRS* 70: 12–27.

———. 1990. "Priesthood in the Roman Republic." In *Pagan Priests: Religion and Power in the Ancient World,* edited by M. Beard and J. North, 17–48. Ithaca: Cornell University Press.

———. 1991. "Writing and Religion: *Ancient Literacy* and the Function of the Written Word in Roman Religion." In M. Beard et al., *Literacy in the Roman World,* 35–58. *JRA* suppl. 3.

———. 1995. "Re-reading (Vestal) Virginity." In *Women in Antiquity: New Assessments,* edited by R. Hawley and B. Levick, 166–77. London: Routledge.

Beard, M., J. North, and S. Price. 1998. *Religions of Rome.* 2 vols. Cambridge: Cambridge University Press.

Beazley, J. D. 1947. *Etruscan Vase-Painting.* Oxford: Clarendon.

Beloch, K. J. 1926. *Römische Geschichte bis zum Beginn der punischen Kriege.* Berlin: de Gruyter.

Bendlin, A. 2000. "Looking beyond the Civic Compromise: Religious Pluralism in Late Republican Rome." In *Religion in Archaic and Republican Rome and Italy,* edited by E. Bispham and C. Smith, 115–35. Edinburgh: Edinburgh University Press.

Bers, V. 2000. "Just Rituals, Why the Rigamarole of Fourth-Century Athenian Lawcourts?" In *Polis and Politics: Studies in Ancient Greek History,* edited by P. Flensted-Jensen, T. H. Nielsen, and L. Rubinstein, 553–62. Copenhagen: Museum Tusculum Press.

Bettini, M. 1995a. "Le donne romane, che non bevono vino." In *Vicende e figure femminili in Grecia e a Roma,* edited by R. Raffaelli, 531–36. Ancona: Commissione per le Pari Opportunità tra Uomo e Donna della Regione Marche.

———. 1995b. "In vino stuprum." In *In Vino Veritas,* edited by O. Murray and M. Tecusan, 224–35. London: British School at Rome.

Biblia sacra iuxta vulgatam versionem. 1983. 3rd ed. Stuttgart: Deutsche Bibelgesellschaft.

Bietti Sestieri, A. M. 1992. *The Iron Age Community of Osteria dell'Osa.* Cambridge: Cambridge University Press.

Blayney, J. 1986. "Theories of Conception in the Ancient Roman World." In *The Family in Ancient Rome: New Perspectives,* edited by B. Rawson, 230–36. London: Croom Helm.

Boak, A. E. R. 1916. "The *Magistri* of Campania and Delos." *CP* 11: 25–45.

Bodel, J. 1994. "Graveyards and Groves. A Study of the Lex Lucerina," *AJAH* 11 (1986) [pub. 1994]: 1–133.

⸻, ed. 2001. *Epigraphic Evidence: Ancient History from Inscriptions*. London: Routledge.

Boëls-Janssen, N. 1993. *La vie religieuse des matrones dans la Rome archaïque*. CEFR(A) 176. Rome: École Française de Rome.

Bömer, F. 1969–86. *Metamorphosen*. 7 vols. Heidelberg: Carl Winter.

Bonfante, L. 1993. "Fufluns Pacha: The Etruscan Dionysus." In *Masks of Dionysus*, edited by T. H. Carpenter and C. A. Faraone, 221–35. Ithaca: Cornell University Press.

Bouma, J. W. 1996. *Religio Votiva: The Archaeology of Latial Votive Religion*. 3 vols. Drachten: Donkel and Donkel.

Boyce, A. A. 1937. "The Expiatory Rites of 207 B.C." *TAPA* 68: 157–71.

Bradley, K. R. 1986. "Wet-Nursing at Rome: A Study in Social Relations." In *The Family in Ancient Rome: New Perspectives*, edited by B. Rawson, 201–29. Ithaca: Cornell University Press.

Bremmer, J. N. 1982. "The Suodales of Poplios Valesios." *ZPE* 47: 133–47.

⸻. 1998. "'Religion,' 'Ritual' and the Opposition of 'Sacred vs. Profane.'" In *Ansichten griechischer Rituale: Geburtstag-Symposium für Walter Burkert*, edited by F. Graf, 9–32. Stuttgart: Teubner.

Brilliant, R. 1974. *Roman Art from the Republic to Constantine*. London: Phaidon.

Briscoe, J. 1973. *A Commentary on Livy Books XXXI–XXXIII*. Oxford: Clarendon.

Brouwer, H. H. J. 1989. *Bona Dea: The Sources and a Description of the Cult*. Études Préliminaires aux Religions Orientales dans l'Empire Romain, 110. Leiden: E. J. Brill.

Bruhl, A. 1953. *Liber Pater: Origine et expansion du culte dionysiaque à Rome et dans le monde romain. BEFAR* 175. Paris: E. De Boccard.

Brunt, P. A. 1988. *The Fall of the Roman Republic and Related Essays*. Oxford: Clarendon.

Burkert, W. 1985. *Greek Religion*. Translated by J. Raffan. Oxford: Blackwell.

Cancik-Lindemaier, H. 1996. "Der Diskurs Religion im Senatsbeschluß über die Bacchanalia von 186 v. Chr. und bei Livius (B. XXXIX)." In *Geschichte-Tradition-Reflexion*, vol. 2, edited by H. Cancik, H. Lichtenberger, and P. Schäfer, 77–96. Tübingen: Mohr.

Canetti, E. 1999. *The Memoirs of Elias Canetti*. New York: Farrar, Straus, and Giroux.

Castagnoli, F. 1980. "Santuari e culti nel lazio arcaico." *ArchLaz* 3: 164–67.

Castagnoli, F., et al. 1975. *Lavinium II: Le Tredici Are.* Rome: De Luca.

Castrén, P. 1975. Ordo Populusque Pompeianus: *Polity and Society in Roman Pompeii.* Acta Instituti Romani Finlandiae 8. Rome: Bardi.

Cébeillac, M. 1973. "Octavia, épouse de Gamala, et la *Bona Dea.*" *MEFRA* 85: 517–53.

Cébeillac-Gervasoni, M., ed. 1996. *Les élites municipales de l'Italie péninsulaire des Gracques à Néron.* CEFR(A) 215. Rome: École Française de Rome.

———. 2004. "La dedica a Bona Dea da parte di Ottavia, moglie di Gamala." In *Ostia, Cicero, Gamala, Feasts, and the Economy: Papers in Memory of John H. D'Arms,* edited by A. Gallina Zevi and J. H. Humphrey, 75–81. *JRA* suppl. 57.

Champeaux, J. 1982. *Fortuna: Recherches sur le culte de la Fortuna à Rome et dans le monde romaine des origines à la mort de César I: Fortuna dans la religion archaïque.* CEFR(A) 64:1. Rome: École Française de Rome.

Chiarucci, P. 1983. *Lanuvium.* Collana di studi sull'Italia Antica 2. Rome: Palaeani.

Chirassi-Colombo, I. 1981. "Funzioni politiche ed implicazioni culturali nell'ideologia religiosa di Ceres nell'Impero Romano." *ANRW* 2.17.1: 403–28.

Coarelli, F., ed. 1986. *Fregellae 2: Il santuario di Esculapio.* Rome: Quasar.

———. 1992. *Il Foro Boario dalle origini alla fine della Repubblica.* 2nd ed. Rome: Quasar.

———. 1996. *Revixit Ars: Arte e ideologia a Roma.* Rome: Quasar.

Colonna, G. 1956. "Sul sacerdozio peligno di Cerere e Venere." *ArchClass* 8: 216–17.

———. 1991. "Riflessioni sul dionisismo in Etruria." In *Dionysos, mito e mistero: Atti del convegno internazionale, Comacchio 3–5 Novembre 1989,* edited by F. Berti, 117–55. Ferrara: Liberty House.

Comella, A. 1978. *Il materiale votivo tardo di Gravisca.* Rome: Bretschneider.

———. 1981. "Tipologia e diffusione dei complessi votivi in Italia in epoca medio- e tardo-Repubblicana." *MEFRA* 93: 717–803.

Conte, G. B. 1994. *Latin Literature: A History.* Translated by J. B. Solodow. Baltimore: Johns Hopkins University Press.

Cordano, F., and C. Grottanelli. 2001. *Sorteggio pubblico e cleromanzia dall'antichità all'età moderna.* Milan: ET.

Cornell, T. J. 1991. "The Tyranny of the Evidence: A Discussion of the Possible Uses of Literacy in Etruria and Latium in the Archaic Age." In M. Beard et al., *Literacy in the Roman World,* 7–33. *JRA* suppl. 3.

————. 1995. *The Beginnings of Rome*. London: Routledge.

Costantini, S. 1995. *Il deposito votivo del Santuario Campestre di Tessennano*. Corpus delle Stipi Votive in Italia 8. Rome: Bretschneider.

Courtney, E. 1995. *Musa Lapidaria: A Selection of Latin Verse Inscriptions*. American Classical Studies 36. Atlanta: Scholars Press.

————. 1999. *Archaic Latin Prose*. American Classical Studies 42. Atlanta: Scholars Press.

Crawford, M. H. 1974. *Roman Republican Coinage*. 2 vols. Cambridge: Cambridge University Press.

Cresci Marrone, G., and G. Mennella. 1984. *Pisaurum I: Le iscrizioni della Colonia*. Pisa: Giardini.

Curchin, L. A. 1982. "Family Epithets in the Epigraphy of Roman Spain." In *Mélanges offerts en hommage au Révérend Père Étienne Gareau*, 179–82. Ottawa: Éditions de l'Université d'Ottawa.

D'Ambra, E. 1993. *Private Lives, Imperial Virtues: The Frieze of the Forum Transitorium in Rome*. Princeton: Princeton University Press.

David, J. 2000. "The Exclusion of Women in the Mithraic Mysteries: Ancient or Modern?" *Numen* 47: 121–41.

de Cazanove, O. 1987. "*Exesto*: L'incapacité sacrificielle des femmes à Rome (à propos de Plutarque *Quaest. Rom.* 85)." *Phoenix* 41: 159–73.

————. 1991. "Ex-voto de l'Italie républicaine: Sur quelques aspects de leur mise au rebut." In *Les sanctuaires celtiques et leurs rapports avec le monde méditerranéen*, edited by J.-L. Brunaux, 203–14. Paris: Errance.

————. 2000a. "I destinatari dell'iscrizione di Tiriolo e la questione del Campo d'Applicazione del Senatoconsulto *De Bacchanalibus*." *Athenaeum* 88: 59–69.

————. 2000b. "Some Thoughts on the 'Religious Romanisation' of Italy before the Social War." In *Religion in Archaic and Republican Rome and Italy*, edited by E. Bispham and C. Smith, 71–76. Edinburgh: Edinburgh University Press.

De Laet, S. J., and M. Desittere. 1969. "Ex voto anatomici di Palestrina del Museo Archeologico dell'Università di Gand." *AntClass* 38: 16–27.

De Marchi, A. 1896–1903. 2 vols. *Il culto privato di Roma antica*. Forli: Victrix.

De Sanctis, G. 1907–64. *Storia dei Romani*. 4 vols. Florence: La Nuova Italia Editrice.

De Vos, A., and M. De Vos. 1982. *Pompei, Ercolano, Stabia*. Guide Archeologiche Laterza. Rome: Laterza.

Dean-Jones, L. 1994. *Women's Bodies in Classical Greek Science*. Oxford: Clarendon.

Decouflé, P. 1964. *La notion d'ex-voto anatomique chez les Étrusco-Romains*. Collection Latomus 72. Brussels: Latomus.

Degrassi, A. 1963. *Fasti Anni Numani et Iuliani*. Inscriptiones Italiae 13.2. Rome: Istituto Poligrafico dello Stato.

———. 1969. "Aretinae Matronae." In *Hommages à Marcel Renard*, edited by J. Bibauw, 2.173–77. Collection Latomus 102. Brussels: Latomus.

Del Chiaro, M. A. 1974a. "A Newly Discovered Etruscan Town." *Archaeology* 27: 270–73.

———. 1974b. "University of California, Santa Barbara Excavations at Ghiaccio Forte, Tuscany (First Campaign, Summer 1973)." *AJA* 78: 385–90.

———. 1976. *Etruscan Ghiaccio Forte*. Santa Barbara: University of California.

Delehaye, H. 1998. *The Legends of the Saints*. Translated by D. Attwater. Dublin: Four Courts Press. Original edition, Brussels: Sociéte des Bollandistes, 1955.

des Bouvrie, S. 1997. "Euripides' *Bakkhai* and Maenadism." *C&M* 48: 75–114.

Dessau, H. 1884. "Archaische Bronce-Inschrift aus Palestrina." *Hermes* 19: 453–55.

Dixon, S. 2001. *Reading Roman Women: Sources, Genres, and Real Life*. London: Duckworth.

Dodds, E. R. 1965. *Pagan and Christian in an Age of Anxiety*. Cambridge: Cambridge University Press.

Dorcey, P. F. 1989. "The Role of Women in the Cult of Silvanus." *Numen* 36: 143–55.

———. 1992. *The Cult of Silvanus: A Study in Roman Folk Religion*. Columbia Studies in the Classical Tradition, 20. Leiden: E. J. Brill.

Dothan, T. 1982. *The Philistines and Their Material Culture*. New Haven: Yale University Press.

Dumézil, G. 1970. *Archaic Roman Religion*. Translated by P. Krapp. 2 vols. Chicago: University of Chicago Press.

Durry, M. 1955. "Les femmes et le vin." *REL* 33: 108–13.

Dyck, A. R. 2004. *A Commentary on Cicero, De Legibus*. Ann Arbor: University of Michigan Press.

Edlund, I. 1987. "Mens Sana in Corpore Sano: Healing Cults as a Political Factor in Etruscan Religion." In *Gifts to the Gods: Proceedings of the Uppsala Symposium 1985*, edited by T. Linders and G. Nordquist, 51–56. Boreas: Uppsala Studies in Ancient Mediterranean and Near Eastern Civilizations 15. Upsala: Ubsaliensis S. Academiae.

Ernout, A. 1965. *Philologica III.* Paris: Klincksieck.

Ernout, A., and A. Meillet. 1959. *Dictionnaire étymologique de la langue latine.* 4th ed. Paris: Klincksieck.

Fabian, K.-D. 1978. "Aspekte einer Entwicklungsgeschichte der römischlatinischen Göttin Iuno." Ph.D. diss., Frei Universität Berlin.

Fantham, E., et al. 1994. *Women in the Classical World: Image and Text.* New York: Oxford University Press.

————. 1998. *Ovid* Fasti *Book IV.* Cambridge Greek and Latin Clasics. Cambridge: Cambridge University Press.

Fears, J. R. 1975. "The Coinage of Q. Cornificius and Augural Symbolism on Late Republican Denarii." *Historia* 24: 592–602.

Felletti Maj, B. M. 1977. *La tradizione italica nell'arte romana I.* Rome: Bretschneider.

Fenelli, M. 1975. "Contributo per lo studio del votivo anatomico: I votivi anatomici di Lavinio." *ArchClass* 27: 206–52.

Fishwick, D. 1987–2002. *The Imperial Cult in the Latin West.* 3 vols. Leiden: Brill.

Flemming, R. Forthcoming. "Festus and the Role of Women in Roman Religion." In *Verrius, Festus and Paul: Lexicography, Scholarship and Society*, edited by F. Glinister, M. H. Crawford, J. A. North, and C. Woods. BICS Supplement. London: Institute of Classical Studies.

Flower, H. I. 2000. "*Fabula de Bacchanalibus*: The Bacchanalian Cult of the Second Century BC and Roman Drama." In *Identität und Alterität in der frührömischen Tragödie*, edited by G. Manuwald, 23–35. Würzburg: Ergon.

————. 2002. "Rereading the *Senatus Consultum de Bacchanalibus* of 186 BC: Gender Roles in the Roman Middle Republic." In *Oikistes: Studies in Constitutions, Colonies, and Military Power in the Ancient World*, edited by V. B. Gorman and E. W. Robinson, 79–98. Leiden: Brill.

Forbis, E. P. 1990. "Women's Public Image in Italian Honorary Inscriptions." *AJP* 111: 493–512.

Fowler, W. W. 1899. *The Roman Festivals of the Period of the Republic.* London: Macmillan.

————. 1911. *The Religious Experience of the Roman People.* London: Macmillan.

Frankiel, T. 1990. *The Voice of Sarah: Feminine Spirituality and Traditional Judaism.* San Francisco: Harper.

Fraschetti, A., ed. 2001. *Roman Women.* Translated by L. Lappin. Chicago: University of Chicago Press.

Frazer, J. G. 1929. *The Fasti of Ovid*. 5 vols. London: Macmillan.

Frederiksen, M. W. 1959. "Republican Capua: A Social and Economic Study." *PBSR* 27, n.s. 14: 80–130.

———. 1984. *Campania*. Edited by N. Purcell. London: British School at Rome.

Friggeri, R., and C. Pelli. 1980. "Vivo e morto nelle iscrizioni di Roma." In *Tituli* 2: *Miscellanea*, edited by S. Panciera, 95–172. Rome: Edizioni di Storia e Letteratura.

Gabba, E. 1976. *Republican Rome, the Army and the Allies*. Translated by P. J. Cuff. Berkeley: University of California Press.

———. 1994. "Rome and Italy: The Social War." In *The Cambridge Ancient History* 9, 104–28. 2nd ed. Cambridge: Cambridge University Press.

Gagé, J. 1963. *Matronalia*. Collection Latomus 60. Brussels: Latomus.

Gatti, S., and M. T. Onorati. 1992. "Praeneste medio-repubblicana: Gentes ed attività produttive." In *La necropoli di Praeneste*, 189–252. Palestrina: Comune di Palestrina.

Gatti Lo Guzo, L. 1978. *Il deposito votivo dall'Esquilino detto di Minerva Medica*. Studi e Materiali de Etruscologia e Antichità Italiche, 17. Florence: Sansoni.

Gill, C., and T. P. Wiseman. 1993. *Lies and Fiction in the Ancient World*. Austin: University of Texas Press.

Girardon, S. 1993. "Ancient Medicine and Anatomical Votives in Italy." *Institute of Archaeology Bulletin* 30: 29–40.

Glinister, F. Forthcoming. "Reconsidering Religious Romanization." In *Religion in Republican Italy*, edited by C. E. Schultz and P. B. Harvey Jr. Yale Classical Studies. Cambridge: Cambridge University Press.

Gordon, A. E. 1938. *The Cults of Lanuvium*. University of California Publications in Classical Archaeology 2.2. Berkeley: University of California Press.

Gourevitch, D. 1996. "La gynécologie et l'obstétrique." *ANRW* 2.37.3: 2083–146.

Gradel, I. 2002. *Emperor Worship and Roman Religion*. Oxford: Clarendon.

Gras, M. 1983. "Vin et société à Rome et dans le Latium à l'époque archaïque." In *Modes de contacts et processus de transformation dans les sociétés anciennes*, 1067–75. CEFR(A) 67. Rome: École Française de Rome.

Grueber, H. A. 1910. *Coins of the Roman Republic in the British Museum*. 3 vols. London: British Museum.

Gruen, E. S. 1990. *Studies in Greek Culture and Roman Policy*. Leiden: E. J. Brill.

Hackens, T. 1963. "Favisae." In *Études étrusco-italiques: Mélanges pour le 25e anniversaire de la Chaire d'Étruscologie à l'Université de Louvain*, 71–99. Re-

cueil de Travaux d'Histoire et de Philologie 4e séries, fasc. 31. Louvain: Université de Louvain.

Halkin, L. 1953. *La supplication d'action de Graces chez les Romains*. Bibliothèque de la Faculté de Philosophie et Lettres de l'Université de Liège 128. Paris: Société d'Édition "Les Belles Lettres."

Hänninen, M.-L. 1998. "Conflicting Descriptions of Women's Religious Activity in Mid-Republican Rome: Augustan Narratives about the Arrival of Cybele and the Bacchanalia Scandal." In *Aspects of Women in Antiquity*, edited by L. L. Lovén and A. Strömberg, 111–26. Jonsered: P. Åströms Förlag.

———. 1999a. "The Dream of Caecilia Metella: Aspects of Inspiration and Authority in Late Republican Roman Religion." In *Female Networks and the Public Sphere in Roman Society*, edited by P. Setälä and L. Savunen, 29–38. Acta Instituti Romani Finlandiae 22. Rome: Institutum Romanum Finlandiae.

———. 1999b. "Juno Regina and the Roman Matrons." In *Female Networks and the Public Sphere in Roman Society*, edited. P. Setälä and L. Savunen, 39–52. Acta Instituti Romani Finlandiae 22. Rome: Institutum Romanum Finlandiae.

Hansen, W. 1996. *Phlegon of Tralles' Book of Marvels*. Exeter: University of Exeter Press.

Hanson, A. E. 1992. "Conception, Gestation, and the Origin of Female Nature in the *Corpus Hippocraticum*." *Helios* 19: 31–71.

Harmon, D. P. 1978a. "The Public Festivals of Rome." *ANRW* 2.16.2: 1440–68.

———. 1978b. "The Family Festivals of Rome." *ANRW* 2.16.2: 1592–603.

Harris, W. V. 1971. *Rome in Etruria and Umbria*. Oxford: Clarendon.

Harvey, P. 1975. "Cicero *leg. agr.* 2.78 and the Sullan Colony at Praeneste." *Athenaeum* 53: 33–56.

———. Forthcoming. "Religion and Memory at Pisaurum." In *Religion in Republican Italy*, edited by C. E. Schultz and P. B. Harvey Jr. Yale Classical Studies. Cambridge: Cambridge University Press.

Häussler, R. 2002. "Writing Latin—from Resistance to Assimilation: Language, Culture and Society in N. Italy and S. Gaul." In *Becoming Roman, Writing Latin? Literacy and Epigraphy in the Roman West*, edited by A. E. Cooley, 61–76. *JRA* suppl. 48.

Haynes, S. 2000. *Etruscan Civilization: A Cultural History*. Los Angeles: J. Paul Getty Museum.

Henzen, W. 1874. *Acta Fratrum Arvalium quae supersunt*. Berlin: Reimer.

Heurgon, J. 1959. "The Date of Vegoia's Prophecy." *JRS* 49: 41–45.

———. 1973. *The Rise of Rome to 264 B.C.* Translated by J. Willis. London: Batsford.

Holland, L. A. 1961. *Janus and the Bridge.* Papers and Monographs of the American Academy in Rome, 21. Rome: American Academy.

Holland, L. L. Forthcoming. "*Diana Feminarum Tutela?* The Case of *Noutrix Paperia.*" In *Essence of the Huntress: The Worlds of Artemis and Diana*, edited by N. Bannister and N. Waugh. Bristol: Phoenix Press.

Holländer, E. 1912. *Plastik und Medizin.* Stuttgart: Enke.

Jackson, R. 1988. *Doctors and Diseases in the Roman Empire.* Norman: University of Oklahoma Press.

Johnson, J. 1933–35. *Excavations at Minturnae.* 2 vols. Philadelphia: University of Pennsylvania Press.

Kampen, N. 1981. *Image and Status: Roman Working Women in Ostia.* Berlin: Mann.

Kleiner, D. E. E. 1996. "Imperial Women as Patrons of the Arts in the Early Empire." In *I Claudia: Women in Ancient Rome*, edited by D. E. E. Kleiner and S. B. Matheson, 28–41. Austin: University of Texas Press.

Koep, L. 1962. "'Religio' und 'Ritus' als Problem des frühen Christentums." *Jahrbuch für Antike und Christentum* 5: 43–59.

Köves, T. 1963. "Zum Empfang der Magna Mater in Rom." *Historia* 12: 321–47.

Kraemer, R. S. 1992. *Her Share of the Blessings: Women's Religions among Pagans, Jews, and Christians in the Greco-Roman World.* New York: Oxford University Press.

Kraus, C. S., and A. J. Woodman. 1997. *Latin Historians.* Greece & Rome: New Surveys in the Classics, no. 27. Oxford: Oxford University Press.

Laffi, U. 1973. "Sull'organizzazione amministrativa dell'Italia dopo la guerra sociale." In *Akten des VI. Internationalen Kongresses für Griechische und Lateinische Epigraphik, München 1972. Vestigia* 17: 37–53.

Lake, A. K. 1937. "The *Supplicatio* and *Graecus Ritus.*" In *Quantulacumque: Studies Presented to Kirsopp Lake*, edited by R. P. Casey, S. Lake, and A. K. Lake, 243–51. London: Christophers.

Latte, K. 1960. *Römische Religionsgeschichte.* Handbuch der Altertumswissenschaft 5.4. Munich: Beck.

Le Bonniec, H. 1958. *Le culte de Cérès à Rome.* Études et Commentaires 27. Paris: Klincksieck.

Lefkowitz, M. R., and M. B. Fant. 1992. *Women's Life in Greece and Rome.* 2nd ed. Baltimore: Johns Hopkins University Press.

Lesk, A. L. 2002. "The Anatomical Votive Terracotta Phenomenon in Central Italy: Complexities of the Corinthian Connection." In *Symposium on Mediterranean Archaeology (SOMA) 2001*, edited by G. Muskett, A. Koltsida, and M. Georgiadis, 193–202. BAR International Series 1040. Oxford: Archaeopress.

Linderski, J. 1986. "Religious Aspects of the Conflict of the Orders: The Case of *confarreatio*." In *Social Struggles in Archaic Rome*, edited by K. A. Raaflaub, 244–61. Berkeley: University of California Press. Reprinted in *Roman Questions, Select Papers*, 542–59. Stuttgart: Franz Steiner Verlag, 1995.

Lodge, G. 1925–26. *Lexicon Plautinum*. 2 vols. Leipzig: Teubner.

Lowe, C. 1978. "The Historical Significance of Early Latin Votive Deposits (Up to the Fourth Century B.C.)." *Papers in Italian Archaeology I: The Lancaster Seminar. British Archaeological Reports*, edited by H. M. Blake, T. W. Potter, and D. B. Whitehouse. BAR Supplementary Series 41(i): 141–52.

Lucchesi, E., and E. Magni. 2002. *Vecchie e nuove (in)certezze sul Lapis Satricanus*. Pisa: Edizioni ETS.

MacBain, B. 1982. *Prodigy and Expiation: A Study in Religion and Politics in Republican Rome*. Collection Latomus 177. Brussels: Latomus.

MacCormack, G. 1975. "Wine Drinking and the Romulan Law of Divorce." *Irish Jurist* 10:170–74.

MacCormick, A. G., and T. C. Blagg. 1983. *Mysteries of Diana: The Antiquities from Nemi in Nottingham Museums*. Nottingham: Castle Museum Nottingham.

MacMullen, R. 1982. "The Epigraphic Habit in the Roman Empire." *AJP* 103: 233–46.

Mann, J. C. 1985. "Epigraphic Consciousness." *JRS* 75: 204–6.

Marouzeau, J. 1922–38. *L'ordre des mots dans la phrase latine*. 4 vols. Collection Linguistique 12. Paris: Champion.

Marshall, B. A. 1985. *A Historical Commentary on Asconius*. Columbia: University of Missouri Press.

Martini, C. 1990. *Il deposito votivo del Tempio di Minerva Medica*. Rome: Fratelli Palombi.

Marx, F. 1904–5. *C. Lucilii Carminum reliquiae*. 2 vols. Leipzig: Teubner.

Mattingly, H. 1923–62. *Coins of the Roman Empire in the British Museum*. 6 vols. London: Trustees of the British Museum.

Maule, Q. F., and H. R. W. Smith. 1959. *Votive Religion at Caere: Prolegomena*. University of California Publications in Classical Archaeology, 4.1. Berkeley: University of California Press.

McGinn, T. A. J. 1998. *Prostitution, Sexuality, and the Law in Ancient Rome.* New York: Oxford University Press.

Mello, M., and G. Voza. 1968–69. *Le iscrizioni latine di Paestum.* 2 vols. Naples: Università degli Studi di Napoli.

Meyer, E. 1919. *Caesars Monarchie und das Principat des Pompejus.* Stuttgart: Cotta.

Miles, G. B. 1995. *Livy: Reconstructing Early Rome.* Ithaca: Cornell University Press.

Minieri, L. 1982. "Vini Usus Feminis Ignotus." *Labeo* 28: 150–63.

Moeller, W. O. 1976. *The Wool Trade of Ancient Pompeii.* Leiden: Brill.

Mommsen, T. 1874. "Die Erzählung von Cn. Marcius Coriolanus." *Hermes* 4: 1–26.

Morel, J.-P. 1983. "Les producteurs de biens artisanaux en Italie à la fin de la République." In *Les "bourgeoisies" municipales italiennes aux IIe et Ier siécle av. J.-C,* 21–39. Colloques Internationaux du Centre National de la Recherche Scientifique 609. Paris: Centre National de la Recherche Scientifique.

Mouritsen, H. 1998. *Italian Unification: A Study in Ancient and Modern Historiography.* BICS Supplement 70. London: Institute of Classical Studies.

Murray, O. 1985. "Symposium and Genre in the Poetry of Horace." *JRS* 75: 39–50.

Murray O., and M. Tecusan, eds. 1995. *In Vino Veritas.* London: British School at Rome.

Mustakallio, K. 1990. "Some Aspects of the Story of Coriolanus and the Women behind the Cult of Fortuna Muliebris." In *Roman Eastern Policy and Other Studies in Roman History,* edited by H. Solin and M. Kajava, 125–31. Commentationes Humanarum Litterarum 91. Helsinki: Societas Scientiarum Fennica.

———. 1992. "The 'crimen incesti' of the Vestal Virgins and the Prodigious Pestilence." In *Crudelitas: The Politics of Cruelty in the Ancient and Medieval World,* edited by T. Viljamaa, A. Timonen, and C. Krötzl, 56–62. Helsinki: Societas Scientiarum Fennica.

Nagy, B. 1985. "The Argei Puzzle." *AJAH* 10: 1–27.

Nilsson, M. P. 1953. "The Bacchic Mysteries of the Roman Age." *HTR* 46: 175–202.

———. 1957. *The Dionysiac Mysteries of the Hellenistic and Roman Age.* Skrifter Utgivna av Svenska Institutet I Athen 8°. Lund: Gleerup.

Nippel, W. 1997. "Orgien, Ritualmorde und Verschwörung?" In *Große Prozesse*

der römischen Antike, edited by U. Manthe and J. von Ungern-Sternberg, 65–73. Munich: Beck.

Noailles, P. 1948. "Les tabous du mariage dans le droit primitif des Romains." In *Fas et jus: Études de droit romain* by P. Noailles, 1–27. Paris: Société d'Édition "Les Belles Lettres."

Nock, A. D. 1972. "The Augustan Restoration." In *Arthur Darby Nock: Essays on Religion and the Ancient World,* edited by Z. Stewart, 16–25. Cambridge, Mass.: Harvard University Press. Originally published in *CR* 39 (1924–25): 60–67.

North, J. A. 1976. "Conservatism and Change in Roman Religion." *PBSR* 44, n.s. 30: 1–12.

———. 1979. "Religious Toleration in Republican Rome." *PCPhS* 25: 85–103.

———. 2000. "Prophet and Text in the Third Century, B.C." In *Religion in Archaic and Republican Rome and Italy,* edited by E. Bispham and C. Smith, 92–107. Edinburgh: University of Edinburgh Press.

Nutton, V. 1993. "Roman Medicine: Tradition, Confrontation, Assimilation." *ANRW* 2.37.1: 49–78.

Oakley, S. P. 1997–. *A Commentary on Livy, Books VI–X.* 3 vols. Oxford: Clarendon.

O'Dowd, M. J., and E. E. Philipp. 1994. *The History of Obstetrics and Gynaecology.* New York: Parthenon.

Ogilvie, R. M. 1970. *A Commentary on Livy, Books 1–5.* 2nd ed. Oxford: Clarendon.

Orlin, E. M. 1997. *Temples, Religion and Politics in the Roman Republic.* Leiden: Brill.

Orr, D. G. 1978. "Roman Domestic Religion: The Evidence of the Household Shrines." *ANRW* 2.16.2: 1557–91.

Pailler, J.-M. 1971. "Bolsena 1970: La maison aux peintures, les niveaux inférieurs et le complexe souterrain." *MEFRA* 83: 367–403.

———. 1976. "'Raptos a Diis Homines Dici . . .' (Tite-Live, XXXIX, 13): Les bacchanales et la possession par les nymphes." In *Mélanges offerts à Jacques Heurgon: L'Italie préromaine et la Rome républicaine,* 2.731–42. CEFR(A) 27. Rome: École Française de Rome.

———. 1983. "Les pots cassés des bacchanales: La couche d'incendie d'un sanctuaire de *Volsinii* et la chronologie de la céramique campanienne." *MEFRA* 95: 7–54.

———. 1988. *Bacchanalia: La répression de 186 av. J.-C. à Rome et en Italie.* BEFAR 270. Rome: École Française de Rome.

————. 1997. "La vierge et le serpent: De la trivalence à l'ambiguïté." *MEFRA* 109: 513–75.

————. 2000. "Quand la femme sentait le vin." *Pallas* 53: 73–100.

Pairault-Massa, F.-H. 1987. "En quel sens parler de la romanisation du culte de Dionysos en Étrurie?" *MEFRA* 99: 573–94.

Palmer, L. R. 1988. *The Latin Language*. Reprint, Norman: University of Oklahoma Press. Original edition, London: Faber and Faber, 1954.

Palmer, R. E. A. 1970. *The Archaic Community of the Romans*. Cambridge: Cambridge University Press.

————. 1974a. *Roman Religion and Roman Empire: Five Essays*. Philadelphia: University of Pennsylvania Press.

————. 1974b. "Roman Shrines of Female Chastity from the Caste Struggle to the Papacy of Innocent I." *RSA* 4: 113–59.

————. 1996. "The Deconstruction of Mommsen on Festus 462/464L., or the Hazards of Restoration." In Imperium Sine Fine: *T. Robert S. Broughton and the Roman Republic*, edited by J. Linderski, 75–101. Historia Einzelschrift 105. Stuttgart: Franz Steiner Verlag.

Panciera, S. 1989–90. "Le iscrizioni votive latine." *Scienze dell'Antichità* 3–4: 905–14.

Pautasso, A. 1994. *Il deposito votivo presso la Porta Nord a Vulci*. Corpus delle Stipi Votive in Italia 7. Rome: Bretschneider.

Pazzini, A. 1935. "Il significato degli 'ex voto' ed il concetto della divinità Guaritrice." *RAL* 11: 42–79.

Pearce, T. E. V. 1974. "The Role of the Wife as *Custos* in Ancient Rome." *Eranos* 72: 16–33.

Pease, A. S. 1920–23. *M. Tulli Ciceronis* De Divinatione. University of Illinois Studies in Language and Literature, 6 and 8. Urbana: University of Illinois Press.

Pensabene, P. 2001. *Le terrecotte del Museo Nazionale Romano II. Materiali dai depositi votivi di Palestrina Collezioni "Kircheriana" e Palestrina*. Studia Archaeologica 112. Rome: L'Erma di Bretschneider.

Pensabene, P., et al. 1980. *Terracotte votive dal Tevere*. Studi Miscellanei 25. Rome: Bretschneider.

Peruzzi, E. 1995. "La sacerdotessa di Corfinio." *ParPass* 50: 5–15.

Petit, J. 1980. *Bronzes antiques de la Collection Dutuit*. Paris: les Presses Artistiques.

Pfiffig, A. J. 1975. *Religio etrusca*. Graz: Akademische.

Piccaluga, G. 1964. "Bona Dea: Due contributi all'interpretazione del suo culto." *SMSR* 35: 195–237.

Pomeroy, S. B. 1975. *Goddesses, Whores, Wives, and Slaves: Women in Classical Antiquity.* New York: Schocken Books.

Potter, T. W. 1985. "A Republican Healing-Sanctuary at Ponte di Nona near Rome and the Classical Tradition of Votive Medicine." *Journal of the British Archaeological Association* 138: 23–47.

———. 1989. *Una stipe votiva da Ponte di Nona.* Lavori e Studi di Archeologia 13. Rome: De Luca.

Price, S. R. F. 1984. *Rituals and Power: The Roman Imperial Cult in Asia Minor.* Cambridge: Cambridge University Press.

Pugliese Carratelli, G. 1968. "Lazio, Roma e Magna Grecia prima del secolo quarto A.C." *ParPass* 23: 321–47.

———. 1981. "Cereres." *ParPass* 36: 367–72.

Purcell, N. 1986. "Livia and the Womanhood of Rome." *PCPS* 32: 78–105.

Quilici Gigli, S. 1993–94. "Appunti di topografia per la storia di Norba." *RPAA* 66: 285–301.

Raaflaub, K. A., and T. Cornell, eds. 1986. *Social Struggles in Archaic Rome.* Berkeley: University of California Press.

Rahlfs, A. 1979. *Septuaginta.* 2nd ed. Stuttgart: Deutsche Bibelgesellschaft.

Rakob, F., and W.-D. Heilmeyer, eds. 1973. *Der Rundtempel am Tiber in Rom.* Mainz am Rhein: Verlag Philipp von Zabern.

Rathje, A. 1990. "The Adoption of the Homeric Banquet in Central Italy in the Orientalizing Period." In *Sympotica*, edited by O. Murray, 279–88. Oxford: Clarendon.

Rawson, E. 1991a. "The Identity Problems of Q. Cornificius." In *Roman Culture and Society* by E. Rawson, 272–88. Oxford: Clarendon. Originally published in *CQ* 28 (1978): 188–201.

———. 1991b. "L. Cornelius Sisenna and the Early First Century BC." In *Roman Culture and Society* by E. Rawson, 363–88. Oxford: Clarendon. Originally published in *CQ* 29 (1979): 327–46.

———. 1991c. "The Life and Death of Asclepiades of Bithynia." In *Roman Culture and Society* by E. Rawson, 427–43. Oxford: Clarendon. Originally published in *CQ* 32 (1982): 358–70.

———. 1991d. "Discrimina Ordinum: The Lex Julia Theatralis." In *Roman Culture and Society* by E. Rawson, 508–45. Oxford: Clarendon. Originally published in *PBSR* 55 (1987): 83–114.

Richardson, L., Jr. 1977. *Propertius: Elegies I–IV*. Norman: University of Oklahoma Press.

———. 1992. *A New Topographical Dictionary of Ancient Rome*. Baltimore: Johns Hopkins University Press.

Richlin, A. 1997. "Carrying Water in a Sieve: Class and the Body in Roman Women's Religion." In *Women and Goddess Traditions in Antiquity and Today*, edited by K. L. King, 330–74. Minneapolis: Fortress Press.

Rives, J. B. 1992. "The *Iuno Feminae* in Roman Society." *EMC* 36, n.s. 11: 33–49.

———. 1995. *Religion and Authority in Roman Carthage from Augustus to Constantine*. Oxford: Clarendon.

Rizzello, M. 1980. *I santuari della Media Valle del Liri IV–I sec. a. C.* Sora: Centro di Studi Sorani <Vincenzo Patriarca>.

Roller, L. E. 1999. *In Search of God the Mother: The Cult of Anatolian Cybele*. Berkeley: University of California Press.

Rose, H. J. 1959. *Religion in Greece and Rome*. New York: Harper and Row. Originally published as *Ancient Greek Religion* (London: Hutchinson, 1946) and *Ancient Roman Religion* (London: Hutchinson, 1948).

Rosenstein, N. 1995. "Sorting out the Lot in Republican Rome." *AJP* 116: 43–75.

Rotondi, G. 1912. *Leges Publicae Populi Romani*. Milan: Società Editrice Libraria.

Rouquette, P. 1911. "Les ex-voto médicaux d'organes internes dans l'antiquité romaine." *Bulletin de la Société française d'Histoire de la Medecine* 11: 370–414.

Rousselle, R. J. 1982. "The Roman Persecution of the Bacchic Cult, 186–180 B.C." Ph.D. diss., State University of New York at Binghamton.

———. 1989. "Persons in Livy's Account of the Bacchic Persecution." In *Studies in Latin Literature and Roman History V*, edited by C. Deroux, 55–65. Collection Latomus 206. Brussels: Latomus.

Rüpke, J. 1995. "Iuno Sospita oder Victoria Virgo? Zur Identifizierung des sogenannten Auguratoriums auf dem Palatin." *ZPE* 108: 119–22.

Russell, B. F. 2003. "Wine, Women, and the *Polis*: Gender and the Formation of the City-State in Archaic Rome." *G&R* 50: 77–84.

Ryberg, I. S. 1955. *Rites of the State Religion in Roman Art*. Memoirs of the American Academy in Rome 22. Rome: American Academy in Rome.

Saller, R. P., and B. D. Shaw. 1984. "Tombstones and Roman Family Relations in the Principate: Civilians, Soldiers, and Slaves." *JRS* 74: 124–56.

Salmon, E. T. 1967. *Samnium and the Samnites*. Cambridge: Cambridge University Press.

Sambon, L. 1895. "Donaria of Medical Interest in the Oppenheimer Collection of Etruscan and Roman Antiquities." *British Medical Journal* 2: 146–50, 216–19.

Sawyer, D. F. 1996. *Women and Religion in the First Christian Centuries*. London: Routledge.

Scafuro, A. 1989. "Livy's Comic Narrative of the Bacchanalia," *Helios* 16: 119–42.

Scarborough, J. 1993. "Roman Medicine to Galen." *ANRW* 2.37.1: 3–48.

Scheid, J. 1990. *Romulus et ses frères*. BEFAR 275. Rome: Ecole Française de Rome.

———. 1992. "The Religious Roles of Roman Women." In *A History of Women in the West*, vol. 1: *From Ancient Goddesses to Christian Saints*, edited by P. S. Pantel, 377–408. Translated by A. Goldhammer. Cambridge, Mass.: Belknap.

———. 1993. "The Priest." In *The Romans*, edited by A. Giardina, 55–84. Translated by L. G. Cochrane. Chicago: University of Chicago Press.

———. 1995. "*Graeco Ritu*: A Typically Roman Way of Honoring the Gods." *HSCP* 97: 15–31.

———. 2003a. *An Introduction to Roman Religion*. Translated by J. Lloyd. Edinburgh: University of Edinburgh Press.

———. 2003b. "Les rôle religieux des femmes à Rome, un complément." In *Les femmes antiques entre sphère privée et sphère publique*, edited by R. Frei-Stolba, A. Bielman, and O. Bianchi, 137–51. Bern: Peter Lang.

Schilling, R. 1954. *La religion romaine de Vénus depuis les origines jusqu'au temps d'Auguste*. Paris: De Boccard.

Schmidt, E. 1909. *Kultübertragungen*. Giessen: Töpelmann.

Schultz, C. E. 2000. "Modern Prejudice and Ancient Praxis: Female Worship of Hercules at Rome." *ZPE* 133: 291–97.

———. Forthcoming. "Juno Sospita and Roman Insecurity in the Social War." In *Religion in Republican Italy*, edited by C. E. Schultz and P. B. Harvey Jr. Yale Classical Studies. Cambridge: Cambridge University Press.

Scullard, H. H. 1980. *A History of the Roman World from 753 to 146 B.C.* 4th ed. London: Methuen.

———. 1981. *Festivals and Ceremonies of the Roman Republic*. London: Thames and Hudson.

Sebesta, J. L., and L. Bonfante. 1994. *The World of Roman Costume*. Madison: University of Wisconsin Press.

Segenni, S. 1992. "Regio IV: Sabina et Samnium—Amiternum et Ager Amiterninus." *SupplIt* 9: 11–209.

Shackleton Bailey, D. R., ed. 1965–71. *Cicero's Letters to Atticus.* 7 vols. Cambridge: Cambridge University Press.

Söderlind, M. 2000–2001. "Romanization and the Use of Votive Offerings in the Eastern *Ager Vulcentis.*" *Opuscula Romana* 25–26: 89–102.

———. 2002. *Late Etruscan Votive Heads from Tessennano.* Studia Archaeologica 118. Rome: Bretschneider.

Sokolowski, F. 1962. *Lois sacrées des cités greques. Supplément.* Paris: De Boccard.

Spaeth, B. S. 1996. *The Roman Goddess Ceres.* Austin: University of Texas Press.

Staples, A. 1998. *From Good Goddess to Vestal Virgins: Sex and Category in Roman Religion.* London: Routledge.

Stibbe, C. M., et al. 1980. *Lapis Satricanus.* Archeologische Studiën van het Nederlands Instituut te Rome Scripta Minora 5. The Hague: Staatsuitgeverij.

Sydenham, E. A. 1952. *The Coinage of the Roman Republic.* 2nd edition. London: Spink and Sons.

Syme, R. 1939. *The Roman Revolution.* London: Oxford University Press.

Szemler, G. J. 1972. *The Priests of the Roman Republic.* Collection Latomus 127. Brussels: Latomus.

Tabanelli, M. 1962. *Gli ex-voto Poliviscerali etruschi e romani.* Pocket Library of "Studies" in Art 14. Florence: Olschki.

Temkin, O. 1956. *Soranus' Gynecology.* Baltimore: Johns Hopkins University Press.

Thilo, G., and H. Hagen. 1881–87. *Servii Grammatici qui feruntur in Vergilii Carmina Commentarii.* 3 vols. Leipzig: Teubner.

Thomasson, B. M. 1961. "Deposito votivo dell'antica città di Lavinio (Pratica di Mare)." *Opuscula Romana* 3: 123–38.

Tierney, J. J. 1947. "The *Senatus Consultum de Bacchanalibus.*" *PRIA* 51: 89–117.

Torelli, M. 1982. *Typology and Structure of Roman Historical Reliefs.* Ann Arbor: University of Michigan Press.

———. 1984. *Lavinio e Roma: Riti iniziatici e matrimonio tra archeologia e storia.* Rome: Quasar.

———. 1996. "Donne, *domi nobiles* ed evergeti a Paestum tra la fine della Repubblica e l'inizio dell'Impero." In *Les élites municipales de l'Italie péninsulaire des Graques à Néron,* edited by M. Cébeillac-Gervasoni, 153–78. CEFR(A) 215. Rome: École Française de Rome.

———. 1999. *Tota Italia: Essays in the Cultural Formation of Roman Italy.* Oxford: Clarendon.

Torelli, M., and I. Pohl. 1973. "Veio." *NS* 27: 40–258.

Treggiari, S. 1991. *Roman Marriage*: Iusti Coniuges *from the Time of Cicero to the Time of Ulpian*. Oxford: Clarendon.

Turcan, R. 1976. "Encore la prophétie de Végoia." In *Mélanges offerts à Jacques Heurgon: L'Italie préromaine et la Rome républicaine*, 2.1009–19. CEFR(A) 27. Rome: École Française de Rome.

———. 2000. *The Gods of Ancient Rome*. Translated by A. Nevill. New York: Routledge.

Turfa, J. M. 1986. "Anatomical Votive Terracottas from Etruscan and Italic Sanctuaries." In *Italian Iron Age Artefacts in the British Museum*, edited by J. Swaddling, 205–13. London: British Museum.

———. 1994. "Anatomical Votives and Italian Medical Traditions." In *Murlo and the Etruscans: Art and Society in Ancient Etruria*, edited by R. D. De Puma and J. P. Small, 224–40. Madison: University of Wisconsin Press.

———. 2004. "I.B. Anatomical Votives." In *Thesaurus Cultus et Rituum Antiquorum*, edited by V. Lambrinoudakis and J. Ch. Balty, 359–68. Los Angeles: J. Paul Getty Museum.

Vagnetti, L. 1971. *Il deposito votivo di Campetti a Veio*. Studi e Materiali di Etruscologia e Antichità Italiche 9. Florence: G. C. Sansoni.

Valvo, A. 1988. *La profezia di Vegoia: Proprietà fondaria e aruspicina in Etruria nel I secolo a.c.* Studi Pubblicati dall'Istituto Italiano per la Storia Antica 43. Rome: Istituto Italiano per Storia Antica.

Vanggaard, J. H. 1988. *The Flamen: A Study in the History and Sociology of Roman Religion*. Copenhagen: Museum Tusculanum.

Vermaseren, M. J. 1977. *Cybele and Attis: The Myth and the Cult*. Translated by A. M. H. Lemmers. London: Thames and Hudson.

Versnel, H. S. 1996. "The Festival for Bona Dea and the Thesmophoria." In *Women in Antiquity*, edited by I. McAuslan and P. Walcot, 182–204. Oxford: Oxford University Press. Originally published in *G&R* 39 (1992): 31–55.

Von Staden, H. 1989. *Herophilus: The Art of Medicine in Early Alexandria*. Cambridge: Cambridge University Press.

Walbank, F. W. 1957–79. *A Historical Commentary on Polybius*. 3 vols. Oxford: Clarendon Press.

Walsh, P. G. 1996. "Making a Drama Out of a Crisis: Livy on the Bacchanalia." *G&R* 43: 188–203.

———. 1997. *Cicero: The Nature of the Gods*. Oxford: Clarendon Press.

Wardle, D. 1998. *Valerius Maximus: Memorable Deeds and Sayings, Book I.* Oxford: Clarendon.

Weinstock, S. 1971. *Divus Julius*. Oxford: Clarendon.

Wells, C. 1964. *Bones, Bodies, and Disease: Evidence of Disease and Abnormality in Early Man.* London: Thames and Hudson.

Wildfang, R. L. 1999. "The Vestal Virgins' Ritual Function in Roman Religion." *C&M* 50: 227–34.

———. 2001. "The Vestals and Annual Public Rites." *C&M* 52: 223–55.

Wiseman, T. P. 1979. *Clio's Cosmetics: Three Studies in Greco-Roman Literature.* Leicester: Leicester University Press.

———. 1994. *Historiography and Imagination.* Exeter Studies in History 33. Exeter: University of Exeter Press.

———. 1998. "Two Plays for the Liberalia." In *Roman Drama and Roman History* by T. P. Wiseman, 35–51. Exeter: University of Exeter Press.

Wissowa, G. 1912. *Religion und Kultus der Römer.* 2nd ed. Handbuch der klassichen Altertumswissenschaft 5.4. Munich: Beck.

Woodman, A. J. 1988. *Rhetoric in Classical Historiography.* London: Croom Helm.

Wulff Alonso, F. 2002. *Roma e Italia de la guerra social a la retirada de Sila (90–79 A.C.)* Collections Latomus 263. Brussels: Latomus.

Zambelli, M. 1968. "Iscrizioni di Formia, Gaeta e Itri." *Miscellanea Greca e Romana* 2: 335–78.

Zanker, P. 1988. *The Power of Images in the Age of Augustus.* Translated by A. Shapiro. Ann Arbor: University of Michigan Press.

———. 1998. *Pompeii: Public and Private Life.* Translated by D. L. Schneider. Cambridge: Harvard University Press.

Zappata, E. 1996. "Les divinités dolichéniennes et les sources épigraphiques latines." In *Orientalia Sacra Urbis Romae: Dolichena et Heliopolitana,* edited by G. M. Bellelli and U. Bianchi, 87–256. Studia Archaeologica 84. Rome: Bretschneider.

Ziolkowski, A. 1992. *The Temples of Mid-Republican Rome and Their Historical and Topographical Context.* Saggi di Storia Antica 4. Rome: Bretschneider.

———. 1998–99. "Ritual Cleaning-up of the City: From the Lupercalia to the Argei." *AncSoc* 29: 191–218.

CONCORDANCE OF
INSCRIPTIONS

Inscriptions appearing in the standard corpora are listed below in boldface in
in ascending order. Numbers following the colon after each entry correspond to
the pages of this book where discussion can be found.

CIL

1².42: 52, 104, 115, 189 (n. 46); 1².45: 54,
101; 1².60: 53, 157 (n. 25), 169 (n. 19),
189 (n. 46); 1².61: 174 (n. 69); 1².62:
174 (n. 69); 1².359: 56, 169 (n. 15);
1².360: 55, 57, 169 (n. 15), 171 (n. 31);
1².361: 56, 171 (n. 31); 1².377: 171
(n. 22); 1².378: 54; 1².379: 55, 170
(n. 22); 1².380: 170 (n. 22); 1².581:
16, 50, 72, 82–92, 176 (n. 88); 1².610:
169 (n. 15); 1².677: 177 (n. 90), 182
(n. 138); 1².680: 185 (n. 5); 1².800:
185 (n. 5); 1².972: 158 (n. 9), 169

(n. 15); 1².974: 174 (n. 74), 178 (nn.
104, 113); 1².979: 52; 1².981: 59,
167 (n. 67); 169 (n. 13); 1².987: 52,
104; 1².988: 197 (n. 84); 1².989: 197
(n. 84); 1².1211: 195 (n. 55); 1².1430:
23, 158 (n. 11); 1².1436: 169 (n. 15);
1².1450: 157 (n. 25); 1².1481: 52;
1².1512: 55; 1².1532: 76, 174 (n. 74),
178 (n. 104); 1².1533: 172 (n. 48);
1².1537: 172 (n. 49); 1².1541: 175
(n. 76); 1².1550: 175 (n. 77), 178
(n. 111); 1².1688: 59, 167 (n. 67);
1².1696: 169 (n. 15); 1².1721: 172

(n. 47); 1².1745: 60; 1².1751: 74–75,
174 (n. 75); 1².1759: 60; 1².1773: 169
(n. 11); 1².1774: 175 (n. 76); 1².1775:
175 (n. 76); 1².1777: 175 (n. 76);
1².1793: 158 (n. 9); 1².1816: 169
(n. 13); 1².1928: 169 (n. 13); 1².1994:
176 (n. 87), 177 (n. 97); 1².2171b: 169
(n. 13); 1².2288: 169 (n. 15); 1².2440:
189 (n. 46); 1².2646: 172 (n. 51);
1².2685: 175 (n. 83), 177 (n. 96);
1².2699: 177 (n. 90), 182 (n. 138);
1².2832a: 41; 1².3025: 59, 167 (n. 67),
172 (n. 43); 1².3047: 55; 1².3110: 76,
174 (n. 74), 178 (n. 104); 1².3212: 169
(n. 11); 1².3213: 169 (n. 11); 1².3214:
169 (n. 11); 1².3215: 169 (n. 11);
1².3216: 174 (n. 74); 1².3257: 174
(n. 74), 178 (n. 104); 1².3260: 174–
75 (n. 75), 178 (n. 104); 3.1772: 169
(n. 15); 5.762: 175 (n. 84); 5.2799: 169
(n. 13); 5.4400: 175 (n. 82); 6.7: 185
(n. 5); 6.18: 108; 6.59: 158 (n. 9), 169
(n. 15); 6.68: 73, 101, 104, 175 (n. 84);
6.75: 169 (n. 15); 6.84: 169 (n. 13);
6.168: 52; 6.286: 62, 104; 6.327: 62;
6.333: 62; 6.334: 64–65; 6.337: 63, 173
(n. 56); 6.357: 56, 171 (n. 31); 6.358:
165 (n. 49); 6.361: 52, 104; 6.424:
169 (n. 13); 6.492: 201 (n. 30); 6.580:
108; 6.971: 197 (n. 84); 6.2074: 160
(n. 17); 6.2123: 179 (n. 115); 6.2124:
179 (n. 115); 6.2181: 174 (n. 74), 178
(n. 113); 6.2182: 174 (n. 74), 178 (nn.
104, 113); 6.3696: 197 (n. 84); 6.3877:
197 (n. 84); 6.15346: 195 (n. 55);
6.30688: 158 (n. 9), 169 (n. 15);
6.30777: 201 (n. 30); 6.30853: 53;
6.30899: 59, 167 (n. 67); 169 (n. 13);
6.30932: 197 (n. 84); 6.30939: 108;
6.31032: 51; 6.32371: 160 (n. 17);
6.32443: 174 (n. 74), 178 (n. 113);
6.32448: 197 (n. 84); 6.33936: 63;
173 (n. 59); 6.36756: 197 (n. 84);

8.22770: 194 (n. 31); 9.307: 175
(n. 79); 9.1084: 174 (n. 74); 9.1138:
172 (n. 47); 9.1538: 175 (n. 82);
9.1540: 71–72, 171 (n. 29), 175 (n. 78),
182 (n. 137); 9.1541: 175 (nn. 81,
82); 9.2174: 60; 9.2569: 74–75, 174
(n. 75); 9.2802: 60; 9.3032: 174–
75 (n. 75), 178 (n. 104); 9.3087: 175
(n. 76); 9.3089: 175 (n. 76); 9.3090:
175 (n. 76); 9.3091: 175 (n. 78);
9.3138: 158 (n. 9); 9.3146: 176 (n. 85);
9.3166: 175 (n. 75); 9.3677: 61, 173
(n. 53); 9.4200: 77; 9.4460: 176
(n. 85); 9.5803: 169 (n. 13); 9.6323:
175 (n. 76); 10.39: 73–74; 10.129: 174
(n. 74), 175 (n. 82); 10.292: 59, 167
(n. 67); 10.772: 193 (n. 24); 10.810:
61, 172 (n. 52); 10.846: 175 (n. 79);
10.928: 169 (n. 13); 10.1036: 77;
10.3779: 177 (n. 90), 182 (n. 138);
10.3781: 185 (n. 5); 10.4789: 175
(n. 78), 176 (n. 86); 10.4790: 175
(n. 78); 10.4791: 176 (n. 86); 10.4793:
175 (n. 81), 178 (n. 113); 10.4794:
175 (n. 81), 178 (n. 113); 10.5046:
169 (n. 13); 10.5073: 76, 174 (n. 74),
178 (n. 104); 10.5074: 172 (n. 48);
10.5191: 175 (n. 76); 10.5422: 175
(n. 77), 178 (n. 111); 10.5679: 172
(n. 49); 10.6103: 76, 174 (n. 74), 178
(n. 104); 10.6109: 77; 10.6510: 169
(n. 13); 10.6511: 171 (n. 28): 10.6518:
55; 10.8416: 200 (n. 24); 11.2630:
176 (n. 87), 177 (n. 97); 11.1295: 102;
11.1303: 108–09; 11.1305: 101, 104,
108; 11.3076: 194 (n. 34); 11.4635:
175 (n. 84); 11.6299: 171 (n. 22);
11.6300: 54; 11.6301: 55, 170 (n. 22);
11.6302: 170 (n. 22); 14.2090: 23,
158 (n. 11); 14.2863: 53, 157 (n. 25),
169 (n. 19), 189 (n. 46); 14.2878: 157
(n. 25); 14.2891: 174 (n. 69); 14.2892:
174 (n. 69); 14.2997: 177 (n. 97);

14.3006: 177 (n. 97); 14.3538: 52;
14.4268: 169 (n. 15); 14.4270: 52, 104,
115, 189 (n. 46)

ILS

18: 16, 50, 72, 82–92, 177 (n. 88); 116:
194 (n. 34); 120: 194 (n. 34); 316: 23,
158 (n. 11); 2289: 193 (n. 25); 2290:
193 (n. 25); 2291: 193 (n. 25); 2292:
193 (n. 25); 2979: 171 (n. 22); 2980:
54; 2981: 55, 170 (n. 22); 2982: 170
(n. 22); 2992: 169 (n. 13); 3097: 23,
158 (n. 11); 3101: 56, 171 (n. 31); 3102:
165 (n. 49); 3103: 52, 104; 3112: 175
(n. 78), 176 (n. 86); 3113: 176 (n. 86);
3135: 101, 104, 108; 3187: 175 (n. 75);
3213: 169 (n. 13); 3234: 52, 104, 115,
189 (n. 46); 3235: 54, 101; 3237: 169
(n. 15); 3337: 174 (n. 74), 175 (n. 82);
3340: 177 (n. 90), 182 (n. 138); 3342:
174 (n. 74), 178 (nn. 104, 113); 3343:
174 (n. 74), 178 (n. 113); 3344: 76,
174 (n. 74), 178 (n. 104); 3345: 174
(n. 74); 3346: 175 (n. 81), 178 (n. 113);
3347: 175 (n. 81), 178 (n. 113); 3351:
175 (n. 76); 3353: 175 (n. 77), 178
(n. 111); 3367: 169 (n. 13); 3419: 174
(n. 69); 3420: 174 (n. 69); 3423:
59, 167 (n. 67); 169 (n. 13); 3487:
200 (n. 24); 3488: 171 (n. 28); 3491:
158 (n. 9), 169 (n. 15); 3494: 175
(n. 84); 3498: 175 (n. 84); 3508: 169
(n. 15); 3513: 73, 101, 104, 175 (n. 84);
3638d: 157 (n. 25); 3683c: 157 (n. 25);
3684: 53, 157 (n. 25), 169 (n. 19), 189
(n. 46); 3700: 52; 3828: 176 (n. 85);
3836: 185 (n. 5); 3970: 108; 4107: 176
(n. 85); 4184: 175 (nn. 81, 82); 4185:
175 (n. 82); 4186: 71–72, 171 (n. 29),
175 (n. 78), 182 (n. 137); 4941: 179
(n. 115); 4941a: 179 (n. 115); 4963:
197 (n. 84); 5035: 160 (n. 17); 5367:
172 (n. 48); 5430: 59, 167 (n. 67);

5528: 60; 5561: 185 (n. 5); 5683: 23,
158 (n. 11); 5684: 61, 173 (n. 53); 5738:
172 (n. 49); 5896: 60; 6196: 23, 158
(n. 11); 6273: 55; 6365: 77; 6367: 175
(n. 79); 7066: 193 (n. 26); 7067: 193
(n. 26); 8403: 195 (n. 55); 9230: 56,
169 (n. 15); 9230a: 55, 57, 169 (n. 15),
171 (n. 31); 9246: 23

ILLRP

22: 171 (n. 22); 23: 54; 24: 55, 170
(n. 22); 25: 170 (n. 22); 39: 185 (n. 5);
44a: 169 (n. 11); 49: 169 (n. 13); 56:
158 (n. 9), 169 (n. 15); 57: 158 (n. 9);
61: 174 (n. 74), 178 (nn. 104, 113);
62: 76, 174 (n. 74), 178 (n. 104);
63: 175 (n. 76); 65: 175 (n. 76); 66:
175 (n. 76); 75: 169 (n. 15); 78: 169
(n. 15); 81: 54, 101; 82: 52, 104, 115,
189 (n. 46); 86: 169 (n. 15); 87: 169
(n. 15); 89: 52; 98: 52; 101: 53, 157
(n. 25), 169 (n. 19), 189 (n. 46);
106: 157 (n. 25); 106a: 157 (n. 25);
110: 157 (n. 25); 126: 59, 167 (n. 67);
169 (n. 13); 131: 174 (n. 69); 132: 174
(n. 69); 160: 165 (n. 49); 161: 56, 171
(n. 31); 162: 56, 169 (n. 15); 163: 55,
57, 169 (n. 15), 171 (n. 31); 170: 23,
158 (n. 11); 185: 197 (n. 84); 195: 169
(n. 13); 204: 189 (n. 46); 205: 175
(n. 77), 178 (n. 111); 273: 74–75, 174
(n. 75); 301: 55; 511: 16, 50, 72, 82–92,
177 (n. 88); 522: 172 (n. 47); 546: 172
(n. 49); 551: 172 (n. 48); 552: 60; 568:
60; 574: 59, 167 (n. 67); 705–46: 176
(n. 87); 714: 177 (n. 90), 182 (n. 138);
717: 185 (n. 5); 729: 177 (n. 90), 182
(n. 138); 737: 175 (n. 83), 177 (n. 96);
775: 197 (n. 84); 973: 195 (n. 55)

AE 1973.127: 59, 167 (n. 67), 172 (n. 43)
AE 1978.97: 175 (n. 83)
AE 1978.99: 175 (n. 83)

AE **1980.374**: 175 (n. 75)
AE **1989.239**: 169 (n. 13)
AE **1990.202**: 175 (n. 79)

Brouwer 1989, 27–28, no. 13: 169
(n. 15)
Brouwer 1989, 29–30, no. 15: 158
(n. 9), 169 (n. 15)
Brouwer 1989, 39, no. 28: 53
Brouwer 1989, 53–54, no. 44: 73, 101,
104, 175 (n. 84)
Brouwer 1989, 97–98, no. 93: 175
(n. 84)
Brouwer 1989, 116–18, no.113B: 175
(n. 84)

CCCA **4.40, no. 100:** 71–72, 171 (n. 29),
175 (n. 78), 182 (n. 137)

Courtney 1995, 46–47, no. 17: 195
(n. 55)

Frederiksen 1984, 281, no. 8: 177
(n. 90), 182 (n. 138)
Frederiksen 1984, 282, no. 12: 185
(n. 5)

Johnson 1933–35, 2.25, no. 8: 175
(n. 83), 177 (n. 96)
Johnson 1933–35, 2.41, no. 22: 177
(n. 90), 182 (n. 138)

LSAM **48:** 182 (n. 134)

OGIS **735:** 182 (n. 134)

Sokolowski 1962, 202–3, no. 120: 182
(n. 134)
Sokolowski 1962, 210–12, no. 126: 182
(n. 134)

INDEX

Names of individuals discussed in the main text are listed here; those appearing only in inscriptions cited as comparanda are not. Individuals are listed by family name (*nomen*).

Aebutius, 82, 90

Aemilia (Vestal), 140

Aemilia (wife of P. Cornelius Scipio Africanus), 148–50

Aeneas, 123

Aesculapius, 99, 107, 108

Albius, 41

Alfia of Marruvium, 61

Alleia (pr. of Ceres), 77–78, 178 (n. 108)

Anaceta Cerria, 51

Anatomical votives, 10–11, 17, 54, 95–120, 197 (n. 77); and Romanization, 98–99; origin of, 99; and inscriptions, 100–102, 106–7; medical inter-

pretation of, 100–114; metaphorical interpretation of, 105; expiatory offering, 105–9; and gender, 110, 114–20

Anna Perenna, 13, 133

Annia Paculla, 181 (nn. 130, 131)

Ansia Rufa, 59–61

Aphrodite-Turan, 107

Apis, 76

Apollo, 30–31, 33, 43, 51; priestesses of at Delphi, 76

Argei, 73, 106, 165 (n. 49), 188 (n. 40), 189 (n. 41), 195 (n. 48)

Arval Brethren, 141, 199 (n. 15)